STAN LEE'S
HOW TO WRITE COMICS

JOHN ROMITA

Watson-Guptill Publications
New York

Cowriter: Bob Greenberger

Contributing artists: Neal Adams, Ross Andru, Erica Awano, Mark Bagley, Diego Bernard, John Byrne, Aaron Campbell, J. Scott Campbell, Chris Caniano, Milton Caniff, John Cassaday, Cliff Chiang, Gene Colan, Steve Dillon, Steve Ditko, Glenn Fabry, Francesco Francavilla, Frank Frazetta, Frank Kelly Freas, Dick Giordano, George Herriman, Bill Hughes, Bryan Hitch, Dan Jurgens, Gil Kane, Jack Kirby, David Lafuente, Jonathan Lau, Bob Layton Sr., Larry Lieber, Mike Mayhew, Bob McLeod, Frank Miller, Tom Morgan, Katsuhiro Otomo, Richard F. Outcault, Carlos Paul, Frank Paul, George Pérez, Wendy Pini, Joe Quesada, Frank Quitely, Carlos Rafael, Caesar Razek, Wagner Reis, Paul Renaud, John Romita, John Romita Jr., Alex Ross, Mel Rubi, Edgar Salazar, Manuel Clemente Sanjulian, Mike Sekowsky, Joe Shuster, Bill Sienkiewicz, Dave Sim, Vin Sullivan, Rodolphe Töpffer, Michael Turner, Mike Zeck

Paperback edition cover artists: Jonathan Lau; color by Ivan Nunes

Produced in association with Dynamite Entertainment

www.dynamite.net

Library of Congress Cataloging-in-Publication Data
Lee, Stan, 1922–
Stan Lee's how to write comics / by Stan Lee.— 1st ed.
p. cm.
Includes bibliographical references and index.
1. Comic books, strips, etc. Authorship. I. Title. II. Title: How to write comics
PN6710.L44 2010
808'.066741—dc22
2010045663

Paperback Edition: 978-0-8230-0084-5
Hardcover Edition: 978-0-8230-0709-7

Cover design by Jess Morphew
Interior design by Ellen Nygaard

Special thanks to POW! Entertainment, Inc., Gil Champion, Michael Kelleher, Arthur Lieberman, Luke Lieberman, Mike Kelly, Heritage Auctions, Michael Lovitz, Digikore, Carol Punkus, Dave Altoff, Mike Raicht, Eli Bard, Gregory Pan, Nick Barrucci, Juan Collado, Josh Johnson, and Josh Green.

Printed in China

10 9 8 7 6 5 4 3 2 1

First Edition

TO ALL
TRUE BELIEVERS,
KEEP ON
DREAMING!

ACKNOWLEDGMENTS

Stan wishes to thank the following creators for

contributing their opinions and advice, making this a far better book

than it would have been otherwise: Roy Thomas, Brian Bendis,

Mark Waid, Jerry Ordway, Kurt Busiek, Gene Colan,

Richard Starkings, Tom Orzechowski, Ken Bruzenak, Richard Pini,

Marv Wolfman, John Romita, Chris Ryall, Andy Schmidt,

Shawna Gore, and Chuck Dixon.

by Stan Lee

SECRETS
BEHIND
THE
COMICS

PRICE $1

Stan Lee's original "how-to" book from the 1940s.

PREFACE

Hi, Comic Book Writers!

Interviewers often ask me to describe those exciting days at Marvel in the early '60s when we were creating a brand-new universe of superheroes. It's hard to put into words the fun and excitement of bringing new types of characters and stories onto the printed page. And it's almost impossible to give enough credit to the enormously talented artists I worked with, artists who took our stories and depicted them so thrillingly, so dramatically that every tale was like watching a fantastic movie on the pages of each amazing comic book.

But every strip begins with one thing—the story! And that's what we're gonna be talking about on the pandemonious pages that follow!

Ever since Marvel's superheroes conquered the world, or at least it feels that way, people have wanted to learn the magic; much as Stephen Strange sought the Ancient One to learn how to cast spells and help mankind, men and women of all ages have sought to learn how to string the words together to tell stories in comic book form.

Of course, creatively, comic books are a literary world of their own. Unlike movies, television, or video games, they're unique in the way they blend words and art on the printed page to tell titanic tales designed to open new vistas of imagination and excitement for the lucky reader.

Writers who come from other disciplines soon discover just how challenging comics can be. In the past, some have asked me for tips, but there's no way I could ever tell them all they had to know in a brief conversation. However, thanks to this book, which you're so happily holding in your grateful hands, all of that has changed.

What follows are the rules, the hints, and the tips as I have come to know them. But teamwork is as important in comics as it is in sports and life itself. To make certain that there's nothing I've neglected, to ensure that I've covered all the literary bases, I've been lucky enough to be able to recruit Bob Greenberger and the hip horde of heroes at Dynamite Entertainment to help me put together a lifetime's worth of comic book–writing experience into this valiant volume of indispensable info.

Obviously, styles and methods have changed over the years just as typewriters have given way to computers. So, what you're about to read is an amalgamation of the current collective wisdom on how to write comics today.

But what has not changed, nor will it ever, is the desire to tell a story and tell it well. In each case, you want to write something new, something that's never been written before. You want to explore situations no one has read before—and you have that in common with your readers. Every day, as fans walk into their comic shops or bookstores seeking the latest comic books, they have one thing in mind. They want to be transported into adventures and situations they've never encountered before. They want to be entertained, thrilled, and surprised.

And that's our job—to show you how to do it!

Excelsior!

The Marvel Universe was born when I created the
Fantastic Four with Jack Kirby.

THE HISTORY OF COMICS

Looking around today, it's hard to believe that comics haven't always been a part of the world's culture. No, they didn't arrive fully formed from the fevered brow of some genius but rather, much like the process of writing, are the culmination of building blocks that date back thousands of years.

The idea of using pictures to tell a story pretty much dates back to the earliest cave dwellers, who decorated their walls with images recounting their successful hunts and conquests.

Through the centuries that followed, pictures were used as a part of developing languages, as seen in the colorful hieroglyphics found in the temples and pyramids of ancient Egypt. On the Pacific Rim, pictures of objects were simplified into a few elegant brushstrokes so pictograms, not letters, formed the written culture in China, Japan, Korea, and other countries.

Gorgeous and meticulously crafted stained glass was used to tell religious tales, while illuminated scrolls throughout Europe decorated the words with pictures to enhance the reading experience. The printing press gave the world mass-produced books, which were often illustrated, and as the process evolved, illustrated stories became possible. Beginning in the eighteenth century, newspapers and magazines often used illustrations with their fiction.

The Adventures of Mr. Obadiah Oldbuck, an 1837 English translation of the 1833 Swiss publication *Histoire de M. Vieux Bois* by humorist Rodolphe Töpffer, is the oldest recognized American example of comics.

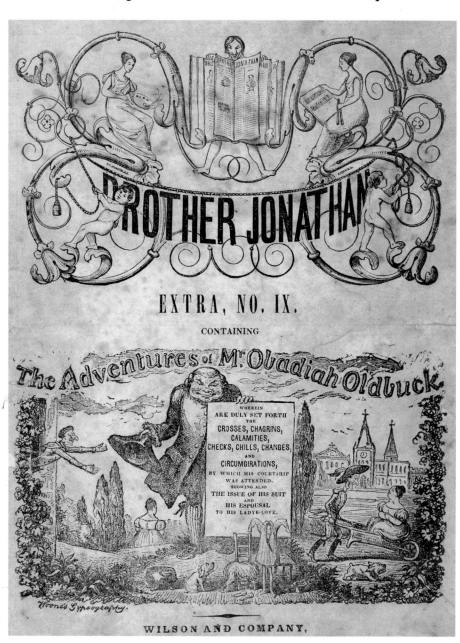

The Adventures of Mr. Obadiah Oldbuck Extra, No. IX *Bound Volume (Wilson Publishing, 1842).*

THE COMIC STRIP

Improved printing techniques allowed newspapers to begin using color, which led to the Hearst papers featuring Richard Outcault's cartoon in color, notably the bald, big-eared central figure whose bedclothes were colored yellow. The *Yellow Kid* became the first significant recurring comic strip character, which led to an explosion of merchandising after his 1895 debut, including an 1897 collection of the strips—the first graphic novel, using modern terms.

The comic strips took everything that came before and synthesized it into a new form to entertain the masses. Newspapers fought bitterly to gain the rights to the most popular features, and their creators got rich and became newsworthy figures on their own.

When I was born, in 1922, comic strips could be found in every paper, usually spread across many pages and printed far larger than what you're accustomed to today. The larger size led to gorgeous color pages and magnificently detailed artwork. Truth to tell, I read the strips but didn't devour them with the same fervor as my friends. My favorites were George Herriman's *Krazy Kat*, *Red Barry*, *Skippy*, and *They'll Do It Every Time*.

Yellow Kid *advertising poster (circa 1898) demonstrates the character's popularity, used to sell newspapers and, later, merchandise.*

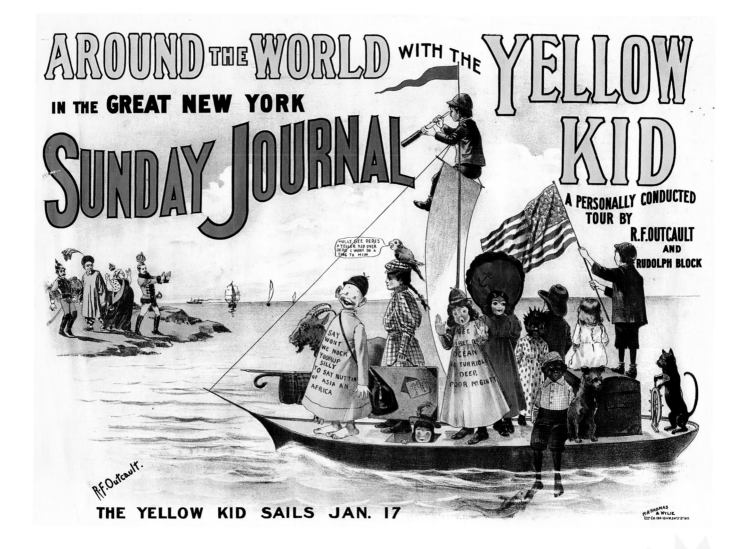

Instead, I read comics strips and everything else. As I'll stress throughout this book, writers have to read and expose themselves to different types of storytelling. When I was a kid, I read books, discovering Shakespeare and coming to love his use of language. But my pulse quickened when I read the visceral adventures of pulp heroes in the dime magazines that had vivid and lurid covers. I also went to the movies as often as family finances allowed, and every Sunday we gathered around the radio to listen to the popular radio programs, from comedy to high adventure.

As newspapers began to include comic strips, collections of the more popular strips seemed a logical way to make some money. By 1901, there were regular book collections of these strips. Just before I arrived in the world, some of these collections wound up being sold on newsstands in cities and train stations.

A company called Cupples & Leon packaged and sold many of these collections, and in time they developed the size and shape of what became the comic books we know and love today. They were followed in 1929 by George Delacorte's *The Funnies*, a twenty-four-page tabloid that mixed color with black-and-white strips, selling the publication on newsstands for one thin dime. While the publication struggled for thirty-six issues before folding, Delacorte went on to greater fame as the founder of Dell Publishing.

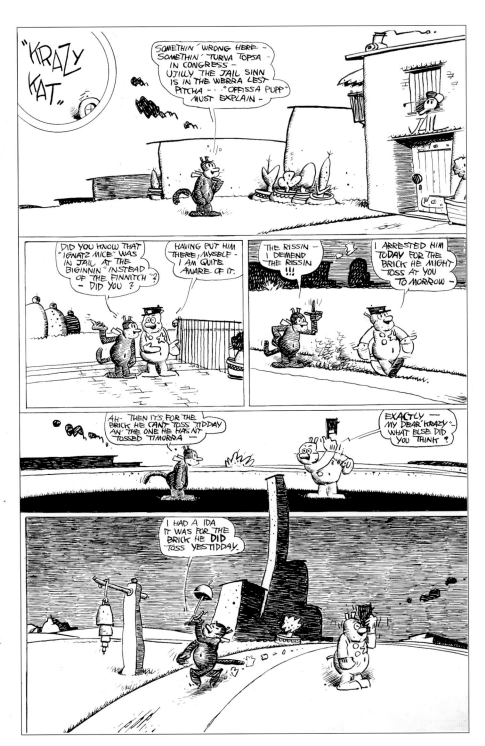

A favorite comic strip of mine was Krazy Kat *(dated September 25, 1938). Note the surrealistic art style that still tells the story.*

BIRTH OF THE COMIC BOOK

Famous Funnies is the comic that most historians will tell you is the first modern comic book. Conceived by Harry I. Wildenberg, the publication boasted a hundred different strips and features beginning in 1934. Never heard of Wildenberg? Well, he was a salesman for Eastern Color Printing Company in Waterbury, Connecticut. Since Eastern was the premier printer of color Sunday sections for newspapers around the country, they had the expertise to find a new format and a fresh way to turn a profit.

It was Wildenberg who also conceived of repurposing comics as retailer premiums beginning with the Gulf Oil Company. One such premium led to the development of folding the tabloid-sized newsprint sheets into a sixty-four-page package that could be covered, stapled, and sold.

With a fellow salesman named Maxwell Charles Gaines, Wildenberg sold armloads of premium comics. Gaines was equally successful partnering with Delacorte to work on *The Funnies*. Wildenberg and Gaines decided to try something: Stick a dime price tag on the cover of one of their premiums and sell it directly to kids on newsstands. The experiment was such a wild success that the comic book became the next Big Thing.

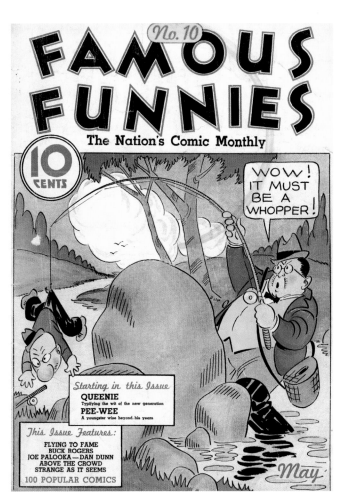

Famous Funnies #10 (Eastern Color, 1935) boasts a hundred popular comics, all reprinted from the newspapers in a mix of color and black and white.

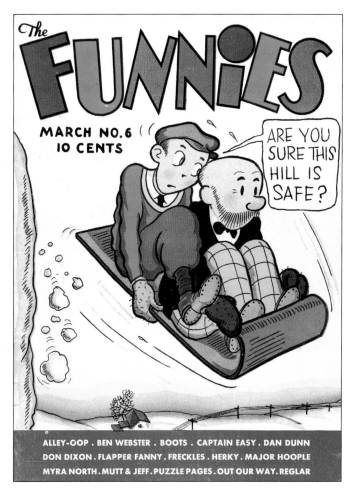

The Funnies #6 (Dell, 1937) features two characters from different comic strips meeting up for winter fun. All the strips listed are reprinted from newspaper syndication.

As it turned out, 1935 was the year of the comic book. Not only was *Famous Funnies* selling like gangbusters, but it also gained some competition. *Popular Comics* from Dell was packaged by Gaines, who smelled the profit in the air and went out on his own, buying the presses from the defunct New York Graphic. Then there was Major Malcolm Wheeler-Nicholson, solider-turned-pulp-writer, who also wanted in on the comics business but took the notion one step further by offering readers nothing but new material—which he could then own and exploit, rather than pay license fees to the newspaper syndicates. His aptly named *New Comics* is now considered the first release from the company that evolved into DC Entertainment, which just celebrated its seventy-fifth anniversary in 2010.

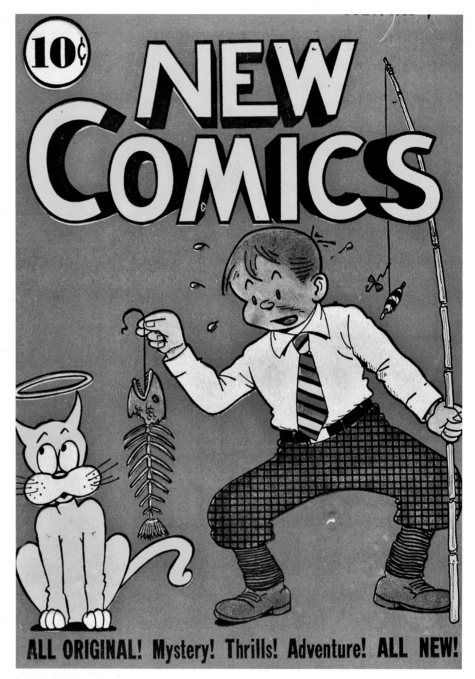

DC Entertainment's success with New Fun Comics *in 1935 led to a second title,* New Comics *(1936), which continued the trend away from reprint material to all-new stories.*

An example of the pulp magazines churned out with astonishing regularity by Martin Goodman, which led to the use of the Marvel name when he jumped into the growing comic book field.

The growth proved exponential, and the kids (including yours truly) couldn't get enough of these four-color comics. Everyone wanted in on the field, including a relative of mine named Martin Goodman. I started writing comics for him when I was sixteen. His publishing empire had him producing pulp magazines on every concept imaginable, with titles like *Western Book* and *Marvel Science Stories*. He was a terrific distribution man and could sense when a trend was developing, so he could order up new titles to capitalize on the interest.

So, when Wheeler-Nicholson's Detective Comics, Inc., released a new book in the spring of 1938, Goodman's personal spider-sense started tingling. By then, the good major's company had three successful titles, and they were seeking a cover feature for the newest addition, to be called *Action Comics*. Maxwell Gaines of EC Comics sent over a rejected comic strip from Jerry Siegel and Joe Shuster, who were already churning out detective and science fiction stories for Wheeler-Nicholson. The young cartoonist-turned-editor Vin Sullivan liked what he saw and put the new feature, Superman, on the cover.

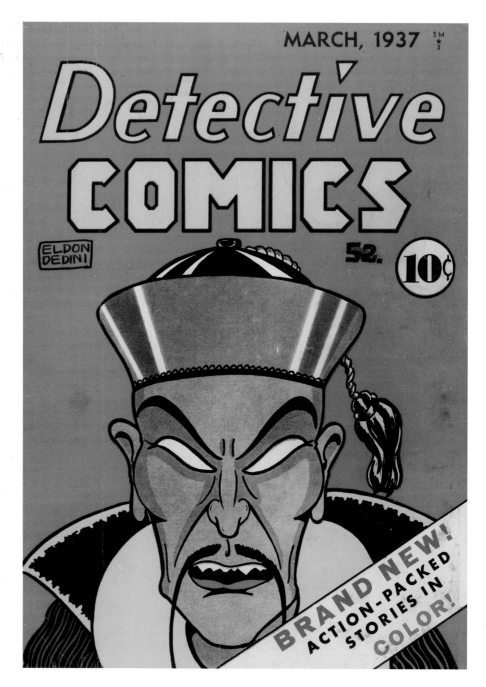

Above: DC Entertainment's third title was the first with a specific theme. Behind the Vin Sullivan cover, Detective Comics #1 *also featured Siegel and Shuster's Slam Bradley.*

Opposite: Action Comics #1, *the first appearance of Superman and the book that propelled publishers to add costumed do-gooders with powers and abilities that dwarfed the imagination.*

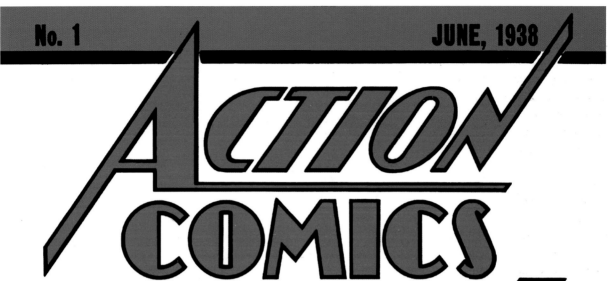

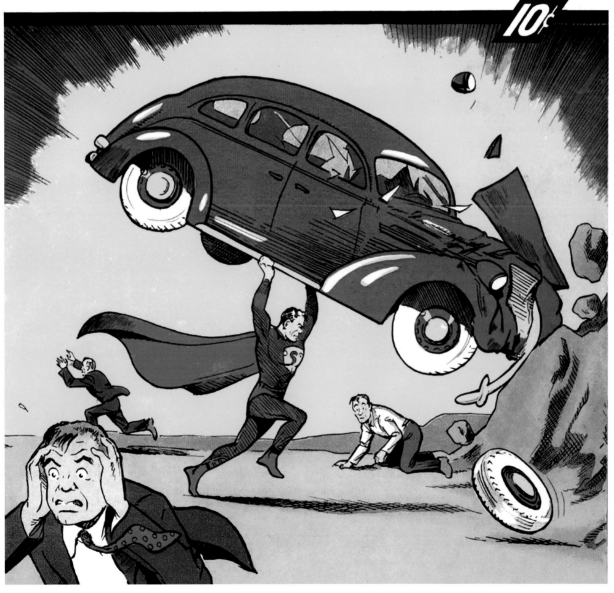

Well, you know what happened next.

Everyone wanted costumed heroes, their colorful capes flapping in the wind, bullets bouncing off their chests, and evil-doers cowering in fear. Goodman decided it was time to enter the field of comic books.

He quickly assembled a team of writers and artists to fill several sixty-four-page titles, buying packages of material from studios until he could do it all himself. Along the way, Goodman resurrected the Sub-Mariner, a character from the black-and-white promotional comic *Motion Pictures Funnies Weekly* created by Bill Everett. The Sub-Mariner was far different than the Man of Steel, and Goodman had his first hit.

Along with Carl Burgos's Human Torch, the features debuted in *Marvel Comics* #1 in 1939, and the Golden Age of Marvel had begun. Joe Simon was hired away from a studio to be the line's editor, and he brought with him a young artist named Jack Kirby, and together they gave the world Captain America. Soon after, at seventeen, I walked through the doors figuring I'd work for my relative for a while and move on to "real" writing. I went from gofer to temporary editor to publisher, a pretty amazing trajectory, and one totally unforeseen.

Comic books thrilled kids of all ages, helped farm-boys-turned-soldiers learn to read en route to combat, and put hundreds of writers and artists to work at the tail end of the Great Depression. Superheroes rallied readers to collect scrap metal and buy war stamps, but after they licked the Axis (along with some help from the Allied forces), they began to lose steam.

The second half of the 1940s saw an explosion in genres from funny animals to teen romance to crime to horror. Popular characters with names like Archie and Millie were now found

alongside Batman, Captain Marvel, and Captain America. You name it, someone probably tried a comic about the subject. For me, it was a great learning experience as Martin had us stop one line of books and crank up another. I had to switch gears daily, something we'll talk about in later chapters.

Marvel Entertainment's first comic book, Marvel Comics #1, which spotlighted Carl Burgos's Human Torch but also contained Wild Bill Everett's Namor, the Sub-Mariner, the Angel, and Ka-Zar (coming from Goodman's pulps).

THE DREADED COMICS CODE ARRIVES

Most of you also know of the dark days that followed. Parents grew concerned that their children were turning into juvenile delinquents, with comics cited as one of the root causes. Congress held hearings on these matters, studying radio, movies, this new thing called television, and, yes, comic books.

With sales plummeting, the surviving publishers banded together under Max Gaines's son William. While Bill wanted to fight back, he was outvoted, which led to the formation of the Comic Magazine Association of America and the birth of the Comics Code Authority. Now comics were scrubbed clean of horror and violence, with distributors safely displaying approved titles. There were just a lot fewer of them, and with tears in my eyes, I had to let dozens of people go during some of the bleakest days of my professional life.

Soon after, Martin made a bad bet on switching distributors, and when American News went under without notice, we were in a jam. He made a pact with Independent News, the sister company to our rival DC Comics (formerly Detective Comics, Inc.), and we were limited to eight books a month, so Martin settled on a mix of sixteen bimonthly titles across all genres.

During this time, DC's editorial team tried reviving one of their moribund heroes, the Flash, in an issue of *Showcase*. Sales were encouraging, so he came back three more times and then returned to his own title. Other revivals followed, and suddenly DC was back in the superhero business. There were so many flying around then, they banded together as the Justice League of America.

The JLA's sales success was not lost on Martin, who one day ordered up a new superhero title. With my wife, Joan's, encouragement, I figured I had nothing to lose and created a team that *I* wanted to read. With the

MLJ Publishing hit pay dirt when they introduced a teen humor feature set in suburban America. Archie Andrews captured readers'— and publishers'—attention.

peerless pencils of Jack Kirby, we produced the *Fantastic Four*, and sure enough, it clicked with readers. Suddenly, the Marvel Universe was born.

The 1960s saw Marvel introduce one pulse-pounding hero after another, while DC's line also grew.

We saw more publishers arrive, and a new sales cycle was underway, fueled by the Baby Boomers, the children now buying our books. They were better educated, had more free time on their hands, and were seeking diversions, and our stuff proved very diverting.

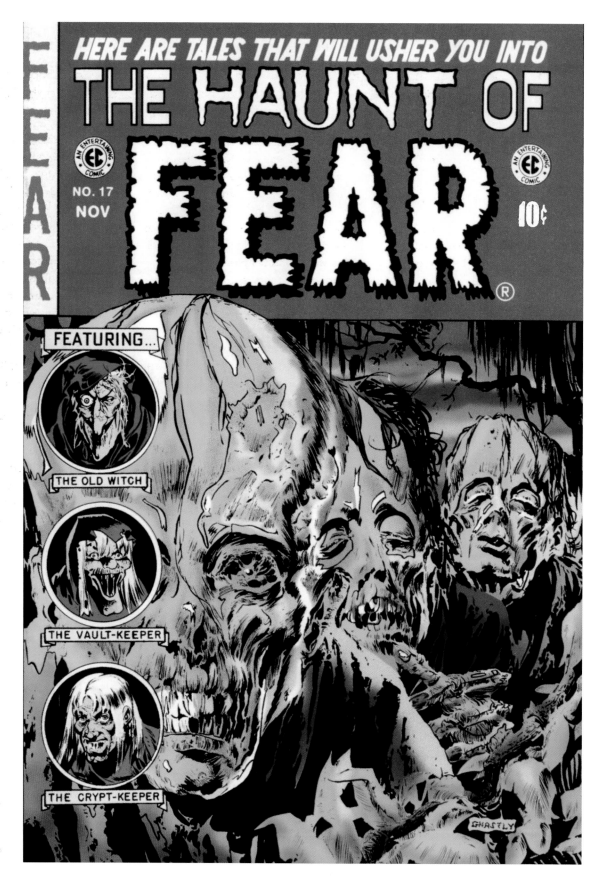

The Haunt of Fear (#17 shown here) were the types of comic books that were difficult to approve by the Comics Code.

MODERN COMICS

As all things do, times changed, and we finally managed to convince the Comics Code to relax their rules to reflect modern-day sensibilities. That led to new genres arriving in the 1970s, as horror became the next wave of titles, with publishers now free to use vampires and werewolves once more.

Another thing happened at that time: The readers found one another. They exchanged letters with each other and with us. They wrote about their favorite characters and creators in fanzines and then began convening at conventions. Some wound up trying out at and getting hired by DC, Marvel, Charlton, and Gold Key. They brought fresh blood to the field, which made it an exciting time to be working.

Then came the arrival of what we call the Direct Sales Channel, which basically means that the distributor sold the books to retailers but at a deeper discount with the proviso that the books could not be returned for credit. This led to the formation of comic book stores, consolidating the field and creating a financial climate that would allow smaller publishers to enter the field.

Many of these early pioneers proved to be one- or two-man operations, producing their one title, such as *Cerebus the Aardvark* or *ElfQuest*. Those successes led to an explosion of new publishers around 1980. I couldn't keep up with the announcements, as we welcomed Eclipse, Pacific, First, and many others to the party. Most of them are long gone, but the talent they introduced and many of their creations are still with us.

The increasing sophistication of the field allowed everyone to experiment with formats and subject matter. Parallel to all this was the evolution of the comic book into a graphic novel, which is a longer story with better production values. Jack and I even dipped our collective toes into this format with 1978's *Silver Surfer* book published not by Marvel but by a division of Simon & Schuster. Today, graphic novels are either these longer stories or collections of serialized storylines.

And during the 1980s, and continuing today, imported material from international publishers broadened the choices available to readers. Obviously, the most popular of those imports are the Japanese manga, but walk into a bookstore or comic shop and you can sample works from Italy, France, England, and elsewhere.

Digital comics seem to be the new frontier being explored with classic material and newly created content. It's very exciting, since it means new pioneers are using the tools available to create exciting or moving stories, delivered to your computer, cell phone, or the next great gadget that I can't even conceive of.

But all these devices and delivery systems exist to tell stories. And storytelling is the primary job of the writer. So let's get started with figuring out how to write these graphic stories.

Dave Sims's delightful Cerebus the Aardvark was one of the first self-published success stories of the modern age. His stories veered from high drama to subtle satire and ran an incredible three hundred issues.

Wendy and Richard Pini met through the letter column of my Silver Surfer comic and went on to create their own wondrous world with ElfQuest, which endures today.

Comic book characters have all the greatest gadgets.
But what tools does a comic book creator need?

WHAT YOU NEED

Writers write, but what do they use to write on? You want to write stories, you have ideas just exploding within you, but you sit there, stumped. You've tried keeping notes, or started manuscripts, or have dictated into digital recorders, but you struggle to finish those thoughts.

We've all been there. Quite often the problem is that you just don't have the proper tools at your disposal. In this chapter, we'll explore what every good writer keeps in his or her office.

Obviously, everyone does things just a little differently, and no one is right or wrong; people just pick what makes them most comfortable and productive. That usually changes with time and experience. After all, when I got started, I was scribbling with pencil and paper before graduating to a trusty Remington manual typewriter. These days, I'm pounding away on a computer, but you know what? I still jot down ideas with pen and paper. Some things won't ever change.

PENCILS AND PAPER

Pens and pencils are essential. Even in this digital age, there will come times and opportunities where you just don't have access to your computer, cell phone, or semaphore flags. But, if you keep a writing instrument with you at all times, you can always find something to write on as that moment of inspiration arrives. If all else fails, the palm of your hand is a trusted surface, one you won't lose—as long as you transcribe your thoughts before you next wash your hands.

Many writers keep notepads in their pockets or shoulder bags. This can be anything from a spiral-bound reporter's notepad to a Moleskine journal of blank paper. This way, you can immediately take your brainstorm and preserve it for posterity. Neil Gaiman writes lovingly of the Moleskine journals he uses, and given his

globe-trotting, it comes in handy, since he need never worry about plugs or country-specific adapters. Garth Ennis is also known for jotting his thoughts down in his little black book, an act that is said to cause his artists to shudder, unsure of what visceral thrill they will be called upon to illustrate weeks hence.

In fact, Garth told interviewer Mark Salisbury for his useful *Writers on Comics Scriptwriting*, "What I tend to do is, I have these wee notebooks. Every idea I have, no matter what, no matter when, goes into them; every line of dialogue, every cool scene, every idea for a character, even ideas for whole new stories go in there. Then, when it comes down to writing the particular episode of whatever I'm doing, I trawl through the notebooks. It's my own dopey wee system and I'm loathe to change it, you know. I note down all the ideas, the lines of dialogue, and then I divide it into scenes, which I'll letter, say, A to J, for that issue."

Often, writers will jot down character descriptions, story titles, and a few words describing a scenario, letting them work as bookmarks. We may get to them tomorrow or years from now, but they will sit there, patiently waiting their turn.

These days, most cell phones and PDAs come with digital notepads, and you can easily put those same ideas into bits and bytes, transferring them to your computer for later use. Some writers carry digital recorders with them, speaking into them, sometimes elaborating on the notion to complete the thought.

SOFTWARE

Just about everyone I know, save for Harlan Ellison, uses a computer of some sort. To write, you don't need one kind over another, so if you're comfortable being a Mac, that's swell. Prefer a PC? No problem.

"Assuming you don't use a typewriter, all you need is a decent writing program," Marvelous Marv Wolfman confirmed for me. "The program doesn't make you a better writer, but one thing computers do allow is easy revision. As most people use Microsoft Word, I'd recommend that or a program that can save to it. You don't need screenplay software like Final Draft—which I do use for screenplays, but they are not the best tools for comics. Writing isn't about how good the materials you have are but how you create characters and compose your story. Also, computers allow you to rewrite without retyping the entire page: Rewrite, rewrite, rewrite."

As you might imagine, if you gather a group of a dozen writers in a room and ask a question, you'll get at least two dozen answers. Chris Ryall, a snappy writer and chief creative officer at IDW Publishing, adds to Marv's thoughts.

"I actually don't have a firm recommendation of particular software that writers need to use—anything from open-source word processing to MS Word to Final Draft to a Smith-Corona Sterling typewriter is fine with me, as long as the submission is formatted cleanly and has sound spelling and grammar. Comic book script format is more fluid than screenplay formatting, and there are all kinds of sample

scripts online, as well as good script-writing books that offer appropriate reference. I know some writers get hung up on format, but I'd rather have the heavy lifting done on the story stage."

Chris's IDW colleague, Andy Schmidt, adds, "This is pretty easy. If we're just talking about comics writing, you can do it with a simple word processor like Microsoft Word or Text Edit. As long as you can save in an easy-to-use format like Word or Rich Text, you should be golden.

"Many writers used advanced programs like Final Draft and such, but they really aren't necessary. In my experience, many editors don't have these programs on their own computers, and so the writers have to convert the files anyway. It's really up to what fits you as a writer best.

"Many of the different kinds of software have a trial feature, so I'd suggest you try a couple out and see what works for you. Personally, I stick with Word. It's easy to use and allows for flexibility, but that's just me.

"The only other thing you really need is the ability to e-mail your scripts in. I'd also recommend having a printer. For some reason, and maybe this is just me, reading something on a printed page is a different experience, and so I'm coming to my own writing with a fresher set of eyes and I get a better edit on it before I turn in my first draft if I go through it on paper and then make changes from there."

Before you ask, no, it doesn't matter what e-mail program you use, since you're merely attaching a file for your editor to receive. Now, some companies are particular about the files they receive, preferring, say, Microsoft Word over anything else. Each company has its own system, and rather than operate in blissful ignorance, you should check each company's website for submission guidelines.

Additionally, if you've actually spoken to an editor before you write your story, he or she may have a requirement for the manuscript.

One of the most important rules, valid from cover to cover, is this: When in doubt, ask a question. Far better you ask and get a snappy comeback than not ask and fail to satisfy your editor and botch your sale.

Speaking of snappy comebacks, few are better with them than Mark Waid, now editor in chief at BOOM! Studios. He's a superb writer in his own right and adds, "In terms of software, I don't think you need anything more sophisticated than Microsoft Word (or its freeware equivalent, OpenOffice, found easily with a web search). As an editor, I'm seeing more and more scripts come to me in screenplay format, meaning that more writers are using Final Draft or something similar, but new writers shouldn't feel pressured to lay out money for software—as long as the formatting of your script is clear and easy to read, that's what counts."

While you may look high and low, there are no programs for comic book writers. Any word processing program is fine. After all, the script or plot you write is usually tailored to your artist or your subject matter, unlike screenplays or plays, which are more formally prepared given the needs of the behind-the-scenes personnel. One interesting aspect of writing a comic strip is seeing how the artist finally interprets your script. We'll get into format and structure in chapter 9, so stick with me here.

There are some useful software programs to help you organize your notes, thoughts, research, and partially completed manuscripts. For Mac users, there's Scrivener, and writers I know swear by it. This is good for helping organize projects and is recommended more for long-form

novelists than comic book writers. But there are so many similar tools out there, you just have to sample a few and pick one that works for you.

OTHER TOOLS

Okay, you have pen, paper, and a computer chockfull of software. What else might you need?

Well, a dictionary and a thesaurus are useful tools, either actual books on your shelf or digital versions. You might want to consider a book of quotations to use for inspiration or to gussy up your story just a bit. A good book on grammar can't hurt, since you want your words to sound right, until an opportunity comes up when you don't, but we'll get to that. Still, you should know the rules before you break them (remember this lesson, as it applies to every task you will do in your life).

Mark Waid also says, "I ask all the writers and editors working under me to keep Strunk and White's *The Elements of Style* on hand and to at least read through the grammar book *Eats, Shoots & Leaves*. I also encourage them to read through Scott McCloud's excellent books *Understanding Comics* and *Making Comics*. Finally, I cannot recommend William Goldman's *Adventures in the Screen*

A classic style guide and fully charged computer—you're ready to start writing!

Trade highly enough as a reference; while it's about screenwriting and not comics writing, it's still a brilliant primer on story structure regardless of the medium."

Writer, editor, publisher, and all-around swell guy Shannon Denton also calls attention to two other titles. "I'm going to recommend two books that probably aren't on most writers' list: *Shot by Shot* and *How to Draw Comics the Marvel Way*. Since the medium is a visual one, it's a good idea to understand the process of laying the story out visually.

"*Shot by Shot* covers the art of filmmaking very well from the point of view of the storyboard artist. *How to Draw Comics the Marvel Way* covers things from the comic penciler's point of view. As both are visual mediums that are overlapping more and more, it's an invaluable approach to understand both. The artist in those mediums is largely responsible for telling your story."

I blush that he should mention my first instructional book, produced with the legendary John Buscema back in the 1970s and, thankfully, still relevant today. Better yet, it's still in print!

Fortunately for you, I've taken everyone's recommendations, looked over my own groaning book shelves, and compiled a list of recommended reading, which you can find in the back of this book. Yes, this is just a gateway volume, one that will lead you to much additional reading. Once you begin writing, you never stop reading.

Shannon continues, "To be honest, any how-to-write book is good if it helps you get motivated and you learn anything from it. I believe the most important thing is to find your own voice as a writer. We all have one, but so often the job entails losing that voice and writing in someone else's. I'm not talking about the characters in the story either. I'm talking about the fact that most of the employed writers are working in the style of their show runner, their editor, the people who pay their bills." You'll see I address the whole business of being a professional at the end, after you've learned these basics.

"The trick is to find your own voice and then find a way to get it out there," he continues. "Some people can do that on other people's creations, and some must forge their own paths. If you can convey your voice to the reader/viewer/editor as well as adapt to another voice when the situation demands it, then you'll have a well-balanced career and hopefully will reap the rewards of both pursuits."

Now, when I started out, we wrote everything fast and didn't stop to do more than the most cursory of research. That's one reason I stopped making up generic cities and started setting stories in New York City—it's where I worked daily, and I knew the skyscrapers like the back of my hand.

I didn't have time to look up real science, so I made things sound plausible, but it's also why my devices had names like the Super Weapon Supreme.

Today, you need to convince your readers that they really are in Berlin during the final days of World War II or on the shores of Australia when the first boats containing English convicts arrived. Fortunately, there's a ton of research available to help inform your story and help your artist capture the look and feel.

This is not something new either. The best example would be the meticulous work of Harvey Kurtzman when he wrote and edited the war comics for Bill Gaines at EC Comics. Even then, without the Internet, he managed to find enough information about the locales and the actual battles to convince readers that these were tragic tales of sacrifice and valor. He made certain the artists had the visual details they needed—down to the kinds of buttons worn by Union soldiers.

Your local library is always a good place to start, and most likely they have access to online databases and research sources that can help you become an instant expert, or at least a convincing one.

The Internet is a treasure trove, but you need to make certain what you're reading is accurate and reliable. For example, let's say you want to write about a rocket launch in Florida. Obviously, you'd start by going to NASA's website and reading up on the process, the personnel, and the specifications of the actual launch vehicle. But those are the facts, and you want to bring those facts to life. Search the web and you might find profiles of the mission leader or the man who designed the mission patch.

You absolutely need to consider your source. Are these reports from trusted sources such as newspapers or a personal account found on someone's blog? Those should be fine, but if it turns out the article you're reading is a post from a high school in Ohio, nowhere near the launch, you might want to do a little more digging to find other sources to verify the information in the initial article.

"The Internet has most of what you'd ever need these days," Dark Horse editor Chris Warner says about research. "And these days, there's no excuse not to do research, not only of subject but of visual reference. I expect a writer to go online and find visual reference for the artist."

I should point out that when I started writing and well into the 1970s, after dinosaurs were extinct but before the digital age, artists were largely expected to provide their own reference. Many kept clippings from

newspapers and magazines neatly organized in filing cabinets along with photography books and other visual tomes. These "swipe" or "scrap" files were the lifeblood for many fine artists, but the need to maintain these is long gone now that a few clicks of the mouse can take you to visuals about most anything.

Rascally Roy Thomas, comic book writer and editor, is old school like me and notes, "I've always maintained a large personal library, emphasizing history (especially ancient and World War II) and comics, and I often found that poring over them gave me an idea for a story, particularly concerning Conan and the WWII superheroes I've written."

Andy Schmidt, an editor at IDW, says, "As for reference, Internet access is the biggest tool these days. Search engines are extremely helpful. For writing comics, I rarely need to go beyond my own computer. But occasionally, I'll need to reference a page in another comic, and so a cheap scanner is useful for that."

Let me have Brian Michael Bendis sum things up, since he really hits the nail on the head: "Tools are in their mind," he reminds us. "Some say they need a computer to write. Recently, Matt Fraction came over when our kids had a snow day. He had an idea and just grabbed a pad and started writing. Writers should write with whatever they have at hand. They have a sheer force to create. You don't need anything else to get rolling.

"I like to create an environment for myself where I can get rolling and not stop. I'm much more interested in the organic flow of the story and the characters. I kind of build up to a frenzy. Just before bed last night, a thought occurred to me, and two hours later I had to force myself to go to sleep.

"Optimally, you should de-clutter your life to write."

There you go. I like that bit about de-cluttering your life and agree. When I did most of my writing, it was far from distraction and as close to the sun as circumstances allowed.

It can be time-consuming and slow going getting that idea from your brain to the page, but trust me—you want it to be compelling, but you also want it to be accurate. Otherwise, readers may stop and scratch their heads because something doesn't feel right. Taking the reader out of the experience, for whatever reason, is a sign there's a problem with your tale.

In December 2009, the great novelist Margaret Atwood listed ten items beginning writers should have, and they apply to would-be comic scripters:

1. A small notebook, so your budding novelist can carry it everywhere and jot down notes and possibly addresses. Moleskine is the classic, but there are many others. Should fit in pocket or bag.
2. A large box. This is for all the drafts. Keep them! You may need them later.
3. *Mortification: Writers and Their Public Shame*, compiled by Robin Robertson. Everything awful that may happen to you in public has already happened to someone else, almost. Add to the list (although I hope you don't).
4. *Roget's Thesaurus*. I know there are some thesauri online, but nothing beats the paper version. It is somehow more trollable. And when things go bad, you can warm it in the oven (not to much; it's flammable) and cuddle up to it in bed.
5. *The Stretching Handbook*. Or something like it. Or Pilates lessons. Anything to straighten out that writer spine and bad elbow we get after a while. . . .
6. *A Novel in a Year*, by Louise Doughty. It is what it says, week by week. Not intimidating.
7. *How Not to Write a Novel*, by Mittelmark and Newman. It also is what it says, and funny, too. But if you read it you may never write anything. Beware.
8. *The Art Instinct*, by Denis Dutton. Why do human beings make art, including narrative art? An evolved adaptation, says the author. News just in: Art not a frill! Built in!
9. *The Gift*, by Lewis Hyde. How is art situated in the world of commerce? Or, why do so few artists make lots of money? How do gifts operate, as opposed to buying and selling?

Negotiating with the Dead: A Writer on Writing. I wrote this one. It's not about how to write. It's more like, What is this writing and how does it differ from other art forms, and who are writers, and what do they think they're doing? The underground journey. . . .

IMPORTANT TERMS

Now that we're getting into the nitty-gritty about how we actually write comic books, it will be useful to have a handy glossary of terms that we bandy about with abandon. See, most people working in comic books today grew up reading them, writing about them, attending conventions and the like, so they speak the language without realizing that to some, it requires a scorecard. Consider the following your primer, although there are many, many more terms you will encounter as your experience grows.

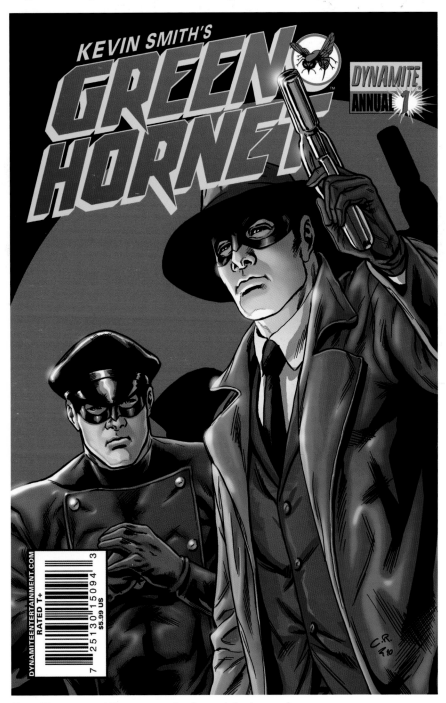

Green Hornet annual #1—*an example of a comic book annual.*

ANNUAL

A one-shot edition of an existing title usually with expanded pages and features. Annuals first started appearing around 1960 and have been a staple of comics publishing ever since. When they first appeared, they were reprints of older material, but Marvel decided to beat the competition by offering readers longer original stories in our first annuals. These days, annuals tend toward original content.

ARC

A storyline that spans across more than one issue of a title and possibly includes more than one title. This is different than a character's arc, which is another way to describe the character's journey from the beginning of the story to the end.

B&W

An abbreviation for a story printed in black and white. The choice to use black and white used to be an economic one. Today, it tends to be a creative decision, since the artwork without color conveys a different mood.

BACKUP FEATURE

A secondary feature to a title, usually featuring lesser-known characters and often using lesser-known talent in a shorter number of pages than the lead feature. Usually, comic books feature a character or team as the lead and round out the book with secondary features. Few publishers use the backup story with regularity these days.

The Red Sonja "Vacant Shell" one-shot is an example of a black and white comic.

Zorro #9 features an example of a word balloon.

BALLOON

A visual device to contain the dialogue or thoughts of the characters in panels. A word balloon tends to be an oval shape with a tail pointing to the speaker. A thought balloon looks like a cloud and has a tail of smaller balloons leading to the thinker. Voices coming from radios, telephones, etc. tend to be placed in a jagged balloon shape, making it appear, well, electric.

Sometimes balloons are referred to as bubbles, especially in Europe.

BIMONTHLY

A title that is published every two months.

BIWEEKLY

A title that is published every two weeks. Semimonthly means twice a month, which is not the same thing.

BREAKING THE FOURTH WALL

A storytelling technique that allows a character to act like he knows the audience is reading. Sometimes the character interacts with the audience or just makes asides. This is a theatrical technique adapted to comic books.

BRONZE AGE

An era of comic books published from approximately 1970 through 1985, usually noted by the arrival of Marvel's *Conan the Barbarian* #1 and ending with DC's *Crisis on Infinite Earths*.

CAMEO

A brief appearance of a familiar character, usually making a guest appearance in another character's series.

CAPTION

A box containing narration and/or dialogue. Normally, captions are written either in the first or third person and help move the story along by establishing a change in time or place, setting the mood, or counter pointing the action in the same panel.

This panel in Zorro #1 features an example of captions.

The Death-Defying Devil #3 *features a gorgeous two-page spread!*

CCA
An abbreviation for the Comics Code Authority, which is administrated by the Comic Book Association of America.

CENTERFOLD OR CENTER SPREAD
The two pages in the center of a comic book allowing for uninterrupted artwork.

CLIFFHANGER
A phrase from the silent movie serials that ended each chapter with the lead character in a precarious or surprising situation, leaving the audience desperate to see what happens next. As comic book stories became more serialized in nature, cliffhangers became a natural storytelling element.

COLLECTED EDITION
A book comprising reprinted stories. Paperback houses began reformatting comic book stories in this way in the 1960s. Today, story arcs from monthly comics are gathered into collected editions to be read as a whole. In Europe, these books are called albums.

WAGNER + FRANCAVILLA '10

THE
END

While the Zorro storyline concluded with issue #20, a cliffhanger offers fans intrigue for future story possibilities.

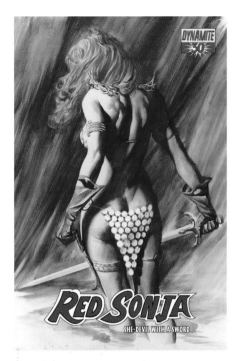

This Red Sonja #1 *cover by Alex Ross has an amazing variety of colors!*

COLORIST
An artist who provides the color to a comic book, usually using computer graphics programs.

COMIC BOOK DEALER
Someone who sells comics, usually referring to someone selling old comics at flea markets or comic book conventions.

COMICS CODE AUTHORITY / COMICS MAGAZINE ASSOCIATION
Once a powerful trade organization, the Comics Magazine Association of America administers the Comics Code, assuring retailers and parents that comic books carrying the seal are appropriate for readers of all ages. Created in response to public concerns over content, it also stalled creative development in comics for years after its introduction in 1955. Today, just a few publishers still submit material for Code approval.

CON
A convention or public gathering of fans. Cons began with science fiction gatherings in 1939 and have now splintered into shows dedicated to comic books, science fiction, fantasy, horror, media, and specific properties, such as *Star Trek*.

CONTINUITY
The cumulative details about characters and settings in a shared universe, which can guide future story development. (See chapter 12.)

CROSSOVER
When a character(s) from one title appears in the title of another character. This first began with the legendary Human Torch versus Sub-Mariner stories from the 1940s. Today, stories also crossover from one title to another.

DEBUT
The first time that a character appears anywhere.

DIALOGUE
The narrative captions, sound effects, and, of course, all the words spoken on a comic book page. If an artist has drawn the story only from the plot, then the writer looks over the penciled pages and adds the dialogue.

DIRECT MARKET DISTRIBUTION
A sales channel where retailers can buy comic books and graphic novels at deep discounts in exchange for being unable to return unsold merchandise for credit, which is the norm for most sales channels.

EDITOR
The person responsible for the creative direction of a title or titles. The editor selects the creative team to best bring this direction to life. The editor also represents and promotes the title to other departments and to the media.

FANBOY
A mostly derogatory description of a diehard fan of comics, science fiction, or other popular culture, denoting the person as being socially inept with few if any interests other than whatever it is he (or she) is a fan of. The sitcom *The Big Bang Theory* has glorified fanboys.

FANZINE
An amateur fan publication usually devoted to a specific topic. Many producers of the earliest fanzines went on to become pioneers in science fiction and comic books, such as Superman co-creator Jerry Siegel. With the advent of the Internet, fanzines have mostly vanished.

FLASHBACK
A storytelling device to show a previous story being recalled. Showing events in the future would be considered a flash-forward.

FOUR-COLOR PROCESS
The process of printing comic books and graphic novels using the three primary colors (magenta, yellow, and cyan) plus black.

FUNNY ANIMAL
A genre of fiction that adapted the animated exploits of Mickey Mouse and Bugs Bunny to comic books. Every major publisher at one time or another has created funny animal comics, from Fawcett's *Marvel Bunny* to Continuity Associate's *Bucky O'Hare*.

GOLDEN AGE
The comic book era from 1938 through, roughly, the end of World War II in 1945. Superman's debut in *Action Comics #1* is generally considered the first Golden Age comic book. The end of the era remains debated by historians but was certainly gone by 1952.

GRAPHIC NOVEL

A long-form story, usually beginning at sixty-four pages and going upward. An original story, the graphic novel tends to be produced by the same creative team from beginning to end. The graphic novel began to develop during the 1940s, but many consider Will Eisner's *A Contract with God*, published in 1978, to be the first modern-day graphic novel.

GUTTER

The space between panels and pages. Most comic book artists leave a standard space between panels to help ease the readers' eyes from place to place.

INDICIA

For legal purposes, all periodical publications from newspapers to magazines to comic books have to include a block of type indicating a set of specific information that includes the name and address of the publisher and the frequency of the publication. Until recently, the indicia tended to be on page 1 of most comic books, but changes in regulations allowed publishers to float the indicia placement to wherever they chose.

INKER

An artist who adds texture and detail to the penciled artwork to complete the artwork and ready it for reproduction. The inker can be the same person as the penciler or a second person. The inker can use pens or brushes or produce the finished work digitally. And no, the inker is not a "tracer."

LETTERER

The artist who adds the words, balloon shapes, sound effects, titles, credits, and panel borders to a page. Traditionally, lettering occurred between penciling and inking. Today, the majority of lettering is done using a computer to mimic the handcrafted look and is a digital layer added when the artwork is completed. (See chapter 15.)

Vampirella #12 displays the added depth that inkers bring to art.

Green Hornet: Year One displays novel ways of using lettering in comics.

LOGO

A stylized rendition of a title or character's name to clearly identify the publication for the reader. The logo can be registered as a trademark so it becomes linked with your company in perpetuity. A well-designed logo can be as durable as the character itself, as seen with Superman and the Amazing Spider-Man.

MANGA

The Japanese word for comic book. In Japan, manga is produced on every subject imaginable and read by people of all ages. The more popular works have been translated and brought to America.

MINISERIES

A series that has a limited duration, anywhere from three to six issues, telling a complete story, usually with the same set of creators. Limited-duration books longer than six issues tend to be called maxiseries. These are ideal testing grounds for new concepts or for spotlighting popular characters.

MODERN AGE

This is a catch-all term that applies to comics published from the mid-1980s to the present. Someday, historians may look back and reclassify the era.

ONE-SHOT

A single issue of a title that can either be a long-form story, such as an annual, or an anthology of stories. Rarely are one-shots published in the standard thirty-two-page format.

The logo for Alice in Wonderland.

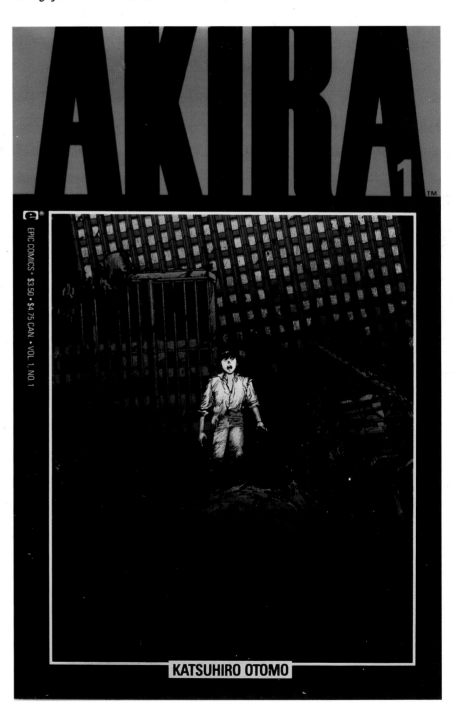

Akira *is one of the most popular manga comics in America.*

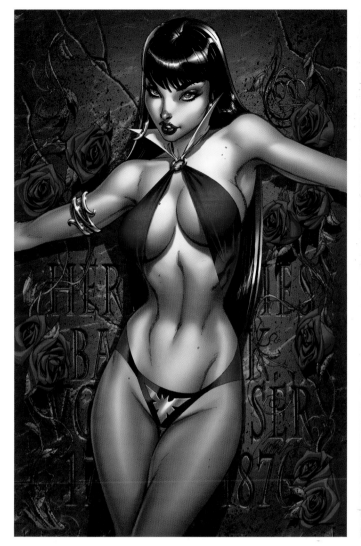

Cover art for Dynamite Entertainment's Vampirella #1.

Origin #2.

ONGOING SERIES

A series intended to continue indefinitely and usually released on a monthly basis with a regularly assigned team of creators. Since the birth of comic books, most titles are introduced in the hopes they will be popular enough to have a long run as an ongoing series.

ORIGIN

The story providing the who, what, where, when, why, and how of a character's life. Most new characters are introduced via an origin tale, although there have been notable exceptions, such as Batman and Wolverine.

The amazing pencils of Edgar Salazar from Project Superpowers #11.

PANEL

An individual illustration, usually one of several constituting a page in the publication. Panels, or frames, usually contain words and pictures. A sequence of panels helps tell the story.

PENCILER

An artist who creates the visuals, using an outline, plot, or full script, to tell the story across panels and pages. Some pencilers will rough out their pages using a non-reproducible blue pencil, then go over those lines with lead pencil, and some artists create their work digitally.

PLATINUM AGE

Comics published from approximately 1900 to 1938 in a variety of sizes, shapes, and page counts, in both black and white and color.

PLOT

A story for an artist to work from, but without all the panel-by-panel information and before dialogue is written. Plot-first is also known as the Marvel style. A plot can run from a few sentences to several pages. (See chapter 5.)

PUBLISHER

A person responsible for running a company, working with sales, marketing, manufacturing, and, of course, the editorial departments to produce a title or titles. Also the term used for the individual company, such as Marvel or DC. I was a publisher once and found it not to my liking, since it removed me from the truly creative aspects of the company.

QUARTERLY

A title published every three months (four times a year).

REBOOT

When a character or series is refreshed by starting over, bringing the reader back to the beginnings of the premise, usually intended to modernize the character. The most famous reboot may have been 1986's re-imagining of Superman as envisioned by John Byrne and Marv Wolfman.

RETCON

A shorthand term for "retroactive continuity" that may reposition previously published facts about characters and their world. Some retcons fill in the blanks between stories or attempt to smooth over contradictions between appearances of a character. (See chapter 11.)

REVIVAL

Taking a moribund character or title and bringing it back for modern readers. DC Comics' revival of the Flash, for example, kicked off the Silver Age, while I brought back the Sub-Mariner as an antagonist for the Fantastic Four.

SCRIPT

A script is a panel-by-panel, page-by-page story describing all the details for the artist and comes complete with captions, dialogue, and sound effects. A script tends to run at least one page of script for one page of printed comic book—although some provide such detail that they can rival a novel.

SEDUCTION OF THE INNOCENT

A poorly researched 1953 book by Dr. Fredric Wertham. Its release added fuel to the fire as parents complained about comic book stories turning their children into juvenile delinquents. Some of the accusations were absurd and have not held up to reexamination.

SEMIMONTHLY

Published twice a month, but not necessarily biweekly. Semimonthly would mean twenty-four issues in a year, whereas biweekly would result in twenty-six issues in a year.

SEQUENTIAL ART

Coined by the pioneering artist Will Eisner, the term describes a series of illustrations intended to be read in consecutive order, creating a coherent narrative. Basically, it's a synonym for comic book storytelling.

SHARED UNIVERSE

The idea behind a series of characters and/or titles being set in the same reality. In comics, this can be traced back to All-American Comics banding together their heroes in *All Star Comics* to swap stories and share adventures as the Justice Society of America followed by the Sub-Mariner meeting the Human Torch over at Timely. Most publishers now tend to lump their series in the same universe to appeal to readers.

SILVER AGE

Showcase #4, presenting a new interpretation of the Flash in 1956, kicked off a new age for superheroes, helped reinvigorate DC Comics, and gave birth to the Marvel Universe. Most historians feel this era ended in 1969, although that remains subject to debate.

SPLASH PAGE

A panel taking up the entire page, therefore making a "splash." Introduced during the Golden Age, splash pages became a comic book staple forever after.

SPLASH PANEL

An oversized interior panel as part of a sequence of panels on a page but designed for maximum impact. Traditionally, series with multiple stories tended to open with a splash panel as opposed to a splash page.

SUPERHERO

A costumed figure who usually has powers and abilities far beyond those of mortal man. A superhero is not required to have powers but certainly has to have mental and physical skills setting him or her apart from the average person. A larger-than-life figure, the superhero can trace its roots back to Philip Wylie's 1930 novel *Gladiator* and Lester Dent's *Doc Savage* pulp novels. The first comic strip superhero is arguably Popeye, while the first costumed hero was the Phantom. Superman is the first true comic book superhero.

SUPERVILLAIN

The opposite of a hero, one who chooses to use his or her powers or abilities for personal gain, shunning any sense of moral obligation to help humanity. Without villains, the heroes would be awfully bored. The first supervillain to appear more than once in comics was the Ultra-Humanite, who appropriately battled the first superhero, Superman, beginning in *Action Comics* #13 (1939).

TPB

Short for trade paperback, the softcover edition of a graphic novel or collected edition.

The magic of comic books is a combination of powerful prose and dramatic pictures.

COMIC BOOKS VERSUS STRIPS

A few pages earlier, I mentioned that comic strips helped give birth to comic books. And while that's true, they are very different and require different skills and approaches. While I will focus almost exclusively on the books, I will touch on the strips since I have more than a little familiarity with them. But let's review all the basics in how comics differ from other communications media.

The biggest difference between strips and books, for example, is the sheer size of a strip compared to a comic book. Growing up, my comic strips were printed large and had four detailed panels, letting the creators fill each panel with information and keep the story moving. The continuing stories, though, had to be structured, so you were left wanting more, especially between Friday's installment and the one coming on Monday. Since not everyone read the Saturday paper, it was considered a throwaway strip back then, and the color Sunday strips tended to tell entirely different stories.

Comic books can run from one page to dozens, with graphic novels topping five hundred pages or collected editions reaching the remarkable fifteen-hundred-page mark. In most cases, each page has more panels and story content than any single daily comic strip could hope to provide, especially today, when most comic strips are one, two, or, at best, three panels long. The reduction in size has certainly helped squeeze out the adventure and "serious" strips—there's just a handful left compared with my childhood, when we had dozens to pick from. Thankfully, *Amazing Spider-Man* remains one of those strips.

Comic books allow more room for captions, dialogue, action, and detailed examinations of the characters and the plots.

When the written word was developed, it was used initially to take the oral stories that were told from generation to generation, capturing the histories and legends of the cultures evolving on six of the continents. Regardless of the language being spoken or written, they were all telling stories. You do need an imagination, and the ability to write snappy dialogue and to describe continuity!

"Comic books are a medium of communication—just as television and motion pictures, and all must be judged on their individual merits," I wrote in one of my "Stan's Soapbox" columns back in 1968. "A story is a story, whether presented between two covers or on a screen. If the words have dramatic impact, if the pictures are visually appealing, if the theme is emotionally relevant, then certainly it is worthy of a reader's attention."

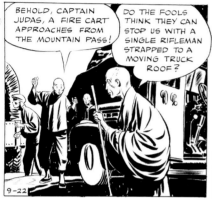

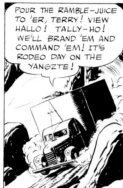
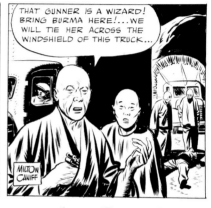

Milton Caniff's Terry and the Pirates *daily comic strip (News Syndicate, September 22, 1941) is an adventure worth reading, even today, given its cast of characters and strong pacing.*

The color is crisp on these Flash Gordon Sunday comic strips, featuring features gorgeous Mac Raboy art.

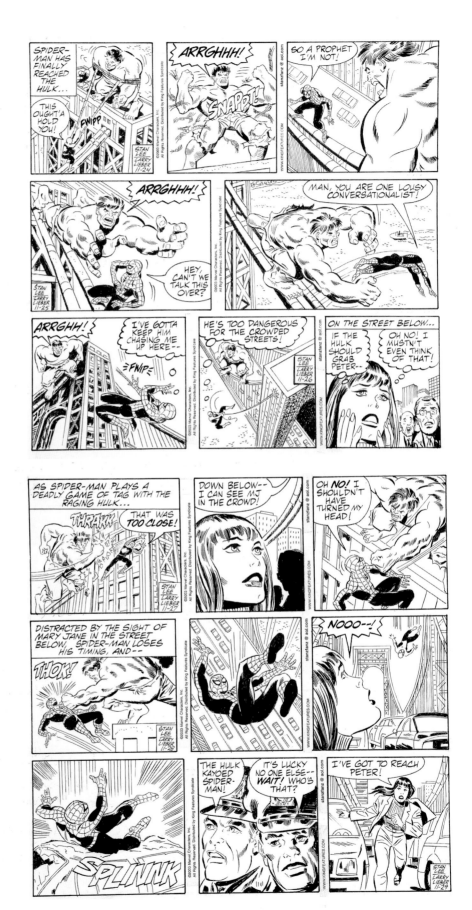

When I began the Amazing Spider-Man comic strip in 1977, I never imagined I'd still be writing it all these years later. Guess I can't resist tormenting Peter Parker on a daily basis.

PROSE

Prose is a powerful thing. Words on a printed page allow the mind to conjure up images, filling in the gaps or mentally bringing the characters and settings to life. Sit around a campfire on a warm summer's night and let the wildlife provide the soundtrack to the speaker as he spins a yarn about the murderer last seen in these very woods. A branch in the fire snaps and the loud crack startles you, certain that the murderer is right behind you.

Reading the exploits of gods that pull chariots containing the sun around the world, explaining how the sun rises and falls, allows you to imagine the size of the steeds and the strength required to move that burning ball of heat and light. String the right words together and you impart lessons; craft them in a different way and you can move the spirit.

There's a rhythm to the written word, not unlike music. When I first discovered Shakespeare, I couldn't make much sense of the archaic words, but I heard the flow of the words and moods being conveyed. In time, and with repeated readings, I managed to figure out the stories. But the Bard's use of language was unique and so moving that I was prompted to work my way through his plays. That's the power of the written word.

This Shakespeare manuscript is an example of prose.

PICTURES

Of course, comics can also be traced back to those cave paintings I mentioned earlier. Those early cave paintings were static images, crowded with hunters and their prey, but there's a lot being left to the imagination. The caveman next door might come by and gaze at the painting and try to imagine which hunter lived in the cave and which mastodon he selected and hunted. Was he successful or was he hurt? Were there leftovers to share?

These cave paintings obviously evolved into the great works of art we see in museums around the world. But look at them, and once you get past the portraits take a look at the story each static image is telling. *The Last Supper* is a great example, as everyone is in motion, interacting with one another. There's business going on in front, behind, and even underneath. What are they saying to one another, what are they eating—the image inspires storytelling. But it's a single image, and you don't know what came before or after, unlike a comic, which can do that with multiple panels.

Scott McCloud, in his must-read book *Understanding Comics*, explores the evolution in detail, noting works such as the Bayeux Tapestry, a French retelling of the Norman Conquest, certainly qualify as graphic storytelling. And before that beautiful work, the Egyptians were using hieroglyphics to tell stories for several millennia.

Artists used improving printing technology to find new ways to tell stories, such as Lynd Ward's "silent" books, telling complete stories using woodcut illustrations. Painters such as William Hogarth and Max Ernst also used a sequence of paintings to tell a story—each painting could therefore be considered a single panel in a longer tale.

At much the same time magazine illustrations evolved into comic strips, photography (similar in its singular nature to a painting) was giving birth to motion pictures. Suddenly these still figures moved and audiences gasped, certain the train hurtling toward the camera was going to leap off the screen and crush them. There was no sound, so the silent films required plots and acting to convey the story. The obvious classics— *The Phantom of the Opera*, Harold Lloyd's shorts, *Metropolis*—worked wonderfully well and still evoke strong responses.

Scott McCloud wrote, "Each successive frame of a movie is projected on exactly the same space—the screen—while each frame of comics must occupy a different space. Space does for comics what time does for film."

An example of Lynd Ward's "silent" stories.

PROSE AND PICTURES—TOGETHER!

Now, imagine, if you will, taking the power of prose and coupling it with a series of drawings to tell a story. That's a comic strip, comic book, or graphic novel. There's nothing else like it.

I was on a panel at Vanderbilt University back in 1972, beside my long-time partner Jack Kirby. He distilled that unique blend of words and pictures down very nicely when he said, "I know that the writing helps the art, and the art is supposed to help the writing. Combined, they're supposed to have an impact on the reader. Some cartoons don't have writing at all, and I suppose you can call that graphic manual art. That's what makes them work. Sometimes the writing will make an adventure strip work. Sometimes, if you get the right man to write the strip, you can get a strip with a lot of impact. So the writer is necessary to the strip because that's been the format all along. Someone has to write the balloons. If you're an extremely talented artist you can write the script yourself; that's been done, too. Writing and drawing are both arts, and the combination of both fields can make a very fine product. They're separate arts, but not inseparable. They help each other in the best possible way."

Neil Gaiman has noted, "The lovely thing about comics, because it's words and pictures together, is that people come to them from different traditions: from the written word, from films, and from comics."

Today, we have people who grew up trained on comic books and have been finding new ways to adapt the storytelling process to the digital world. Many comics are simply scanned and uploaded for your reading pleasure, but others alter the way you go from panel to panel, which subtly changes the reading experience. Then there are the motion comics that take the frozen comic book pages and add animation, making the characters leap off the panel and actually move through the story. This growing field really gained attention with the motion adaptation of *Watchmen*.

Speaking of that phenomenon, its writer, Alan Moore, had this to say on the subject of comics: "What it comes down to in comics is that you have complete control of both the verbal track and the image track, which you don't have in any other medium, including film. So a lot of effects are possible that simply cannot be achieved anywhere else. You control the words and the pictures, and, more importantly, you control the interplay between those two elements in a way that not even film can achieve. There's a sort of 'under-language' at work there that is neither the 'visuals' nor the 'verbals' but a unique effect caused by a combination of the two.

"A picture can be set against text ironically, or it can be used to support the text, or it can be completely disjointed from the text—which forces the reader into looking at the scene in a new way. You can do this to some extent in film, in terms of striking interesting juxtapositions between the imagery and what the intent of the characters may be, but you cannot do it anywhere near as precisely as you can in comics. Here the reader has the ability to stop and linger over one particular 'frame' and work out all of the meaning in that frame or panel, as opposed to having it flash by you at twenty-four frames per second in a cinema."

When I created *Striperella* and *The Seven* for the web, I had to take everything I knew about storytelling and relearn how to tell a story in a finite number of minutes that allowed for the limitations of early Flash animation. These days, animated webisodes are increasingly commonplace and a natural outgrowth of the comic books we still know and love.

And guess what? It still comes down to telling a compelling story with interesting characters. Let us begin, then, by examining the kinds of stories we can tell.

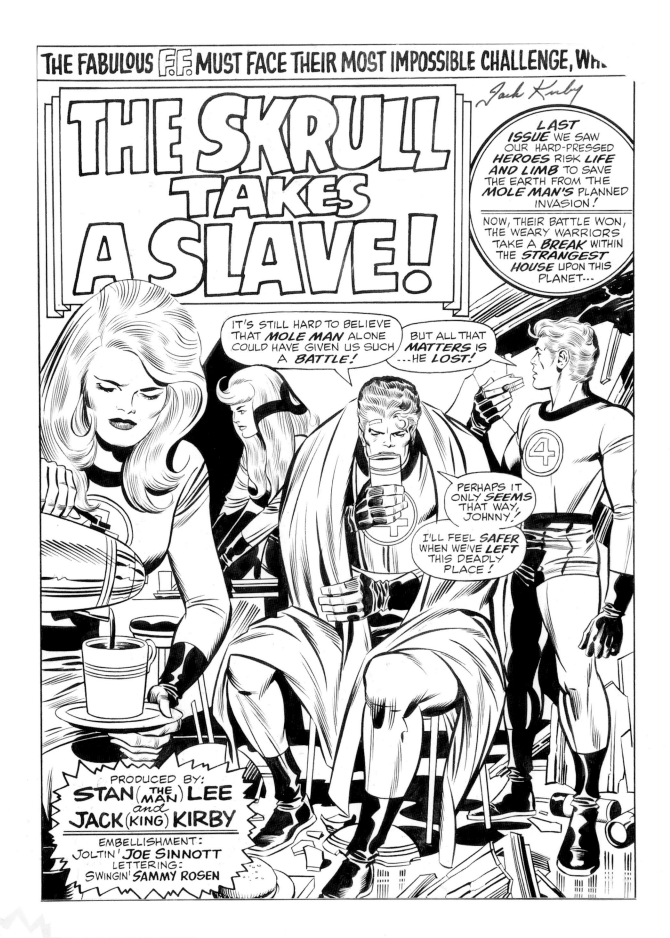

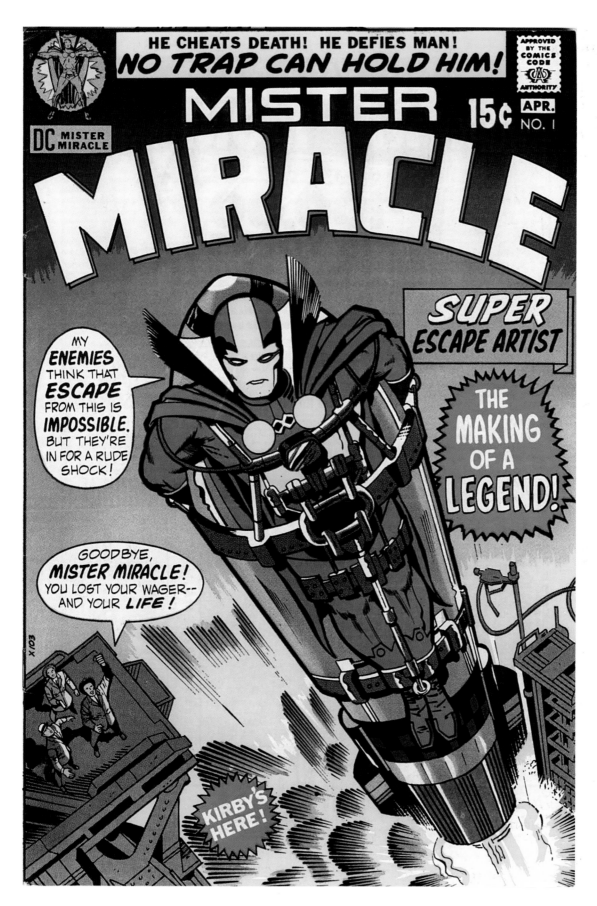

Example of Jack Kirby's artwork and page composition: Fantastic Four #90 *splash page 1 (Marvel, 1969) (opposite page), and* Mister Miracle #1 *(left).*

STAN LEE'S TOP TEN TIPS FOR WRITERS

When I turned 85, several publications celebrated the event and made me blush for the entire year. Danny Fingeroth desperately wanted something from me for his fine and not-forgotten magazine *Write Now!*, so I prepared this collection of tips, and they still hold up.

1. Write about things you know. If you don't know, Google the stuff and start learning. Or else be so vague that no one can pin you down—like when I dreamed up Bruce Banner becoming the Hulk due to a gamma bomb. I don't know any more about gamma bombs than I do about brain surgery, but I didn't try to explain how it worked. I just said that he became the Hulk because of gamma radiation. Hey, who can find fault with that? At least it sounds scientific. So, to summarize—be totally factual, or else be so vague that you can get away with knowing nothing about your subject. But whatever you do, don't try to fake it.

2. When you're reading a comic book or watching a movie or TV show, don't just get caught up in the story and sit there like a couch potato. Try to analyze everything that's on the page or screen. Why did the writer add that bit of dialogue? Was it more dramatic for the hero to say nothing in that particular scene? Why didn't the writer introduce that important story element until fifteen minutes into the film, or until five pages into the story? Why did (or didn't) the writer have such an enigmatic ending? Why, in that movie, was act three so much shorter than act two? Why, in the comic book, did the writer use so many captions on pages 3 and 4 and no captions at all on the next six pages? Why so many long shots or close-ups? Would it have been more interesting the other way around? You should be able to learn something new about writing every time you read a comic or watch a film—if you remember to analyze everything you see.

3. Keep writing. I figure writing is like any other activity—like swimming or jogging or sex. The more you do, the more you enjoy it, the easier it becomes, and the more you improve. If you find yourself getting bored writing, or tired of it, there's only one answer: Find another career.

4. Write about things that interest you. If you write about subjects that bore you, thinking they're what the market wants, you'll just end up writing boring pages. The more interested you are in your subject, the better chance you have of making your subject more interesting, too.

5. Try to write at the same time every day. Writing can be a habit, like anything else. If you stick to a schedule, it makes it easier to turn pages out like a pro.

6. Stop writing if you find yourself getting tired or bored. Take a nap or a short walk to wake yourself up. You can only do your best writing when you're mentally alert and interested in what you're doing.

7. When you've finished with your script, proofread it carefully. Don't read it as if it's your baby and you love every word of it. Pretend you're the world's toughest editor, looking for every fault you can find in story structure, dialogue, characterization, and motivation. Be as tough on yourself as humanly possible, because that's how your editor will be. And keep rewriting until your script is as good as you can possibly make it.

8. In writing dialogue, try to give every character a different way of speaking. In any script, it's boring to have the characters all speaking the same way. Think of people you know—how they speak, their verbal idiosyncrasies and mannerisms. Remember, nobody speaks exactly the same as anyone else. When listening to people conversing, train yourself to pick up all the subtle nuances of dialogue and use those varied nuances in your writing.

9. Make your characters interesting. Sounds obvious, doesn't it? Well, failing to do that is one of the main reasons so many scripts are rejected. Reading a script is like visiting people—the people in the story. You wouldn't want to visit dull, colorless people, would you? You wouldn't want to spend time with bores. The characters you write about must be interesting, colorful, and unique in some special way. They must have problems we'll care about—and solutions to those problems that we can't wait to see.

10. *Don't Get Discouraged!* Lots of really good, successful writers didn't make their first sale until long after they started writing. Of course, if you've been unable to sell anything for years and years and are now starving and homeless, you might start thinking of another vocation. But short of that, stay with it—tomorrow may be your lucky day!

Okay, that's it. If, after reading the wondrous words above, you suddenly become a fantastically successful and wealthy writer, don't forget my commission! Excelsior!

Danny Fingeroth not only edited the line of Spider-Man titles in the 1980s, but he also wrote several of those adventures and several stories of the popular comic series The Avengers.

"Peter, where are you?" Her voice took on that high-pitched tone she so disliked.

"Um, I'm over here." Then he emerged from behind a bookshelf, his face slightly red.

"Were you just on the ceiling?"

"God, MJ, what the hell would I be doing on the ceiling?"

"I don't know." She put down her book bag. "Stranger things have been happening, if you know what I mean."

For a moment he did not say anything. Then he took a deep breath. "Yeah. I know. Hey, how's your cheek?"

"It hurts, but the nurse said it's just bruised. What happened with you guys after the brawl?"

"I wouldn't call it a brawl."

"What would you call it then? Wendy said she saw Flash later with a cast on his hand. If it's not a brawl, it's just a conversation in which someone happened to break a hand?"

"Okay, whatever. Flash and I are both suspended for three days."

"You're kidding!"

"Nope."

"Wow. Peter Parker, suspended. Very impressive. Hey, what about Friday's basketball game against Brooklyn Tech? Can you still play?"

109

Here's an example of prose from Marvel's very first Mary Jane novel, with illustrations that enhance but do not replace the words. Mark Waid's The Life Story of the Flash *(opposite) is designed to look like an illustrated biography, so the Gil Kane illustrations are captioned.*

Neither was the mad magician Abra Kadabra ever accepted as one of the Rogues. They rightfully shied away from a man who could, on a spasmodic whim, transform them into plants or polliwogs. A terrorist and agent of chaos in his home era of the 64th century, Kadabra—reports vary—either left for or was exiled to our time, where he made a name for himself by using malevolent technology so beyond our understanding that it appeared to be magic.

Kadabra gave Barry a tougher time than most. The twinkle in his eye wasn't cleverness. It was insanity. Desperate for attention, for applause, for validation, Kadabra always turned his attacks into elaborate productions, full of sound and light and chilling unpredictability. That said, he still set his sights abominably low. He could have killed Barry. Instead, he turned him into a puppet, or a hunk of sidewalk, or tinkered with his speed. Like all the others, he was, in the end, a little light in the homicidal tendencies department. More meddlesome than threatening, they were all relatively benign, all petty.

Except one.

Barry's ultimate enemy... the only one who absolutely turned his rage into swift vengeance... was born nearly five centuries after Barry's death.

Nursing a family grudge against the Allen clan, he stole from a time capsule one of Barry's original costumes. Treating it with future science...

Iron Fist was used during the kung fu craze of the early 1970's!

COMICS: THE MEDIUM

"People lump all comics together as if it's a genre, but it's not," Marv Wolfman said. "Comics is a medium. We can tell every kind of story using the comics medium, and superhero stories are only one possibility. We can tell mysteries, horror, human interest stories, comedy, romance, funny animals, and more. We can use comics to explain real-life history and science. Anything that can be done in a novel, we can do in comics, plus we have art on top of that, which we can use to excite and inform. Comics are perhaps one of the greatest mediums anywhere."

What he said.

In our fascinating first chapter, I mentioned that comic books started off being compilations of newspaper comic strips. Get a magnifying glass and go look at your local comics section. Most of the strips there, except *Amazing Spider-Man*, of course, tend to be humorous, but notice that some feature animals and others families, and some are set in the past or the future.

Bill Hughes's cover painting for Vampirella #2 goes to show that horror can be a very exciting and dramatic genre for graphic storytelling.

The superhero genre has never been better represented than by the cover of Avengers #24, as our heroes seem outnumbered.

Science fiction came to the comic strips in 1929 with Dick Calkins's Buck Rogers and has endured through the years in all forms of mass media.

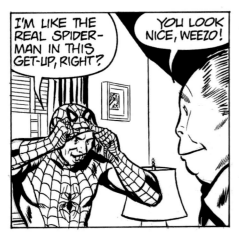

Things don't get more dramatic than seeing someone masquerade as our friendly neighborhood wallcrawler, as seen in this Amazing Spider-Man comic strip that ran on February 20, 1997.

Our unique blend of words and pictures is not at all limited by the subject matter, and in the early days comic books offered readers science fiction, superheroes, romance, funny animals, teenage humor, crime, war, western, mystery, horror, and stuff I'm probably forgetting. They all allow us to tell compelling stories, but each genre has its own rules. No matter what type of writing you specialize in—adventure, detective style, romance stories, or humorous material, there are many comic magazines that use the type of story you'd like to write.

Publishers exist to entertain people and earn a profit while doing so. As you well know, tastes change and the smarter publishers seize on those changes and ride the latest craze until something new comes along. Marvel's founder, Martin Goodman, was perhaps the best at spotting those trends, keeping our doors open for decades when so many competitors faded away. As a result, as a writer, I had to become versed in the different genres pretty quickly. It may sound untrue, but trust me, I'm sincere when I tell you that I really didn't have one favorite genre back in the day. I liked them all, from the funny animals to the teen humor. In many ways, I think switching from writing about *Ziggy Pig* to *Millie the Model* to *The Black Knight* probably kept me fresh.

Al Jaffe, now revered as one of the great *MAD* magazine artists, was a humble staff editor back in the 1950s and recalled, "The one thing that impressed me greatly about Stan was his 'can do' attitude. No matter how many new titles were thrown at him at the last minute, he somehow never failed to meet the deadlines. I remember the first time I was called in for a cover conference. I was an associate editor at the time, responsible for about twenty teenage titles. I figured this would take the better part of the day. 'No way!' Stan said. 'Read the titles off one by one.' I started, and instantly he rattled off a cover idea quicker than I could rough-sketch it. This went on for no more than thirty minutes, until all twenty or so covers were done … It was a bravura performance."

He makes me blush, but the point here is that being a professional means being able to come up with ideas regardless of the time or place or genre. I never have believed in writer's block and can't recall a day going by without ideas coming easily to me.

The best prep, for genres or anything, is to study—by that I mean, if you want to write a western story, read as many western stories as possible—of every type and style. Decide which type you like best, in which style you'd be more comfortable writing, and which you think would be more appealing to a reader. Before you can be effective writing in any genre, you must have a good understanding of that genre.

The Lone Ranger #12 *cover by John Cassaday gives you a sense of the dramatic, but inside it has that ring of authenticity you have to bring to each of your stories.*

TRADITIONAL COMIC BOOK GENRES

Let's talk a bit about each of these genres and what can be done with them in comics.

Science fiction, for starters, has actually proven to be a very difficult genre to successfully make work in comics. Every publisher has tried it, but there have been few enduring successes in the field. It could be that a writer's words about the future work best letting the mind supply the visuals. Of course, it could also be that the artists just didn't run wild enough with the scripts and the future didn't look very appealing. When setting a story in the future, on Earth, or anyplace else, you have to make the science seem plausible. If we're all eating salt water taffy for protein in the year 2525, the reader is going to get that sense of the story feeling *off*—a case of poor research coming into play once more.

Think about the best science fiction you've ever read. What was it that worked for you? Can you apply those lessons to your story? What do you know about building an alien culture or understanding what it means to build a colony on a giant, gaseous star? Your science has to make enough sense, as do the alien life forms you conjure up.

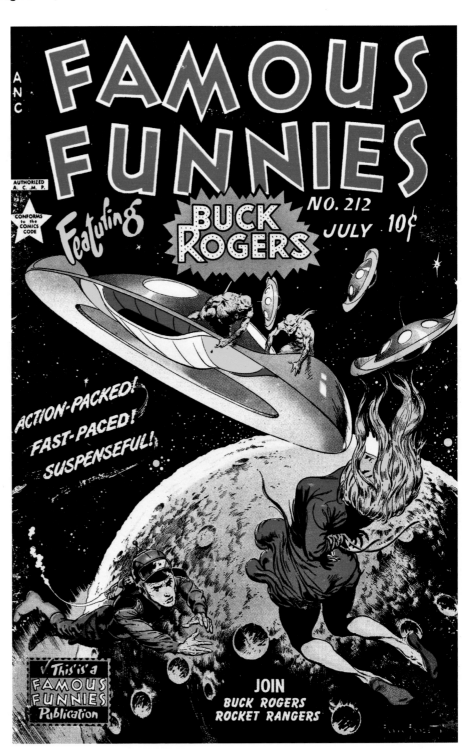

The great Frank Frazetta drew this cover to Famous Funnies #212, featuring the outer space exploits of Buck Rogers.

The same applies to horror, a broad term that can encompass monsters, the occult, and psychological thrillers. Vampires, werewolves, and zombies come from folklore and therefore come with rules. Again, you need to know what those rules are before you toss them out the window so your reader believes your vampire tale. Since the rules regarding the undead vary from culture to culture, you have tremendous flexibility here, but you need to determine what the rules are for your story and stick to them. Horror, by the way, is somewhat different than terror. Horror, to me, is the creepy-crawly things I mentioned above. Terror would be the more modern version of horror with serial murderers, the kind popularized by the *Friday the 13th* and *Saw* movies. I'm sure I've written a handful of terror stories, but I'll take a good old-fashioned monster over Jason Voorhees any day.

The House of Mystery #185 by Neal Adams shows you impending terror, letting the reader imagine the threat, compelling you to buy the comic and see what really happens.

Magic and the occult have the same expectations, and trust me, after traveling the dimensions with Steve Ditko and Doctor Strange, I can tell you that Sturdy Steve's version of magic differs greatly from his peers'. But his world had a look and feel that told you it was a Doctor Strange story. While your science has to work in sci-fi, your ability to evoke mood and feeling is vital for a horror tale. You need to adjust your pacing to heighten suspense and give your artist room to play so the visuals match.

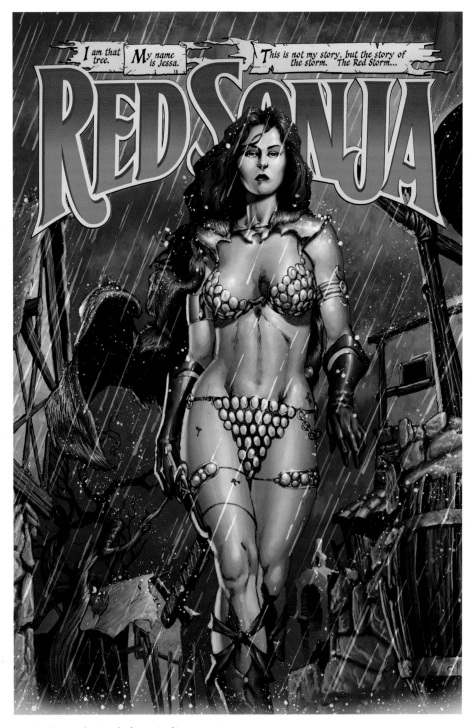

A variation on the occult theme is the tried-and-true sword-and-sorcery genre, as epitomized by the luscious Red Sonja. This genre tends to be set in the dim past or alternate realms with gigantic creatures and big swords.

We all have a war story because the potential for conflict exists in every situation, but actual war stories work best when people are tested. On the fields of combat, your characters have to be challenged and you need to tell your reader something about the battlefield. Unlike the above genres, war stories are very dependent on your research regardless of era or campaign. While I proudly served, I never saw actual combat, unlike my partner in crime, Jack Kirby. Those experiences led to a feel of authenticity when we did *Sgt. Fury and His Howling Commandos* just over a decade and a half after leaving the service. My critical contribution to that series was making certain the Commandos serving under Fury were a mixed bag of types, because that's what I witnessed in the Signal Corps. You take your experiences and apply them whenever possible.

Robert Kanigher brilliantly created comics' first enduring war characters, starting with Sgt. Rock, by carefully researching the theaters of World War II and creating battle-weary soldiers. He then surprised us all by creating Hans von Hammer, a World War I fighter pilot—for the Germans. His poignant portrayal of an enemy ace shows that your stories don't all have to be from the point of view of the victor. In fact, challenging the conventional expectations in these battle tales can be the most fun. You cannot go wrong going back and studying EC's war comics to see how they work best.

War, as they say, is hell, and it looks pretty gruesome in this sequence from Black Terror #5.

When superheroes began to fade in popularity, one of the most successful genres for about a decade was the western. This was coupled with the plethora of television series featuring gunslingers, from *Rawhide* to *Gunsmoke* to *The Lone Ranger* for viewers of all ages. The times were simpler, and things were perceived as black or white, which appealed to a society that had just finished a world war. In comics, we jumped on that desire and had a pretty popular bunch of pistol-packing protagonists. Martin Goodman loved the name Kid, so most of our series featured the So-and-So Kid. When the television series *Rawhide* was popular, sure enough, Martin ordered up the *Rawhide Kid*. What's interesting is it was that series that was among the first I worked on that garnered a lot of fan mail, in the days before we ever published letters from readers.

The era of the cowboy really spans the entire nineteenth century, as Americans tamed the wild frontier—you have tremendous variety in your choice of time and location for your western. There were the successful towns like Dodge City and the small shantytowns that sprang up in the hopes of becoming train depots, only to have politicians and land grabbers turn them into ghost towns. You have cowpokes, farmers, vigilantes, sheriffs, and people from "back east" to use in your stories, so you're far from limited.

John Cassaday's cover to The Lone Ranger #19, *a classic character developed for radio who has become a permanent part of our popular culture.*

When we weren't looking, MLJ launched a new feature about a typical American teenage boy who couldn't decide which gorgeous gal he loved more. Inspired by the successful teen movies and radio shows of the day, *Archie* sparked a new genre for comics—teen humor—and for a time, there were dozens of imitators out there. While we couldn't match Archie's staying power with another guy, we did pretty well with a bunch of other teens, including *Millie the Model* and *Patsy & Hedy*. It was pretty easy to look at the kids in the neighborhood and my own growing daughter, Joanie, to get inspiration for new stories. Teen humor requires your hero, his or her friends and rivals, some adults for contrast, and a town setting that gives you room to explore. These were definitely gentler stories, and while today's teens have troubles Archie or Millie couldn't have imagined back then, there's no reason good high school humor can't be done well.

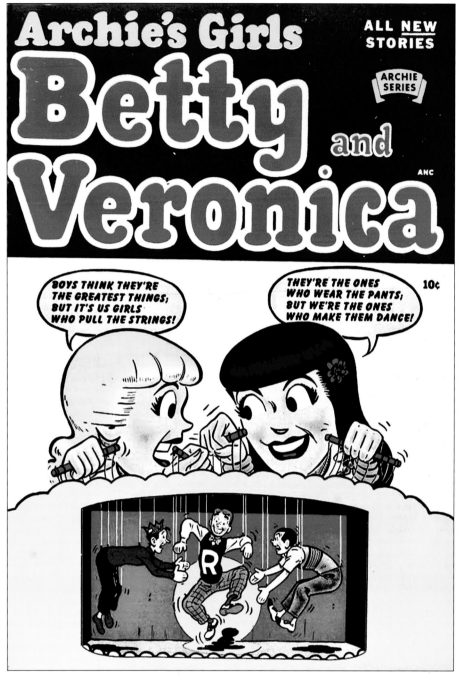

Archie's Girls Betty and Veronica #1
*demonstrates the eternal appeal of teen
characters that younger readers aspire to
become and older readers enjoy as well.*

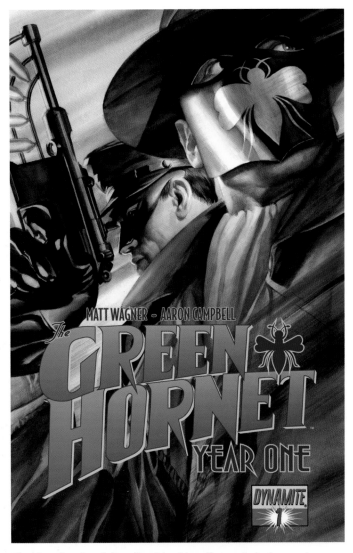

The idea of a crime fighter disguising himself as a criminal was unique when the Green Hornet debuted on radio. His exploits, including Green Hornet: Year One, *are an example of how crime comics can be produced.*

The Comics Code Seal of Approval notified retailers and parents alike that the comic was inoffensive to one and all. All too often, though, they were also drained of creativity and vitality.

Under the Comics Code, the maxim "crime does not pay" certainly was true. But for a while there, crime comics were all the rage. But again, you have to create creditable situations and characters. Why do they rob banks, or by what means do the detectives track down the criminals? Period crime, say the Chicago gangsters of the 1920s, requires just as much research as the war stories, but modern-day crime comes in more varieties. Under the Comics Code, our villains had to be stopped at every

turn and could not be seen glamorizing their craft. That meant heroes stopped villains, and to me that was a challenge.

Look at the first villains in the Marvel Age: the Mole Man, who came from under the surface seeking conquest, and Doctor Doom, monarch of his own country. Their goals and ambitions were beyond typical crime. These days, thanks to the reduced influence of the Code, crime comics have made a comeback. The emphasis is placed more on the characters involved than the crimes themselves, and that makes for more compelling reading.

Romance stories in comics have always been challenging because you need variety to show true love or heartbreak. What brings people together or tears them apart? Class and social upbringing, economic circumstances, education, and careers provide good fodder for stirring the pot as you mix and match. Setting was just as important, and few romance tales took place, for example, during war. School and work were perhaps the most common locations. During the early days of romance comics, the lovers were chaste and their problems of the heart were easily fixed. With time, and countless variations on the theme, more sophisticated reasons had to be found. That could be one reason this genre faded pretty quickly—only a handful of titles made in into the 1970s. No doubt the Code's restrictions over the problems the would-be lovers could experience left them further and further from being identifiable problems with teens during the socially turbulent '60s and '70s. Since then, romance has been left to the subplots in most other genre titles. You can certainly do a good romance comic today given what's permissible, but the publishers need to find to a willing audience.

In *Cartoonist Profiles*, I told Jud Hurd, "I decided to treat the superhero adventure strip as though it's a soap opera story that just happens to be about a superhero who has to defeat villains. But rather than predicating it on great action scenes, I determined to predicate it on characterizations, and on whatever personal problems a superhero might encounter living in a realistic world—in today's world. So I play up Peter Parker's personal problems every bit as much as the problems of having him fighting a villain. Even when he is Spider-Man, rather than resorting to one fight scene after another, I try to put him in unusual situations, and I try to have him come up against villains who are unusual. And I try to make the themes as contemporary, and as relevant, as possible."

Funny animals, the Mickey Mouses and Bugs Bunnies of the world, were one of the staples from most publishers, and today just a handful are seen here and there. Funny animal stories are as dependent on the setting as they are on the characteristics you give your anthropomorphized creature. *Ziggy Pig Silly Seal* was one of the first animal features I wrote. Now, a pig and a seal are not a natural combination, which in itself was humorous. As a duo, one could be the funny one and one could be the straight man following the classic tradition from vaudeville and best remembered today with the likes of Abbott and Costello or Dean Martin and Jerry Lewis. They got into adventures, with Silly's goofy help complicating the situation. About the only other recurring character in their stories was Toughy Cat, since, after all, they needed an antagonist. The humor tends to be broad and bordering on the slapstick as opposed to clever wordplay or complex plots.

I honestly loved writing every genre imaginable, including funny animals such as my pals seen here on the cover of Ziggy Pig Silly Seal Comics #3.

WRITING FOR MULTIPLE GENRES

All too frequently, writers today handle only one genre. Either they prefer one over the other or they get pigeonholed by publishers and the buying public.

One fortunate to have written in a variety of genres is Kurt Busiek, who noted in an interview, "It was engaging to stretch the creative muscles that way and do all kinds of different things. In the morning I'd do a revision on a *Mickey Mouse* script, trying to do what Disney wanted and give Mickey less and less personality, and then in the afternoon I'd be working on the latest chapter of *Vampirella*, where I was trying to do this absolutely compelling, creepily atmospheric horror stuff. It was useful to have different techniques; different tools in my belt as it were, that I could pull out. I'm something of a formalist; I like to play with form, and that gave me an opportunity to do so."

Roy Thomas told me, "The more genres you feel comfortable writing, the better prepared you are. I came into the field primarily because of my interest in superheroes, but the first comics I wrote were the *Millie the Model* books, which were a mix of romance and (very mild) humor, and soon a western or two . . . while my first regular series was *Sgt. Fury*. And, while I was interested in World War II, I had almost never bought real war comics. The real trick is to get your head inside whatever genre you're working in . . . figure out what makes it tick, and what you can bring to the party.

Imagine waking up in the morning, dashing off a story in one genre, then turning your attention to another story in a different genre. One glance at the cover to Vampirella #12 *provides more than enough motivation.*

Another example of how dramatic and tense war stories can be, taken from Black Terror #5.

"Conversely, though, sometimes it's also best to take the opposite approach and bend the genre to what you like to do. In that way, you can often expand a genre rather than just carry it on. While it wasn't a huge commercial success (though it did last fifty issues), Dann's and my *Arak, Son of Thunder* for DC was such a book, taking the sword-and-sorcery genre and applying it to a particular period in history (the early ninth century) so that it wasn't just a copy of Conan or other sword-and-sorcery heroes.

"Sure, there may be some genres I am more comfortable writing than others, but I shy away from none of them. Today, as I conjure up new concepts for a variety of publishers, they tend toward the science fiction and superheroic, but trust me, if I were asked to devise a new occult series, I could stare into space for a nanosecond or two and come up with something. There will be some experience, observation, or notion that you can pluck from the inner recesses of your mind and use it to spin a new yarn.

Red Sonja #1, page 19. Who doesn't like a curvaceous redhead with a sword? The Red Sonja stories have allowed for a nice variety of tales and characters, using the setting and her nomadic nature to offer readers a variety of tales.

Red Sonja #1, *with art by Michael Turner.*

"And when Stan, Gary Friedrich, and I somehow brainstormed the first issue of *Not Brand Echh* back in 1967, it was something moderately new . . . an approach to superhero parody that took early *MAD* as its launching point but which went off in its own direction, even to some extent with continuing characters. Iron Fist was Gil Kane's and my attempt to adapt the super-hero to that new phenomenon—the kung fu action story."

I gotta admit, I loved reading *MAD* when it debuted and loved having a chance to do my own brand of satire and humor in the later 1950s. Our superheroic success in the Marvel Age allowed us to poke some gentle fun at our own heroes as well as some jibes at the distinguished competition.

One thing we all learned from Martin Goodman was to keep your eyes open for the next popular genre and then jump in fast. We certainly did that with the kung fu craze of the early 1970s with several heroes, including Iron Fist.

Not Brand Echh #8.

MAD *Magazine #58.*

Iron Fist #1.

The two methods most often used in comic book writing are Full Script and Marvel Style.

MARVEL STYLE (PLOT-FIRST)

I can't swear to who first figured out how to write comics and what the earliest scripts looked like. The cartoonists wrote and drew their own comic strips so often that I doubt there was anything resembling an accepted method. Later, as time progressed, writers began to pound out stories calling for all the action and dialogue, describing the details panel by panel. These became the full scripts that are still in use today.

Of course, I've been given some credit for developing an alternative method, called the Marvel style, or plot-first style.

Back then, there were no how-to books or convention panels to teach people how it was done. We all learned on the fly, sitting at someone's elbow or maybe over a cup of coffee. Those early veterans, such as Joe Simon, would talk with me as they worked but only when they felt like it. We all learned from one another as we rushed to fill pages and make printer deadlines.

With the Marvel style, I would give the artists the broad outlines of the story, and fill in the dialogue after the penciling was completed. I'd call an artist up on the phone and dictate the script or highlight the plot points. Dave Gantz, on staff at Timely back in the 1940s, once described my work methods this way: "I thought Stan was the Orson Welles of the comic book business. He had energy . . . when Stan would try to explain an action scene, he'd say, 'Take it to its ultimate point. Don't give me the in-between stuff.'"

Honestly, I was working so fast that there were times I couldn't pause to type, so I dictated; I had secretaries taking notes, and after rattling off a few pages of story to one, I'd turn to the next and start a new story. Later on, when I could slow down, I tried recording my dictation for later transcription, but that proved cumbersome. After I hired Roy Thomas to be an assistant editor, I'd have him sit in on the conferences. He'd take notes then type them up with carbon copies going to me and the artist. That, too, proved short-lived.

Some artists, such as Gene Colan, brought their own tape recorders while others would discuss plots with me over the phone. John Buscema, bless him, wanted only the briefest of outlines. We'd chat on the phone, I'd offer to have the plot typed up, but he'd say, "Nah, I have it." Sure enough, a few weeks later, twenty glorious pages of pencils would arrive.

Colan recalled to Danny Fingeroth in *Write Now!*, "Stan had taken on a huge writing load because Marvel had, a few years earlier, been having financial problems, and he decided to write most of his scripts. But he didn't have time to sit down and type out a full-blown script, so he would dictate it to me over the telephone. I would record it . . . he would say to me, 'Well, it's roughly like this.' It's amazing he had that kind of faith in me at that time. And he'd continue something like, 'A couple of guys break into a bank and they steal some money.' And then there was an 'in-between' of the plot—the middle. And then there's an ending to the plot. So it was broken down in three parts, the beginning, the middle, and the end.

"No details. 'And then there's a couple of bad guys here and there.' So he left the characterization up to me. Once in a while he might describe a character, but mostly he gave me my heading. I could do whatever I wanted, so long as I kept within the margins he described in our conference."

Flo Steinberg, who was my secretary from 1964 until 1968, said, "Stan was very physical when describing the plots, and the guys would discuss it. There was a lot of body movement, especially for the covers, what he wanted on them. He'd jump on the desk now and then. He was very athletic.

"They seemed to appreciate it. He gave them the freedom to draw the way they wanted. He did not give them panel-by-panel scripts. They liked that. I remember everyone being in good moods back then."

For artists trained on full scripts, being asked to suddenly help plot out the story can be a daunting experience. John Romita recalls, "The first time I was asked to work from a plot [*Daredevil* #12] I was terrified . . . where to begin? Choose a splash scene? How many panels per page? After fifteen years working from a script (like a screenplay), I'd be lost. But, I tried, and, sure enough, when Stan saw the first few pages he thought they were dull (and they were). He called Jack Kirby and asked him to do a 'pacing breakdown.' Stan briefly gave him the plot, and Jack sent the first ten pages in a couple of days.

"The pages were on 12 x 15–inch Bristol and were like a 'paced diagram,' like a road map showing how to tell a story in pictures...just outline figures with initials to tell you who the characters were and notes in the margins to describe the scene in each

panel…a light (the proverbial light bulb) went on above my head, and I got the message quickly! *Daredevil* #12 and #13 were done that way, and I had been baptized in the 'Marvel Method.'

"I learned all I needed, with Stan Lee's ongoing comments going along, and I never looked back. There were times, early on, when I felt 'taken advantage of' but soon realized that I was enjoying the process and further on began to see that this was like a 'leap forward.'

"My problems stemmed from my foolish mistake in not recording our plot sessions. My job would have been easier if I had, but being in the office daily led to plotting 'on the run' with constant interruptions and half-plots left hanging. But, I never did it!

"The result of all this was a huge step in comics' history, in my opinion. This art form was now the 'visual medium' it was meant to be. This time-saving gimmick of Stan Lee's transformed our product into something substantially better than it was!"

Obviously, the best at this was Jack. While I typed up those first *FF* plots without much discussion, in time he made unique contributions to the story. If he happened to be in the office, we'd drive back to Long Island together plotting out the next issue. I wouldn't have to write it up; he remembered everything and went right to work. Sometimes I could say a few sentences over the phone, and he'd just go to work.

As I said to the *Comic Buyer's Guide* (and elsewhere), "In the beginning I would give Jack the idea for the character. I would describe the characters and give him an idea on how I wanted them to be. Jack would then draw the story and give me the exact rendition that I was looking for in the character.

"After a while he was so good at it that I only had to tell him a few words. I mean I would say something like, 'In the next story let's have Doctor Doom capture Sue and have the other three come and get her." I would tell him a couple more things, and that

was about it. He would then draw the whole story. I would get the story back, and some of the things in it I would have liked and some other things I would have felt he shouldn't have done. It didn't matter though, because it was fun—even the parts that he drew that I felt weren't right for the story.

"I would try and figure out a way when I was writing the story to make it seem as if I wanted those parts included from the start. I made them seem as if they fit in perfectly. I think we had a great collaboration. Whatever he drew, I was able to write, and I was able to enjoy writing it."

Let me point out that, by this point, we'd been working on multiple stories over several years and had grown comfortable with each other's rhythms. As a result, I trusted his storytelling and his story sense, so when he wanted to work from a few sentences, I knew I would get a complete, well-paced story.

Historian Peter Sanderson wrote about an example of what happened

Kevin Smith's Kato #5
Ande Parks

Pages 1-15
Big Fight!
This entire fight is narrated by Mulan, as we fully shift the focus to her in this issue. She is now officially the star of this book. That is reflected in the new ending to this fight, which reverses the roles of Mulan and her father in the final moments. Mulan talks about how her life has changed since the beginning of this series.

Much of this battle will be seen "widescreen", in three panel pages. There will be splashes, as well.

Pages 1-3
BH battles both Katos. Some hand to hand on the rooftop. BH is thrown off the roof. Mulan jumps after. In the air, BH spins and pulls his guns. He fires up at Mulan as he falls. BH lands on a lower rooftop, and Mulan lands on top of him. Kato jumps down, as well.

Here's a great example of plot and art, from Kato #5, written by Ande Parks. It took just fifty-five words to give the artist what he needed to know to draw the first three pages. The end result leaves me breathless.

The results of Ande Park's plot and art script for Kato #5.

when the writer and the artist did not agree on a story point. "This was the second page from the landmark 'Bedlam at the Baxter Building,' the tale of the wedding of Reed and Susan Richards from *Fantastic Four Annual* #3 (1965). We see Doctor Doom, enraged by the news that today is Reed and Sue's wedding day, tearing a newspaper into shreds. In the next panel, he wears a look of angst as he holds out his hands and soliloquizes.

"The second page of *Fantastic Four Annual* #3 was an unfortunate result of a writer and artist not agreeing on a story point.

"According to Kirby's border notes, the act of tearing up the paper sent pain shooting into one of Doom's hands. In his last appearance, in *Fantastic Four* #40, the Thing had crushed Doom's hands in one-on-one combat. So that is why Kirby drew Doom wearing a literally pained expression as he holds out his hands. According to Kirby's notes, it is Doom's rage over his ignominious defeat and injury by the Thing that motivates him to want to launch his attack on Reed and Sue's wedding ceremony.

"But wait—the story is about the wedding, not about the Thing. Surely that is why Stan chose to interpret this sequence with Doctor Doom. In Lee's script, Doom vents his hatred of Reed Richards, not the Thing. After all, despite the humiliating defeat the Thing inflicted on him, it was Richards that Doom had always regarded as his greatest enemy. So, in Lee's telling, Doom is out to take vengeance on Reed by wrecking his wedding. This is a far stronger premise given how the rest of the story unfolds. In this case, I believe Lee was right in overriding Kirby's intentions."

Similarly, Steve Ditko was a quieter, moodier artist, and the sorts of stories he responded to were very different than the bombastic beasties that seemed to appeal to Jack. After working together for a while, I got so jazzed by his introspective and psychological approach to stories that I practically created *Amazing Fantasy* just so we could have an entire book to produce stories together.

Steve once wrote an essay wherein he described how we did it. "Stan provided the plot ideas. There would be a discussion to clear up anything, consider options, and so forth. I would then do the panel/page breakdowns, pencil the visual story continuity, and on a separate paper, provide a very rough panel dialogue, merely as a guide for Stan. We would go over the penciled story/art pages and I would explain any deviations, changes, and additions, noting anything to be corrected before or during the inking. Stan would provide the finished dialogue for the characters, ideas, consistency, and continuity. Once lettered, I would ink the pages."

Of course, *Amazing Fantasy* also gave us the debut of Spider-Man.

When the Webhead earned his own title, Steve and I worked out the stories together in the same give-and-take. I'm told his apartment had plot notes and issue-by-issue subplots tacked up to a wall, so he was putting tremendous thought into this series.

The challenge for me was to find out what he intended, and trust me, sometimes it was like looking at a crossword puzzle. This did lead to some tension when my story instincts and Steve's diverged. By then, he was reading a lot of philosophy and his notion of good versus evil was changing, which meant we butted heads a few times over the dramatic needs of comic books. I can honestly tell you I don't know why he quit when he did,

but the theory is that we clashed over the identity of the Green Goblin. I just don't know.

When Steve abruptly quit after issue #38, I had to stop and rethink the series, which would certainly now both look and read differently. Thankfully, John Romita was ready to step up and take us all into another era.

John and I had a lot in common, had worked together years earlier, and genuinely liked one another a lot. That led to an evolution in the character of Peter Parker, something that may not have happened until later, if at all, with Steve. (And no one drew a sexier Mary Jane, but we're not talking about art here.)

A few pages back, you saw what a plot looks like. Now on page 88 is Eric Trautmann's script to an issue of *Vampirella* and the resulting finished artwork from the first issue published by Dynamic Forces in 2010. Eric has numbered each speech so the letterer can more easily match who's speaking. I call to your attention the different kinds of shots Eric calls for. Now match the script to the artwork to see how closely artist Wagner Reis followed the directions.

Using the Marvel style was a very efficient method to tackle a big 72-page comic book such as this one.

The most famous issue of Amazing Fantasy contains the first appearance of Spider-Man. And to think, they didn't think the character would be appealing!

FULL SCRIPT

Okay, so much for the trip down memory lane. Now, for every writer who adores working plot-first, there is another who prefers writing the full script. There are obviously pros and cons to both styles, and not everyone is suited to both ways of working.

Plot-first makes the story a full collaboration between writer and artist, hopefully bringing out the best in both. They feed off one another's input, and magic happens. Plots can vary in length from a few sentences to detailed pages. Roy, in his fine magazine *Alter Ego*, wrote, "Stan preferred the artist to come up with the pacing and many of the visuals. There was no suggestion that I should pace out the stories panel-by-panel, or even page-by-page. In fact, during this period, I doubt if any Marvel writer ever even indicated that this scene would take up approximately two pages, this one four, etc. We just banged out a simplified short story synopsis for the penciler, and let him take it from there. Don Heck, like Dick Ayers and Werner Roth on the other two hero mags I was scripting, knew enough by now not to draw page after page of the heroes just standing around talking, right?"

I had worked with artists for long enough that by the mid-1950s or so I had a real strong sense of who was good at which kind of story. These were men who were, by and large, working professional storytellers and could work in any genre. I knew they could tell a compelling story, and with my time in short supply, it made increasing sense to let them loose with my plot kernels. It also benefited them because they felt a great sense of pride and proprietorship in the story, and I got better work from them because the story kept their interest.

On the other hand, some artists are great interpreters of the script but not necessarily story driven and could not successfully flesh out a plot. In fact, many first-time artists can fail because they have yet to master crafting a story while learning how to tell a story. They are very different ideas, after all.

Artist Bryan Hitch noted to interviewer Mark Salisbury, "When Stan Lee started the whole Marvel style of plotting, he was working with people who really knew what they were doing, and a lot of them later became writers themselves. But nowadays it's a shortcut and has bred a lot of laziness in less-talented writers. They throw down a bunch of ideas with no clue how much should be on each given page or where things should be. They're not actually doing the page-by-page working out; they're coming up with an idea for a story and guffing out a lot of nonsense onto the page. You end up having almost to be an editor, a writer, and an artist, and you don't get paid any more for doing so. There's a lot to be said for fully fleshed-out scripts.

"Mark Waid has a much looser approach on *JLA*, even though he still works full script. Rather than just send me a script or plot, he wanted to discuss a lot of stuff and get a verbal back and forth going first. Then he goes away and writes it based on those conversations, and that's working out very nicely. He's very open to suggestions, but I'll only offer an opinion if I feel I've got something worth saying, because in the end it is his job and he's a good writer. In all fairness to the Marvel style, there are writers who know how to work that way and give you just enough. Even though their plots don't have any dialogue in them, they're still essentially full scripts, where each paragraph is a panel description that's been fully worked out."

My art skills don't get beyond stick figures, even though I've developed a pretty keen eye toward storytelling. I might have some rudimentary ideas for how to draw someone else's story, but it would be difficult (and probably painful for the reader). On the other hand, Jerry Ordway, who began his career as an inker before becoming an artist, then a writer/artist, told me about the differences: "With regards to working plot-style, the writer can take advantage of the artist's ability to stage the action and even pace the story. I've worked this way for most of my career, both drawing other people's plots as well as writing plot-style for artists other than myself. As an artist, I feel like I contribute more overall to the story, and it's a more enjoyable experience.

"As a writer, I really enjoy giving an artist the freedom to interpret my ideas, because it results in a truer collaboration. We all 'see' things differently, and I was always amazed to get penciled pages from the artist for me to dialogue, because more often than not, the results were better than what I had described on paper. When the artist veered from my staging, I often found better ways to approach the words. I assume this is what jazz musicians go through when they improvise, and I always enjoy it. When I plot a story, I try to include possible dialogue in the descriptions, as a clue for the artist as to the character's emotions, as well as to indicate that I may

need more space for balloons on a given page. I tell the penciler that it's not etched in stone but just there for them to help stage the action."

Kurt Busiek told Salisbury, "What I'll do if I'm plotting an issue is to make a bunch of notes on a yellow pad in enough detail so I can break it down page-by-page. Or I'll make enough notes so I have a sense that this is what happens in the story, and I'll go to the computer and type up a synopsis and then break that down into pages. Then I take my page-by-page outline and type up a full plot for the artist. When I'm plotting an issue it takes a day or two. Some days, if it goes really well, I'll rough out the story by one o'clock in the afternoon and I'll sit down and start typing it up. Once I've got it roughed out it only takes one and a half to two hours to type it up.

"If it's a more complicated story, I may have the structure of it worked out by the end of the first day, where-upon the next day I'll actually do the page-by-page breakdown and look up whatever reference I need, which can be time-consuming, and then type it all up and photocopy the reference for the artist. That's a two-day plot, but it's very rare that it'll take me longer than that. If it's not working, I'll call an editor or a friend and we'll bounce ideas off of each other until it does. On a day that I'm scripting, I'll take the photocopies of the full-size pages that Marvel sends me, shoot them down to 8 ½ x 11" size, go off to my outside office, prop them up on an easel next to the computer, and start scripting. When I finish, I'll indicate where the balloons go, e-mail the script off to Marvel, and fax the balloon placements.

"Doing a full script gives me more control, but doing it plot-style gives the artist more freedom, which can be a good thing, especially if it's for the

The Ultimates #4 by Bryan Hitch, filled with drama thanks to the close-up of Thor and the subtle coloring.

VAMPIRELLA #1

ERIC S. TRAUTMANN

PAGE 1 [4 PANELS]
Four stacked horizontal panels.

PANEL 1

Establishing shot. Ext. — Nightime. Seattle, WA.

We're on a city street in a not-very-nice part of Seattle; there's some garbage and debris scattered around, and we also see that a cloying fog has been rolling in.

The lighting has a yellow-green quality to it, courtesy of the fog muting the streetlamp illumination.

In the foreground, we see some silhouetted figures of four young men, clearly part of a street gang of some kind, clustered around another figure, a homeless man cowering on the ground.

 1.1 **GANG MEMBERS (NO TAIL, OVERLAPPING)**

 --SAID YOU COULD SLEEP HERE, FOOL?

 1.2 **GANG MEMBERS (NO TAIL, OVERLAPPING)**

 --HIT HIM <u>AGAIN</u>—

 1.3 **GANG MEMBER**

 --GONNA HAVE TO TAKE YOUR <u>EYE</u>, DUDE—

 1.4 **HOMELESS MAN (WEAK)**

 --PLEASE, <u>I'M SORRY</u>, I'LL <u>GO</u>--

 1.5 **LOCATION / CAPTION**

 <u>SEATTLE, WA.</u>
 <u>MIDNIGHT.</u>

PANEL 2

Closer in, we see the HOMELESS MAN, bloodied up a bit, pleading with his tormenters. One of the GANG KIDS — the leader — is taunting him.

 1.6 **HOMELESS MAN**

 --DIDN'T MEAN ANYTHING, I'LL JUST LEAVE—

 1.7 **GANG LEADER**

 NOT SO FAST.

Here is an example from a full script and its accompanying art.

right kind of artist. If I did full script for George Pérez, it would be terribly confining for him. He wouldn't enjoy himself and the pages wouldn't come out looking anywhere near as good as if he broke it down himself. But in something like *Marvels* or *Astro City*, where the pacing and the internal narrative—what's going on in the lead character's head—is so important, if I scripted them in Marvel plot-style it wouldn't work as well.

"To me, the connection between the writing and the art is the fun part. It's what makes comics work. So, I enjoy writing comics most when I have a lot of contact with the artist, when I have a sense of what he wants to draw and what he likes best. That collaboration is one of the things that draws me most strongly to the form. I have occasionally written a full script and it's gone off to the artist and I haven't seen it until publication, but I'm usually unhappy when that happens. I did an Arsenal story full script for DC's *Showcase* series; it went off to the artist and when it came out I went, 'My God, this is horrible.' If I had gotten the art back, I could have rewritten the story so that all the stuff I put into the script that didn't work on the page could be made to work."

A full script puts the writer totally in charge of the story. He crafts the beginning, the middle, and the end. He establishes the pacing by determining the number of panels per page and how long each sequence

should be. The obligation is for all the dialogue, captions, and sound effects to be determined at the outset, which many artists like knowing since it simplifies their time commitment. Editors also like full scripts because they can assess the story as a complete unit, making certain that the characters sound right, the plot makes sense, and the right numbers of pages are given to the main plot, subplots, and other business. From a practical timing standpoint, a full script also means the editor doesn't have to worry about the writer taking his time on the dialogue, potentially making the title late.

The script can also act as a letter to the artist with casual thoughts and asides that never make it on to the page but can help explain what's on the writer's mind. Here's an excerpt from Neil Gaiman's script to *Sandman* #24—see the level of detail he provides artist Kelley Jones:

A long panel down the left-hand side of the page. Okay, Kelley, now get whatever reference you think you'll need for this—it's as if we're in ninth-century Norway, or at least, the ninth-century Norwegian idea of what a great palace would be. So the hall is built of woven rushes— no windows, smoky. Forget all the Kirbyish SF stuff: This is dirty and primitive and old-fashioned: almost no metals, just wood and stuff. The floor is mud, strewn with rushes.

Odin sits in his chair. At his feet sit two huge gray wolves, sprawled one on each side of him, huge green wolf eyes staring straight at us. Odin sits on a huge wooden chair, staring at us through his one good eye. He is bare-headed. He has gray hair, thinning, shoulder-length, and a short gray beard-and-moustache. In his left hand he holds a goblet—made of gold, ornamented with jewels. The room is dark and gloomy and muddy. Odin wears a simple leather jerkin; it goes down to his knees and is drawn in at the waist by a heavy leather belt; his legs are covered by cloth leggings, crisscrossed by leather thongs running all the way up his legs. (Check out any good reference on the Vikings.) Odin's face is long and thin and drawn. He doesn't look like a nice man—he looks dangerous.

Like an aging hired killer, his one good eye cruel and nasty. You may want to keep his face fairly shadowy here, so that all we can see is one glowing eye. Steve—get as far from the brightly colored Kirby Asgard as you can here: this is the Asgard of the Old Norse, a bitter, dangerous place, in which all is dull gray and brown, alleviated occasionally by a glint of gold. Odin's right eye is missing—the eye on the left-hand side of his head, as we look at it.

IS ONE BETTER THAN THE OTHER?

Some artists chafe at receiving a full script, feeling they are constrained, but most every writer will allow artists some leeway to alter camera angles or to combine and/or split panels. Very few writers today insist that the artist slavishly follow their scripts.

Defending the full-script method, Brian Bendis says, "Actually, I tried every once in a while to work with a plot. Frank Cho was like that, suggesting I just rough out the action sequences on *Mighty Avengers*, but I can't do it . . . it's not comfortable.

"I know outstanding comics have been produced this way, but I can't do it. What I do for every artist I work with is I make sure I know who's drawing it. The story is written for that artist. If a different artist is assigned, I polish the script to that artist's strength. I tell the artist, 'I'm imagining the world the way I think you see it. If you don't like my choices, or something inspires another idea, do that idea. Look at this as a map. However you need to get there, do

it.' I will re-dialogue or re-script and do whatever I need to do to make the story coherent and make certain the ideas are there.

"I always look at the art when it's completed, and I've removed dialogue from finished art because the facial expressions do all the work. The face says it all. Mark Bagley was great doing that on *Ultimate Spider-Man*. The biggest compliment I can give to an artist is to get my stupid words out of the way.

"Bryan Hitch just wanted me to do the fight scene plot-style. The sequence is designed to show that the Avengers are a great team, in tune with each other, and let them come out of the scene thinking they're great. Instead, I wrote it and told him, 'Here's

how I lay it out and the beats I hit, but anything you want to do that ends with us learning the Avengers are a well-oiled machine is fine with me."

"I do full script," Matt Fraction told Denny O'Neil in *The Comics Journal*. "There are guys I know who do Marvel style, but I think they tend to be viewed a bit like lobster boys, or men with flippers. They're certainly unique in their freakishness. I don't know if it's coming from a film culture and just having thought in storyboard for so long, but I wouldn't even know how to go about working in Marvel style. I've started to fold index cards into my process. This has been exciting. The last couple months I've started to use index cards more and more. Very messy."

An example of Mark Bagley's expertise in facial expressions on Ultimate Spider-Man #109.

A COMPROMISE

Doug Moench, who was one of the second-generation writers at Marvel, after I moved on to become publisher, came up with a unique hybrid approach. Moench told Jon B. Cooke for *Comic Book Artist*, "I was encouraged to use the Marvel Method—the Stan Lee method—but I never could; so I developed this bastardized version of my own.

"What it amounted to was instead of three paragraphs that Jack Kirby could turn into a story (because I wasn't working with Jack Kirby, you know?), I just wasn't confident that somebody else could do it, and if they did, didn't that make them the writer of the story? I mean, I was doing the word balloons, but still! Because I had done so many full scripts, I decided to try for the best of both worlds. I'll do it real tight, a real long detailed plot, but it won't be 'panel one,' 'panel two,' 'panel three'; I'll do it in paragraphs and each paragraph can be a single panel or the artist can break each paragraph into two or three panels or combine two paragraphs into one panel. That way, the artist can still have the freedom of storytelling if he chooses to take it—or, if they felt more comfortable following exactly the way it was written, artists could do that, too. In either case, I still had the luxury of all the strengths of the Marvel Method—which is getting to play off the artwork when the artwork sparks ideas. The facial expression could change the tone of the dialogue—and I could break the balloons up. See, you get to place your own balloons and that facilitates a certain rhythm, a punctuation. Instead of one big balloon per panel, you can have three or four or five of them. It brings a loose, collaborative feeling to the stuff, which I thought was much better than a full script and yet I still felt, legitimately, that I was the actual writer of this stuff because I did put it all in."

Just as writers should probably start writing with shorter works, mastering plot and pacing, they probably should begin with a full script to make certain they know all the elements expected in crafting a story. Once editors deem your work good enough, you can then try your hand at the plot-first method. But either way, it comes down to telling an exciting story, a memorable one, and something that will encourage editors to buy more work from you and readers seeking out your next tale.

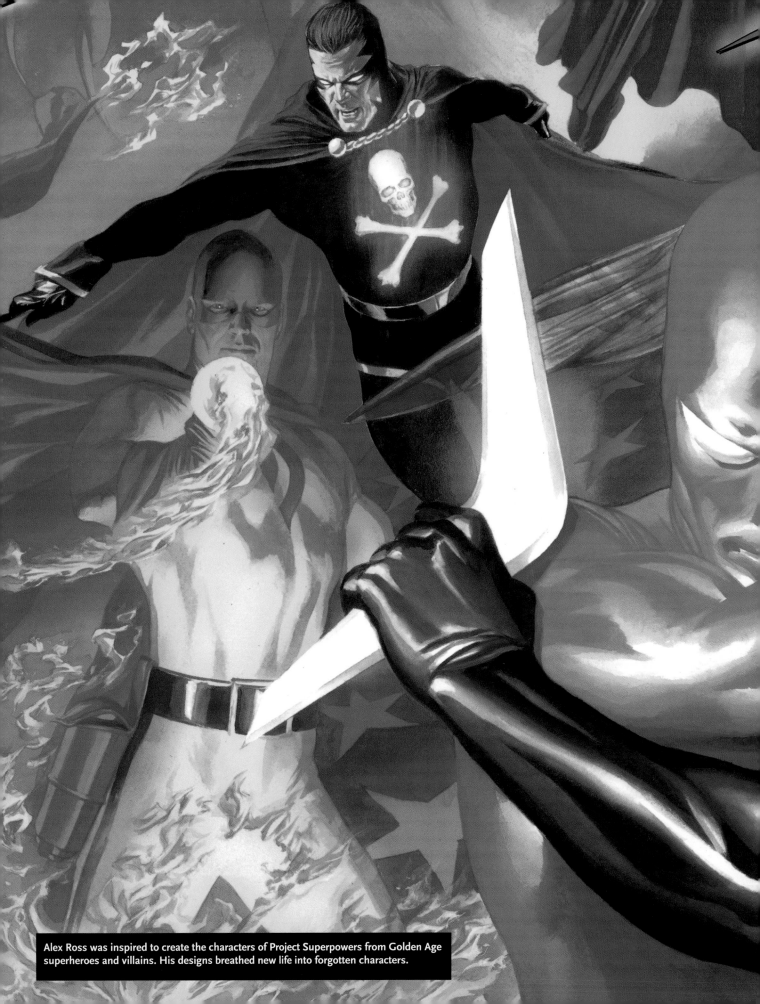

Alex Ross was inspired to create the characters of Project Superpowers from Golden Age superheroes and villains. His designs breathed new life into forgotten characters.

WHERE TO BEGIN

When Martin Goodman told me to create a superhero team in the early 1960's, I actually had to give it a long, hard think. After all, I hadn't written a superhero story in nearly a decade, and I was feeling pretty tired with comics overall. As I told you earlier, my lovely wife encouraged me to go for broke. I've written about this before, but it bears repeating. I wanted to write stories that valued the reader, treated the reader as an intelligent figure, and I therefore wanted heroes who wouldn't talk down to the reader.

"It took a few days of jotting down a million notes, crossing them out, and jotting down a million more until I finally came up with four characters that I thought would work well together as a team," I wrote in *Excelsior!*, my autobiography. "In saying 'well together,' I didn't just mean that their powers would complement each other. I meant that their personalities would enable me to write interesting and amusing dialogue for them. I wanted to think of them as real, living, breathing people whose personal relationships would be of interest to the readers and, equally important, to me.

"I've always found that once the characters were clearly defined in my mind, the actual plotting of the story was comparatively easy; and that was the case with the Fantastic Four, as I decided to call them."

Before you even decide to write plot-first or full script, you need to decide what it is you're writing about. We covered the genres that help dictate your story, but if you want to tell a story—what is the story about? Is this an emotional conflict? A physical conflict?

Your story has to be about something, whether it's a part of a larger whole or just stands on its own. Since the majority of comics feature continuing characters, what is it you are trying to say about the character? Do you have a fresh interpretation of the hero against his environment, or the hero against his enemy, or is this the hero against himself?

Look around you. See people interacting with one another? What are they saying, what are their backgrounds, hopes, and dreams? What obstacles do they need to overcome to achieve those goals? See? Stories abound.

Remember, you're writing about people, places, and things. You need to have something to say about at least one of them, if not more. You also have to challenge yourself to find a way of saying it to entice an editor into buying your tale. With the Fantastic Four, I created heroes who didn't always get along with each other, but heroes that could be counted on when the chips were down.

In that case, I had a specific assignment from the boss. But there were times I had only a genre to work with and no time to ponder. I came up with that opening situation I mentioned in the last chapter and then figured out the kind of people I needed to get that story told. I would come up with some broad-stroke ideas to get across that the person was an athlete, a soldier, an uneducated laborer, or whatever I needed. When we began creating new series, we saw what we had, and I tried to come up with a variation on that. So, if the Two-Gun Kid worked, I followed with the Outlaw Kid, and so on.

For the superheroes, the powers helped lead me to the characters. After the FF, we went in an entirely different direction for the Hulk and then Spidey and Ant Man, all of which lead me to go 180 degrees in another direction to use mythology, not science, to come up with Thor.

Once the hero was created, I knew he or she would need a supporting cast and figured out the personalities that would work best in contrast to the hero. After introducing Iron Man, for example, I brought him home to the United States and needed people for him to deal with. If he was the CEO, a rich, dashing figure, then who would he interact with most often? A secretary and a chauffeur, for starters. That led me to come up with Pepper Potts and Happy Hogan.

American Splendor's Harvey Pekar approached characters differently, explaining, "The main reason I write autobiographically is because I find it hard enough to understand why I myself do things, let alone why others do them. I want my writing to be as accurate and plausible as possible. I find that when others write fiction, they project their own ideas, impressions, sensations, and experiences on their fictional characters. Sometimes, of course, with magnificent results. For my purposes, though, I figured that I'd cut out the middleman, the fictional people, and write about me, the person I know best. Not that everything in my book is completely true, but an awful lot of it is. I will change peoples' names or occupations sometimes or maybe compress events that took place over a period of time into a few days.

"I start by trying literally to stick to the way things are, because that works best for me. The more accurate the details of my stories are, the more people can believe in them. However, if for some reason it makes more sense to depart from the literal truth, sometimes I will.

"I want to write literature that pushes people into their lives rather than helping people escape from them. Most comic books are vehicles for escapism, which I think is unfortunate. I think that the so-called average person often exhibits a great deal of heroism in getting through an ordinary day, and yet the reading public takes this heroism for granted. They'd rather read about Superman than themselves."

As I told one interviewer, "The mechanics of the writing is all pretty much the same. The style being, trying to humanize the characters as much as possible. The big formula, if you want to think of it as a formula, was just saying to myself, Suppose a real, flesh-and-blood human had such and such a super power? What would his life be like anyway? What would happen to him in the real world?

"Like Iron Man: Okay, so he's got this suit of armor and he can fly and he's very strong, but won't he still have to worry about union trouble at his factory? And won't he still have to worry about women problems, girls who are running after him and so forth, and his weak heart and all the problems he has?

"Maybe what I am saying is: I tried to concentrate more on the characters' personal lives, and not just make the story a case of hero sees a crime being committed, hero goes after the criminal, hero fights him and catches him in the end, which had pretty much been the formula up till then."

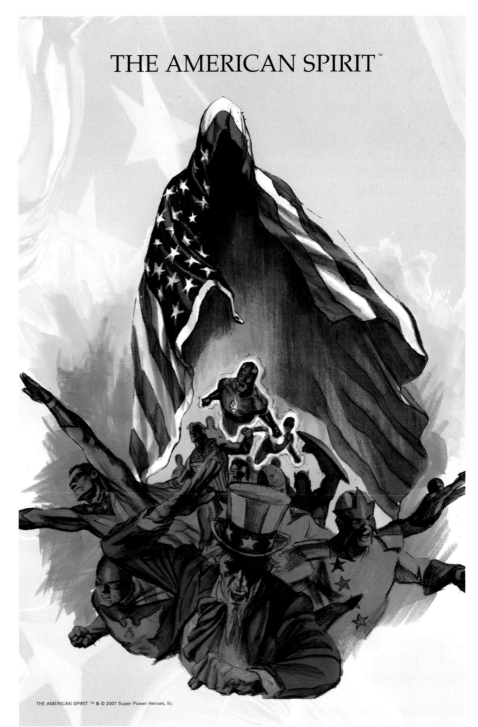

THE AMERICAN SPIRIT™

THE AMERICAN SPIRIT ™ & © 2007 Super Power Heroes, llc.

Even legends like Alex Ross need to start somewhere when designing characters.

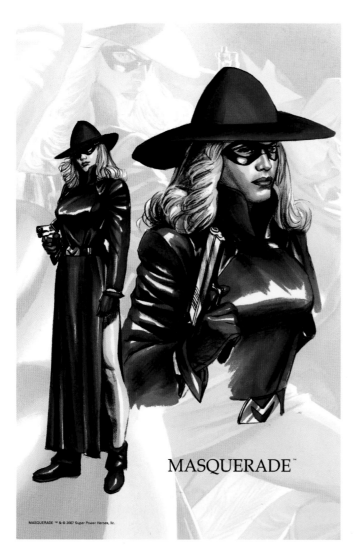

MASQUERADE™

A collection of out-of-print heroes and villains from comics' Golden Age were dusted off and revamped by Alex Ross for modern-day audiences for Project Superpowers.

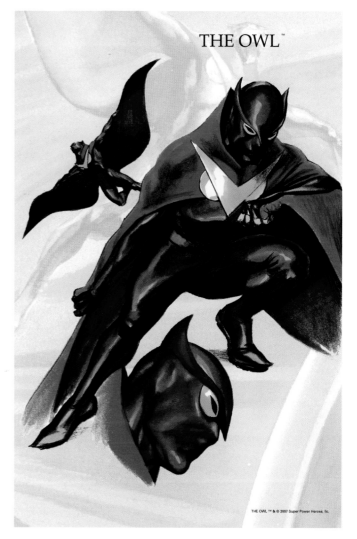

THE OWL™

SAMSON ™

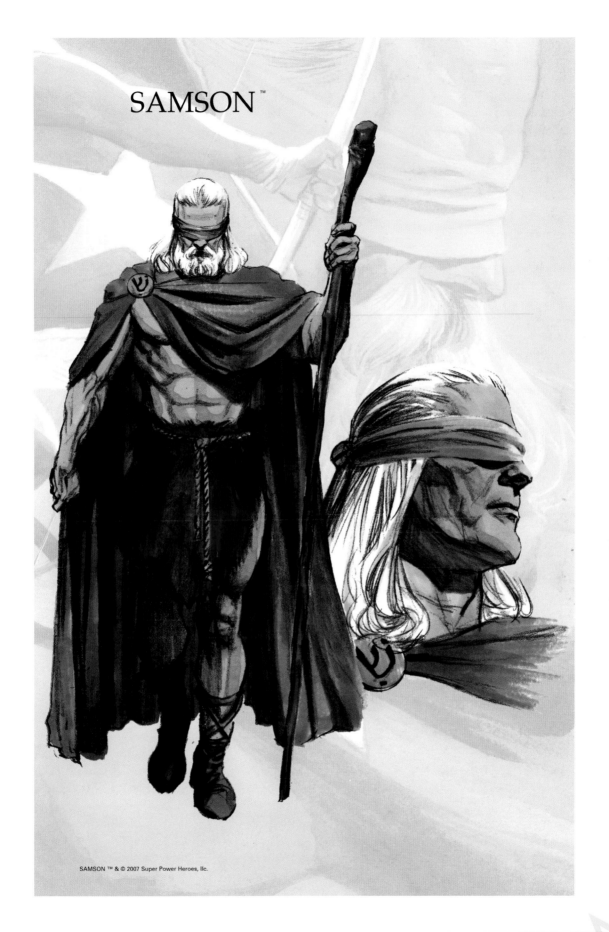

SAMSON ™ & © 2007 Super Power Heroes, llc.

Hard as it may seem today, our heroes and villains before the Marvel Age were pretty much stock players. You had a superficial knowledge of who they were, such as Steve Rogers being a soldier in the United States Army, but that was about all you knew about him. His biggest problem was keeping his red, white, and blue identity from his sergeant, but we never knew how he spent his pay or if he liked beer or preferred blondes to brunettes.

Some of that changed in the 1950s with the introduction of the Silver Age heroes at DC Comics, where my old pal Julie Schwartz rounded out his characters a bit more, but even so, it was an incremental improvement. At Marvel, I focused far more on the man under the mask than the heroic adventures.

Those who grew up on that first decade of Marvel titles wound up coming to work understanding that we were creating stories about characters and how they coped in a world filled with not just cosmic dangers but bills, illness, and dirty laundry.

There's always room for a good story. We grow up on books, movies, and television shows, but I doubt any of us get up one night and declare, "I've seen all the stories I want to see." We love stories and seek them out everywhere.

Every morning the newspaper is filled with articles we also call stories. Good gossip is a story well told. The excuse you give your teacher for not doing your homework is another kind of story. We tell stories all day long and crave more of them. Today, we crave them in a wider variety of formats than ever before, and that's a good thing, because it encourages creativity.

Do I worry about running out of ideas? Not really. I'm an optimistic sort and would hate to think I'm done.

THE CRUSADERS™

THE CRUSADERS ™ & © 2007 Super Power Heroes, llc.

Finished character designs for **The Crusaders,** *so the masks and chest emblems are visible.*

Now that people consider me some sort of sage, I keep being asked about the past when I'd rather look ahead to tomorrow and the next story I tell.

I also told interviewer Pat Jankiewicz, "The funny thing is, the more you do, the more it seems you're able to do. I remember, a million years ago, I was writing a comic book called *Millie the Model* for about fifteen years, and it was very successful for the company—sort of a female Archie. Anyway, after I had been doing it for ten years, my publisher said to me: 'Gee, Stan, don't

you think you ought to stop doing these? You've been doing it for ten years now, it must be tough for you, you're probably running out of ideas, and I don't want you to get stale.'

"The strange thing is, I wasn't running out of ideas. I found it easier than when I started because I knew the characters, their motivations, and the type of situations they would get into, the stories came naturally. I've used the same method on the *Spider-Man* strip."

MOTIVATION

I told Jim Cangialosi in an interview, "Spider-Man's motivation was there from the beginning. I didn't add it. That was there all the time. That was the first thing I thought of when I was sitting down to write the story—because, again, in trying to be realistic about the superheroes, my feeling was that the character needed to be driven into the role of a hero. Why would a guy with superpowers spend all his time risking his life trying to fight bad guys? Why wouldn't he just go on the stage and make a fortune, be an entertainer, or go into sports?

"In order to be realistic, here's a teenage guy, I think he was seventeen at the time, who was suddenly just about the strongest guy around. He could climb on walls and shoot webs and do just about anything he wanted. Why would he want to risk his life all the time fighting super-villains? I had to give him a motive; I had to give him a reason why he's going to be a hero.

"I figured if somebody close to him died, and he felt responsible for that death, then he would perhaps want to spend the rest of his life atoning for that. I said that the death of Uncle Ben was an integral part to Spider-Man's origin, not an add-on."

The character is the sum of his experiences, and there has to be something for the reader to identify with—his humor, his loss, his sense of responsibility. While I attended high school with a few hundred kids from the neighborhood, each and every one of us were different because our parents were different, our economic circumstances were different, and so on. In fact, look around at your family, your coworkers, the people you deal with in school—they're all different characters. What makes them different or appealing or appalling? Now take those elements, amp them up a bit, since comics are larger than life, and you're on your way.

A page from the early days of Vampirella's time on Earth. Here the motivation was that of a fish out of water, and let me tell you, she's one fine, curvaceous character to follow.

CHARACTER AND CHARACTERIZATION

When I chatted with Boisterous Brian Bendis, he cautioned, "What I do think some writers get lost in is the difference between character and characterization. Character is plot. Character is not dialogue. What that character does when they make certain choices and how those choices further the plot in a positive or negative way. The great example is Peter Parker letting Uncle Ben's killer walk by him. A character choice that altered Peter's life for the negative.

"Characterization is dialogue and quirkiness. Using Peter again, Spider-Man's use of verbal abuse of the villain while fighting, that trash-talking basketball player, never letting up while fighting. That's all characterization.

"That difference is a very important element, which is often lost in the writing process, and writers lose the understanding of it. They don't stop and discover what drives the character."

One of the best stories I heard about character creation came from the dear, departed Bob Kanigher. Back in the 1960s, DC had a book called *Showcase*, and the various editors at the time took turns introducing new concepts—this is where Julie Schwartz tried out a new version of the Flash, inadvertently launching both the Silver Age and the Marvel Age. A few years later, in 1977, Kanigher recalled in a letter to a fan, "It wasn't my turn to do another *Showcase*. But the other editors hadn't come up with an idea. Irwin Donenfeld asked me did I have any. I immediately said: 'Metal Men [MM] with human characteristics.' Irwin said: 'Go ahead.' That was Friday, Saturday morning I took my daughter Jan to her ballet class

at Julliard Music School. I sat in my convertible on Riverside Drive, gave myself a crash course in a subject of which I knew nothing, chemistry, and started writing. Monday morning I came in with the finished script.

"Before I started each script, I gave myself an instant refresher course with Nostrand's, to guarantee that each MM acted within his chemical boundaries, which also dictated his human responses. Whatever they did was stretched to the nth degree. But never violated it."

As you know, the Metal Men were popular enough to leap from a four-issue trial to their own series and remain a beloved component of the DC universe.

"The most important thing to remember about creating characters," Mark Waid told interviewer extraordinaire Mark Salisbury, "is to never lose sight of (a) what they want and (b) what's in their way. Everyone in your story wants something, even if he or she is a minor character, and their actions and dialogue will reflect this and will flesh them out, make them realistic.

"Along those lines, one of the tools I always use in character creation is to figure out what's the worst thing that

could happen to that character and what's the best thing. The former gives me a place to go for conflict; the latter helps me articulate his or her goals.

"Be careful with dialogue. Remember, very rarely in life do people simply come right out and say what they're really thinking. More often, they're oblique or guarded about their motives. Beware of ham-fisted diatribes where your hero or villain just comes right out and says exactly who they are and what they want; that's shallow writing. Always, always try to get that information across in a clever, unique, and (preferably) visual way. If you're creating a molecular scientist, don't introduce him by having him say, 'Hi, I'm Bob, I'm a molecular scientist.' Instead, introduce him at a bar or party, idly assembling olives and cocktail straws together (for instance) to look like a model of a molecule while he talks about something else. That's only one example, but there are thousands. Once you've created your character, always try to introduce him or her through action rather than through dialogue. Take advantage of the fact that comics is a visual medium."

Showcase #4 began the reintroduction of DC characters with new concepts.

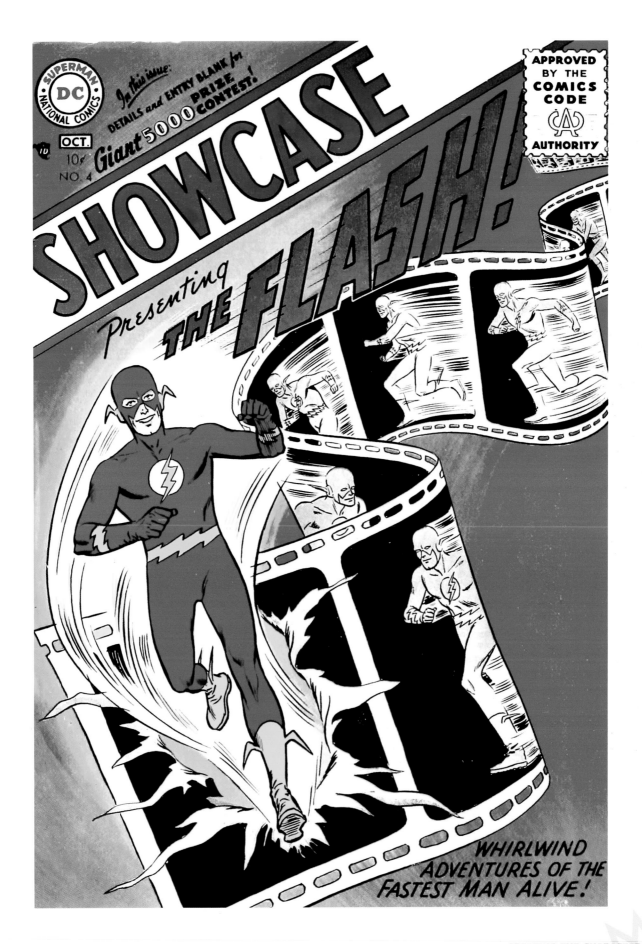

BRING ON THE BAD GUYS

Okay, so we've created the protagonist, gave him a distinctive personality, and surrounded him with pals and gals. All well and good, but he needs someone to challenge him. If you go back and look at the early comic books, the villains usually were bank robbers, jewel thieves, and the usual criminal riffraff. As we entered World War II, spies, saboteurs, fifth-columnists, and their ilk broadened the ranks.

All too rarely did we come up with supervillains powerful enough to challenge the heroes. By the time I was conjuring up the Fantastic Four, not only did the nature of the hero have to be different, but so did the opponent.

As I wrote in my introduction to *Bring on the Bad Guys*, "Once you've invented the hero, that's it. He's pretty much the same, issue after issue. He's predictable. And that's only natural, because we've had time to get to know him, to learn to anticipate his reactions. But each new story needs a new baddie for him to battle, and that's where the fun comes in. Our villain has to be unique, clever, inventive, and full of fiendish surprises. And we never get a chance to tire of him—if our hero knows his stuff, he won't be around long enough to bore us.

"Endowed with a group of great heroes—and we wouldn't be interested in any other kind—the main appeal of our frisky little fables must lie with the villains we concoct. What new threats can they pose to our unsuspecting protagonists? What new weapons will they soon unleash upon a dazed and defenseless world? What new powers can they bring to bear that will give our good guys a run for their dough?

"But they mustn't just be evil. They mustn't just be strong. They've also got to be unusual, exciting, provocative, and surprising. Now, how can you help but dig a gang like that?

Dracula has been used as the antagonist in stories since Bram Stoker wrote his dramatic novel. He was a recurring foe to Vampirella for years.

"You know, writing comic book stories really isn't all that much different from writing any other type of adventure saga. You create a hero for yourself, hoping that the reader will identify with him and care about him. Then you dig up a villain, find a way to motivate him, set the stage, and let them go! But, as any serious scholar of the Marvel mythos is sure to have observed, the key phrase is 'motivate him.' More stories have been ruined, more plots have been diluted, because of villains who were improperly motivated or not really motivated at all. Too many times a villain simply attacks the hero for the same reason men have given for climbing mountains—because they're there. One reason I chose the leering Loki to be the Thunder God's main antagonist was because it was possible to give him so compelling a motive for hating Thor and for continually plotting his brother's downfall. The jealousy of one prince for another! Sibling rivalry between two gods! Those are motives that anyone can accept and understand, motives worthy of ancient Greek drama, or enduring Shakespearian tragedy—or Marvel Comics!"

THE BLACK TERROR

As shown above and on the following pageg, Alex Ross's design work helps tell you something about the characters, both good and evil.

MR. FACE™

SUPPORTING CHARACTERS

Heroes and villains tend to take center stage, but they need people to speak with and interact with. That's where a good supporting cast comes in. After all, who does Superman talk to when he's lonely? He can drop by the *Daily Planet* and there's Jimmy Olsen, Perry White, and Lois Lane. Each distinctive types, but all loyal friends he can confide in.

Now, turn that on its ear.

When I was writing the Hulk, few knew he was also Robert Bruce Banner. He was being hunted by General Thunderbolt Ross, whom Banner worked with. And who did Banner love? Ross's daughter Betty. And who else loved Betty? Ross's right-hand man, Glen Talbot. So, who was Banner's only true friend? The very teen whose life he rescued at the expense of his own happiness, Rick Jones. Gets convoluted, doesn't it? But look at all the interconnections to generate drama while telling exciting stories.

As you create characters, try to figure out whom they will interact with, in addition to the hero or the villain. Could one be weak enough to be convinced by the villain to betray the hero? Will a love triangle develop or become a love trapezoid?

Your supporting cast should be varied in terms of not only gender but also of race, age, temperament, experience, and point of view. The first supporting casts were merely Greek choruses, commenting on the hero's actions, but today they are vital to making or breaking a series.

Too often, comics create a terrific hero and then forget to create equally interesting villains . . . or not enough of them. So, every time the hero is onstage, he or she seems to be fighting the same villain again and again.

A weak supporting cast also drains the series of creative spark and needs to be as well considered as your protagonist.

As much as Robert McKee uses *Casablanca* to teach the three-act

Adam Van Helsing is the love interest of Vampirella as part of her supporting cast.

structure, I urge you to examine the makeup of the most successful television series on the air for other elements. What are the group dynamics, what are the conflicts that drives the drama episode after episode? Who is the star, and who are the supporting players, and are they as interesting as the lead?

Character creation can be tremendously challenging, but when you have the right elements, it can also be wonderfully rewarding. And once you have all your players in position, you can enrich your stories with layers of story known to all as the subplot.

DIALOGUE FOR FUN AND PROFIT

I love writing dialogue and could do that all day if people left me alone. Giving people the tortured Shakespearean of Asgardians or the bluster of J. Jonah Jameson is just so much fun. Team books are a challenge since you want them to have distinctive voices that tell you something of their personality. Look at Reed Richards and Ben Grimm. Have them both tell you who won the ball game and Reed would go on and on about statistics and records while Ben would light up a stogie and say, "Aw, cripes, Stretch, just say the Bums won again."

"I might as well call your attention to the dialogue, also," I wrote in *Origins of Marvel Comics*. "While it's a far cry from Paddy Chayefsky, you may notice the definite effort that was made to have people speak as much as possible like real flesh-and-blood humans, whether they were cab drivers, policemen, garage mechanics, pilots, or whatever. While reasonably natural dialogue is so much a part of writing that I feel foolish even mentioning it, you must remember that we're talking about a medium and a time period where 'So! You wanna play, huh??' was formerly considered a meaningful and profound exclamation when uttered by a hero in the process of being pummeled by a villain or two.

"The best stories of all, whether in comic books, TV shows, movies, novels, or whatever, are the stories in which the characters seem to be real. You feel you know them, you understand them, you can relate to them. And what makes them so? Mostly it's their dialogue. The well-written character must have his own manner of speech, and the style and content of his delivery must be constant. Dickens worked at it in his novels, Herriman did it with Krazy Kat; can we do any less? No, no, a thousand times no! I was bound and determined that Doctorr. Strange would never say, 'Hocus, pocus, go to another dimension!'

"When it comes to words, I am a real cornball. I enjoy them. I relish their sound, the music made by vowels and consonants eternally

jostling each other. I can lose myself completely while putting them together, trying to string them on a delicate stand of rhythm so they have a melody all their own. So, when it came to Doctor Strange I was in seventh heaven. At last I'd have a chance to be as alliterative and schmaltzy as

I could wish. With Thor, I was influenced by Shakespeare and the Bible as I turned to, 'Whither goest thou?' and similar phrases; but with Doctor Strange there were no landmarks, no points of reference. With Doctor Strange I had the chance to make up a whole language of incantations."

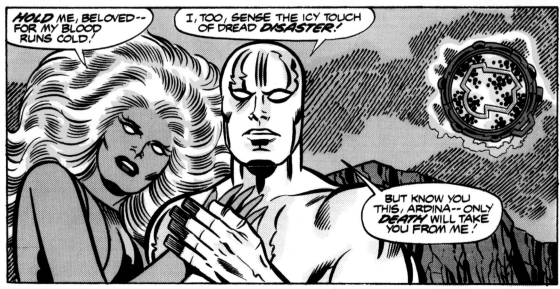

Examples of dialogue from the Silver Surfer *original graphic novel.*

Vampirella is a horror comic with a powerful story of a misunderstood vampire fighting for survival.

IT STARTS WITH AN IDEA

When I was sitting down to figure out a script, I'd just start writing. There was something appealing about being free to make up a story, and honestly, I had to work fast back then since I had many artists waiting for work and lots of pages to fill each and every month. So I'd sit there and an idea would occur to me for an opening image. I'd begin writing the script, surprising myself to see where I could take a story before the final panel. I had to keep the readers' interest from the first. The very first few panels should show the reader that something of interest is happening or is about to happen.

If I had a nickel for every time someone asked me where I get my ideas, I could have retired long ago! I'm still getting that question, and the answer is right before you. As I once wrote in "Stan's Soapbox," "The point is, ideas are no problem. Here in the Bullpen, we can't talk to each other for five minutes without coming up with a zillion new thoughts and angles. The big hang-up is getting the time to develop the ideas . . . to polish them, and refine them until we feel they'll have maximum impact—until we know they'll be an integral part of the ubiquitous Marvel Universe! Everyone has ideas—you, I, the gang in the mailroom—even our competitors, bless 'em. What really counts is what you *do* with them. We believe that almost any idea can be worthwhile, if it's presented with integrity, taste, and imagination. For, an idea is like a guitar—it doesn't mean a thing unless you know how to use it!"

Good words and ones I still believe in.

YOUR CHARACTERS

The trick sometimes is to think about your character and see what you haven't done with him or her yet. What new predicament you can place them in to see how they will react—and hopefully survive.

Each character should spur unique ideas so that the stories are tailored to their particular setting. For example, around the time I wrote that "Soapbox" entry, I was writing *Captain America*, and, being the star-spangled avenger, his stories were reflecting more about the turbulent times America was enduring in the early 1970s. He lent himself to the stories, but some of the readers were complaining that the stories and even the letter columns were getting too political. In a subsequent column, I explained my thinking:

"Even though the plots may be fantasy-filled and seemingly outrageous, we wanted to relate to the real-life problems that crop up—problems that may even parallel your own."

Let's examine the component parts of actual storytelling. After all, there's more than just knowing you need the beginning, middle, and end of the story. We have to address the setting, transitioning from scene to scene, which affects the pacing, action. A writer needs to know how to create tension through words, sounds, and silence. Then there are different kinds of pages you can call for, such as a splash or a spread. Panels can be close-ups, medium shots, or long shots.

Let the lessons begin!

Harvey Kurtzman, a dean of storytelling, once told his fellow pioneer Will Eisner, "The story starts with a paragraph that tries to determine theme and the punch ending. Hollywood would call this a 'treatment.' From there I go on to my thumbnail sketches. My first breakdown of the story is in terms of pictures, not in finished words. Once I have my pictures, then I know what the characters have to say. Then I turn to a yellow Nixon writing tablet and I start writing dialogue, with constant reference to the little thumbnail storyboards. At that point, I try to get all the words down."

But let's examine the story at its beginning. What is about? A character? A situation? What are you trying to tell the reader?

When I asked Brian Bendis, he laughed and replied, "Just yesterday, I began teaching a college course on writing the graphic novel, so I spent the last couple of months redoing all my thoughts on this. I've been rereading all the books, reformulating the concepts and giving this a great deal of consideration.

"In Robert McKee's book *Story*, he speaks of the concept of a central idea. In comics, the central idea has been established (usually by you), and it makes writers who venture out on their own work discover that they don't know how to create a central idea for a story. What's important for a writer is not to create a central idea by jamming it into the work you're doing. You need to write your work and examine your work and decide what you're really writing about.

"It's when you have to become your own worst enemy. Write forty pages, step back, put the pages away for a couple of days, then reread and rewrite. I'm fortunate that I don't recall what I wrote two days before. You can examine it not as your work but as something that you're interested in. You can examine what the ideas

are. I have many friends who are writing about themselves and don't even know it. They lose the central idea.

"For example, in my series *Powers*, the central idea is: We don't live in a world that would allow a hero. We go backwards and open as we let one of our heroes die. There's a murder. From that murder investigation, we peel apart a segment of the *Powers* society that would allow that to happen. I've spent the last ten years examining that.

"I'll tell you a story. Years ago, my wife had an allergic reaction to something and her brain tissue swelled. She slipped into a coma, but I want to stress, she's fine now. But at the time, the doctor came out with the news that she was in coma and could be brain dead. There I am, holding a six-month-old baby, not knowing what to do. Looking back, I wrote something like one hundred coma scenes in Marvel comics, some I had no recollection I'd written until I saw them drawn and lettered. These were moments like the Kingpin's wife in a coma, and Luke Cage. Thank God, I had an outlet for these thoughts.

"Another thing I want to stress, and we do it now in event comics because of their strong structure, is having the inciting incident. How the story starts, when that happens is very important. You could spend the whole first comic book setting up that inciting incident. Setting up the incident and plotting the elements that let you know what your story is about is very important. When is enough information given to the reader to have maximum effect? You have to make certain you're not boring people. Do this too quickly, it doesn't mean anything. The right place, à la *Civil War*, you have yourself a homerun."

CAPTAIN AMERICA 6'2" TALL, 220 POUNDS, STALWART, HEROIC

A character's design like Captain America lends himself to story ideas.

THE THREE-ACT STRUCTURE

These days, theater, movies, books, and, yes, comic books tend to rely on the three-act structure to tell a story. Robert McKee is the prophet of the structure, having taught it for years, and has written a book on the subject. In his course, he uses the film *Casablanca* as an example of the process.

ACT ONE

For an example of a three-act structure, we are going to look at the script and corresponding interior art from the *Eva* one-shot. Page three of *Eva* (right) is an example of Act One of the story.

The structure calls for a setup or, as Brian Bendis put it, the inciting incident. This introduces the reader to the situation, the characters, and other vital details, such as time of day or location. The movie *High Noon*, for example, had a simple setup: A small Western town awaits the arrival of a train, and then two gunfighters will meet in the square and duel—at high noon. In Brian's *Civil War*, it was the New Warriors fighting Nitro with the villain setting off an explosion that blew up a good-sized portion of Stamford, Connecticut. This became an examination of whether superheroes need to be government regulated.

An aside before we go onward: Brian's story was topical, and that was not always the case in comics. All too rarely did our stories touch on the news of the day, the issues that preoccupied our peers. That changed for the better in the 1960s, and some people had difficulty adjusting to that realism. Here's what I wrote about it in my introduction to *Sons of Origins*: "In fact, although it was written quite a few years ago, it points to a philosophical problem which seems to be facing our own nation today, namely, the problem of whether or not those who have great strength should interfere in the affairs of those who are weaker, no matter what their motives may be. Personally, I've always enjoyed stories

PAGE THREE (Seven panels)

Panel 1. We see a large, gothic Monastery sitting on a high ridge in Transylvania. It is late at night and a massive storm is brewing. There is a deep canyon directly behind the monastery. If we see an aerial view, please show a raging river at the bottom of the canyon.

1) CAP: THE <u>SCIENTIST</u> AND THE <u>WARRIOR PRINCE</u> BOTH MADE THEIR PILGRIMAGE TO THE MONASTERY WHERE THE STONE WAS BEING HELD…

2) CAP: …AND THERE, THEY WOULD FIND THEMSELVES AT THE <u>CROSSROADS</u> OF <u>FATE</u> AND <u>HAPPENSTANCE</u>. THIS INTERSECTION WOULD LEAD MORE THAN <u>ONE</u> LIFE ON A NEW JOURNEY BEFORE THE NIGHT'S END.

Panel 2. We're inside the monastery now. Dracula has the stone in his hand, holding it victoriously as we see its smashed protective case and the dead bodies of four monks on the floor around it.

3) CAP: DRACULA ARRIVED <u>FIRST</u>, CLAIMING MANY INNOCENT LIVES IN THE PROCESS OF SEIZING THE STONE.

Panel 3. Frankenstein and his monster appear in a doorway. Frankenstein directs his monster to take the stone from Dracula, who is standing in the foreground.

4) CAP: FRANKENSTEIN WAS NOT FAR BEHIND, HOWEVER, AND HE DID <u>NOT</u> COME <u>ALONE</u>. WITH A SOULLESS CREATION AT HAND TO DO HIS BIDDING, VICTOR HAD NO REASON TO FEAR THE PRINCE OF DARKNESS.

Panel 4. We're outside now, as Dracula fights the Monster, tearing at his skin with one clawed hand. The Monster howls in pain, but he still pummels Dracula in the face with his massive fist. Dracula clutches the stone in his other hand.

5) CAP: THE <u>BATTLE</u> THAT ERUPTED WOULD FOREVER BESMIRCH THIS HUMBLE <u>HOUSE</u> OF <u>GOD</u> AND ITS HOLY GROUNDS.

that can be approached on two levels, both as pure entertainment and as challenging, thought-provoking appetizers for intellectual nourishment. To me, a story that doesn't give you something to think about, that doesn't stimulate you, or anger you, or make you ask questions you might never have thought of asking before—to me, such a story is only half a story. And, whenever possible, I like to give a reader his money's worth.

"Of course, in writing the typical Marvel type of tale, it's almost impossible not to become involved in some extraneous philosophical or moralistic side issue. After all, the battle between a hero and a villain (which is what virtually all our stories get down to) is basically a conflict between a good guy and a bad buy, or between good and evil. Whenever there's a confrontation between two elements, it's almost impossible not to explore the moral ramifications of the actions that unfold. Give any writer a chance to depict the struggle between good and evil, or right and wrong, and how can he help but state the case for one against the other, no matter how subtly or subliminally he may do so?"

Enough about me, let's get back to the lesson.

The inciting incident, in the case of *Civil War*, led to the series' theme, but the incident can also be a tangible object, which Alfred Hitchcock dubbed the MacGuffin. Simply put, the MacGuffin is the object that motivates all the major action in a story. In the director's classic *North by Northwest*, the MacGuffin is some microfilm possessed by a spy, but the villain, in a case of mistaken identity, thinks an innocent man has the microfilm. What's on the film? Doesn't matter. The point is James Mason and Martin Landau are doing everything they can to obtain it from Cary Grant, and that propels the story.

What's the MacGuffin in your tale?

The breakdown of pictures helps in defining characters' identities.

ACT TWO

Once the setup is established, you introduce the confrontation. What is the obstacle to complicate the setup? The first act needs to lead seamlessly to the second act, usually using a turning point incident—meaning the lives of the participants will be forever altered by this event. The train has arrived, and the anticipated gunfighter steps off. That leads to the confrontation, which will have repercussions for everyone in that town. Will law prevail, or will injustice rule the day? Then you focus on your protagonist and antagonist and see how this confrontation will change them. Simply put, one will live and one will die, but will the lawman have the nerve to pull the trigger? Will the outlaw play by the rules?

The nature of the conflict actually drives the story more than the characters inhabiting the titanic tale. Whether it's Spidey versus Doc Ock or Superman versus Lex Luthor, the hero has to have a conflict to overcome. While seeing the hero confront a popular villain is a surefire attention grabber, you might be better off pitting your hero against something he's never handled before.

Pick a hero. What are your favorite stories involving the hero? What have you never seen the hero confront? Aha! Now you just might have a new story to tell. Now, I'm not just saying Spidey should fight the Silver Samurai for variety. I'm saying, how does the Webslinger confront a natural disaster? Or a lost, injured little girl who needs medical attention but is deathly afraid of Spider-Man after hearing all the nasty things J. Jonah Jameson said about him. The conflict in the latter is Spidey confronting the girl's fears, something a punch won't solve.

The second act allows for characterization as well as complications such as someone trying to talk

PAGE SIX (Six panels)

Panel 1. We cut to a gypsy carnival in the village. There are many people there, performing tricks and making crafts for the people of the village. Eva, dressed in a simple brown dress (think Princess Leia on Endor, but nicer) is walking with her Guardian Monk (the one from AOD) toward a tent. A midget with a lute is bidding her to enter. The monk isn't so excited about it, but Eva smiles and reassures him.

1) CAP: PERHAPS IT WAS THE INFLUENCE OF A JUST AND MIRACULOUS <u>GOD</u>, BUT <u>EVA</u> AGED ONLY <u>TWENTY-FIVE YEARS</u> WHILE THE <u>CALENDARS</u> MARKED <u>TWICE</u> THAT. DURING THAT TIME, EVA <u>TRAINED</u> WITH THE MONKS, USING HER ABILITY TO <u>SENSE</u> INNATE <u>EVIL</u> TO WAGE <u>WAR</u> AGAINST THOSE WHO WOULD TREAD <u>OUTSIDE</u> THE <u>LIGHT</u>.

2) CAP: THE MONKS <u>NEVER</u> <u>REVEALED</u> HER TRUE <u>LINEAGE</u>. THEY HAD HOPED TO KEEP THE SECRET <u>FOREVER</u>…

3) MIDGET: <u>FORTUNES REVEALED HERE, MILADY</u>! LET THE ALL-SEEING EYE OF <u>AGATHA</u> TELL YOUR DESTINY!

4) MONK: ABSOLUTELY NOT, <u>EVA</u>.

5) EVA: I'LL BE RIGHT BACK. STOP <u>WORRYING</u> SO MUCH!

Panel 2. Eva enters to find an old gypsy fortune teller sitting on the tent floor with hand-made tarot cards on a simple wooden table and a lone candle lighting the scene. The woman smiles a near-toothless grin of amazement as she looks up to see Eva. It's like the queen has arrived.

6) AGATHA: YES, YES…COME IN AND SIT. OPEN YOUR <u>MIND</u>.

7) EVA: YOU CAN READ MY <u>CARDS</u>?

Panel 3. Eva sits down, smiling but unsure. The gypsy woman waves her hands and insists she doesn't need the cards to tell THIS future.

8) AGATHA: OH, I DON'T <u>NEED</u> CARDS TO TELL <u>YOUR</u> FUTURE! <u>YOUR DESTINY</u> IS AS CLEAR AS THE SUN IN THE CLOUDLESS SKY…

The page above represents an example of Act Two from the Eva one-shot.

the outlaw out of fighting or talk the lawman into doing his duty. Could the outlaw have allies hidden on the rooftops to ensure his own victory? Complications arise out of the situation and characters involved as we move toward the inevitable final act.

ACT THREE

The third act is the resolution, which comes complete with a climax and conclusion. Here, everything started, your main plot, and your subplots have to be wrapped up. The gunfight occurs and the aftermath and the changes to the town are witnessed. Just as the first act had a moment leading to the second act, the same thing occurs here, which in our example would be the two men facing off, about to draw. As they take their places, we're transitioning from second to third act. All the questions your reader has must be answered by story's end.

How much of your story should be devoted to each segment? Well, that depends on the demands of the story, but the rule of thumb says one-quarter is reserved for Act One, one-quarter for Act Three, and the remaining half goes to the second act.

Now, a typical comic is twenty-two pages long, so that would mean you devote about five pages to Act One, eleven pages to Act Two, and six pages to Act Three, give or take a panel. These days, though, many comic book stories are continued, running four to six issues in length. In that case, you need to figure out how the three-act structure can apply to the individual issue and the story arc as a whole. It's trickier but a necessity for a successful tale.

THREE ACTS: A TIMELESS STRUCTURE

You may think that the classic structure, as taught by many, from McKee to your English teacher, can't possibly still be employed today. Alas, you'd be wrong, as I will demonstrate by breaking down a more contemporary film in the same way. Let's use 2009's reimagining of a classic for modern-day audiences. That's right, I'm talking

about *Sherlock Holmes*, arguably a nineteenth-century hero still popular and vital today (and portrayed by Robert Downey Jr., who also wonderfully essayed the role of Tony Stark in the two *Iron Man* movies, based on a little something I created once upon a time).

Act One would be the entire opening sequences as we meet Holmes and Watson, see them save the girl from Lord Blackwell, and see how Holmes observes everything and reacts accordingly. We're treated to a glimpse of his home life and learn something about this particular moment as Watson prepares to move out of 221B Baker Street as he readies to marry.

The inciting incident, as we transition to Act Two, would be word reaching the duo that Blackwell has

apparently risen from the dead and is once more at large.

Act Two would cover the investigation, complicated by Irene Adler's arrival once more in Holmes's life, and the subsequent warrant for the great detective's arrest.

The climax comes as Holmes, Watson, and Adler work together to prevent Blackwell from poisoning the members of parliament and taking control of the country. The transitional moment here would be when Adler winds up atop the unfinished Tower Bridge, needing Holmes to save the day.

Act Three then would tidy everything up once Holmes emerged victorious (of course) and we resolve the plot threads and tidy things up before the end credits.

PAGE SEVENTEEN (Artist's choice of panels)

I will dialogue this once we see the art. Eva enters the dimly-lit warehouse to find at least two dozen werewolves in various states of transformation, some of them injured and crazed. What follows should be a colossal battle in which Eva destroys these creatures, but takes some damage herself. The last panel of page 18 should find her standing amidst the fallen beasts, looking around for their leader.

Panel 1.

1) WOLF 1:	*snarrrlll*
2) WOLF 1:	<u>WELCOME</u>, PRETTY.
3) WOLF 2:	WE'LL ENJOY <u>STRIPPING</u> YOUR <u>BONES</u> WITH OUR <u>TEETH</u>.
4) EVA:	MAKE YOUR <u>MOVE</u>, BEASTS…

Panel 2.

5) SFX:	SHUUUK
6) SFX:	SHKRUUUSSSK
7) EVA:	…AND DIE <u>HUNGRY</u>.
8) SFX:	SHRIIIK

Panel 3.

9) EVA:	YOU'LL NEVER KEEP <u>ME</u> FROM <u>HIM</u>…
10) SFX:	SHOOMP
11) SFX:	KRIISK

Panel 4.

12) WOLF:	AAAHHWWOOO
13) SFX:	SHRUUUK

Panel 5.

Example of the third act from the Eva one-shot.

SETTING

The setting is vital. As I've said earlier (you're paying attention, right?), I set so many of my stories in New York City because I know it well and don't have to think too hard about it. But setting is important since it can influence how your characters think and interact with one another. Okay, let's say we're in New York. Are we in Manhattan or one of the other boroughs? Which part of Manhattan: Midtown, Alphabet City, Central Park?

Setting informs the reader not only of the location of the story, but the time as well. Nineteenth-century New York City looked a lot different than it does today! Also, when the story takes place—morning, afternoon, middle of the night (the best time for crime stories)—can say something about the story.

All too often writers forget to take into account the weather and time of year. A story might work better in summer than in winter. Setting a story in a particular season can also be a comment on the characters and the story. A romance that is coming to an end might work best as fall turns to winter with gray skies, leaves falling to the ground, and people bundled up in warm coats. Rain during funeral scenes is a cliché to show how somber the emotions are. A bright, sunny day, on the other hand, provides a stark contrast to the scene.

One look at the clothing, architecture, and mode of transportation tells you all you need to know about this scene from Sherlock Holmes #1.

TRANSITIONS

Now, we have a plot, a three-act structure, and a setting. You need to get us from point to point, and that means transitioning from scene to scene. It used to be a simple caption reading, "Meanwhile, in a hidden laboratory beneath the unsuspecting city . . ." and you go to the next scene. These days, film and television techniques are borrowed to take us from point A to point B, and this can be done cleverly.

Let's say your hero and villain are duking it out on the Golden Gate Bridge. The fight is out in the open and is being covered by a television news crew. We can go from the fight to a television screen image of the reporter on the scene with the fight in the background, and then the next panel pulls back and we see the hero's boss watching the news report from his office. TA DA! We have now gone from San Francisco to New York in three panels.

Many writers will use dialogue and captions to carry us from scene to scene, so, for instance, someone may be saying, "I will never, ever be late again!" and then the next panel is our hero's mother sitting at the table, dinner cooling, and her thinking, "He's late again."

You need a way to move from scene to scene that continues the mood or feel and absolutely advances the story. It also allows you to control the pace of the story. Rather than have an eleven-page second-act fight scene, you can break it up and cut to

your hero's supporting cast reacting to the battle or, ignorant of the battle, dealing with some other issue that lays the groundwork for the next story. That's sub-plotting, which we'll get to soon enough.

Another thing to keep in mind is when to begin and end scenes. The rule of thumb for screenwriting—and it applies here—is to begin a scene as close to the action as humanly possibly and get out of the scene just as quickly.

Imagine, if you will, Dr. Donald Blake is at his office and a patient needs to be given a grim diagnosis that will prompt an ethical debate, putting him and his nurse, Jane Foster, at odds. Do you open with Blake arriving at work, reading the lab results, putting on his lab coat, walking down the hall to the exam room, and then talking to the patient? Or do you open the scene as Blake enters the room, lab report in hand, and the nervous patient sitting there?

Now, imagine the diagnosis being given, treatment options discussed,

and the ethical disagreement begins. The argument escalates until Jane storms out of the exam room and we're left with Blake and the patient exchanging shocked glances. Would it not be stronger to end with her slamming the door behind her?

An even shorter way to convey action could be this:

Rather than going from Bruce Wayne seeing the Bat-Signal, walking down to the Batcave, putting on the costume, grabbing the keys, firing up the Batmobile, adjusting the mirrors, and heading through the tunnel toward Gotham City, you can go from Bruce seeing the signal in the night sky to having the Batmobile roaring out of the cave in the next panel.

One final thought about transitions: Think of the final panel on any page to be a mini-cliffhanger, compelling your reader to turn the page. It's also a good idea to transition scenes from one page to the next rather than in the middle of a page.

ART DIRECTIONS

Now, while you're constructing your transitions, you also need to start figuring out how to direct your artist. By now you know about the splash page and the double-page spread, but when do you use them?

It used to be that comics would open with a splash panel, something eye-catching to launch the story. As story page counts grew, the splash panel became a page, and it gave us a way to grab the reader by the throat and compel him to actually buy the book to see what happens on page 2. It gave us room for the title, credits, and some captions to recap where we were last month.

Today, writers more cleverly work in the splash page to have more impact. It could be, you open with a page or two of setup and you transition to the splash panel, using it to kick-start your action or as an exclamation point. Splash pages later in the story, or even as the final page, can be used to heighten tension or introduce a new player or complication.

The spread is either a splash page on steroids or a two-page opportunity for your artist to play with the panel arrangements. If the spread is a single image, it needs to have a reason for existing. Why waste two pages on a single image unless that carried

tremendous impact and could transition us from the second to the third act?

I was always conservative with my pages, wanting to make them all count. One of the earliest uses of a two-page spread in my writing experience was from *Captain America* #113. Cap had been declared dead, killed by Hydra, and the Avengers, along with Nick Fury, were captured during his funeral. As the Hydra agents began to bury the slumbering heroes, they hear a sound. You turn the page and there is a spread of Captain America, not dead after all, launching himself at the enemy from an airborne motorcycle. Masterfully drawn by Jim Steranko, it contained power and carried with it tremendous impact and was an emotional rallying point. I still tear up when I see the story.

Roy Thomas, no slouch as a writer or an editor, reminded me, "In the 'old days,' I rarely called for a specific shot like a close-up or long shot, because our artists knew their business and how to vary the panel layouts . . . but

even in that method, a writer sometimes needed to make sure the artist understood what to emphasize. Usually the pacing was left to the artist, but even so, the writer's synopsis had to make it clear what was important. Some artists would tend to use up too much available space playing up the part of the story that most interested them . . . and, not having paced themselves, they would run out of room at the end, so that a new interim ending had to be hurriedly dreamed up. Not that that didn't sometimes lead to an interesting situation, as well . . . just not the one the writer originally intended. I have writer friends who objected when I castigated a particular artist (in the 90s) for deviating from the story . . . but it was a story of only eight or ten pages, and in such tales the pacing is often especially important, since the whole impact of the story may rest on the ending . . . and the ending may not work if there is deviation in the middle."

CLOSE-UPS, MEDIUM SHOTS, AND LONG SHOTS

Since Roy brought it up, let me elaborate on the use of close-ups, medium shots, and long shots.

A close-up is great for conveying emotion, or for when the character has much to say. A good close-up can also be of a hand reaching for an object, a specific action, or a still object that requires the reader's attention.

A medium shot is good to establish the characters in relation to one another in a setting. It leaves room for dialogue, body language, and some background.

Here's a good dramatic close-up, taken from Project Superpowers #1, Chapter 1.

Now, here's a medium shot. Devil is still predominant in the panel, but you see a good amount of background detail; from The Death-Defying Devil #3.

The long shot gives you a chance to show an establishing shot of the setting or gives you a sense of scope, such as one man left standing on a battlefield of bodies.

As writer, in a full script, you call for these shots and you need to mix and match, serving the needs of the story. You can't do all close-ups or all long shots. Similarly, the number of panels per page should be varied to give the artist and reader variety, and the exact number of panels per page can be used as a storytelling device.

Originally, comics were four tiers—eight panels or so per page.

As the size of comics got trimmed down to what we know today, the four tiers became three. Six-panel pages became the norm for many publishers. By the 1960s, a new age was here and artists loosened up and played more with page designs. Jack Kirby certainly led the way here, but he was accompanied by the likes of John Buscema, Gene Colan, Gil Kane, and Jim Steranko.

The acclaimed series *Watchmen* actually worked with a rigid nine-panel grid per page for all twelve issues. Any deviation from that was attention-getting and helped show where the impact was.

Similarly, the *Superman* line of comics did a clever bit in 1992 when they killed the Man of Tomorrow. The issues leading up to his death told the story in a decreasing number of panels per page, so *Adventures of Superman* had four-panel pages, *Action Comics* had three-panel pages, *Man of Steel* had two-panel pages, and, finally, *Superman* had one-panel pages, so there was a countdown to the climax, the blow that killed the hero. It's subtle at first and packs an emotional wallop as the tension is heightened. Go to the collection and see for yourself.

This long shot from Project Superpowers #4, Chapter 2 *allows the reader a sense of place.*

PUTTING IT ALL TOGETHER

"Storytelling in comics is pretty much the same as it is in all other mediums: Your job is to tell an intriguing story with great characters," Marv Wolfman told me. "First and foremost, you tell your story through structure: how it's paced. How the action and emotions rise and fall. How you surprise your readers and lead them down one path only to pull the rug out from under them and take them a different way. Where comics is different from other mediums is the combination of writing and art; how you tell a completely silent sequence. How you break it down to slow down the action or to speed it up. Use the medium to tell your story."

The key is making it clear to your reader what is happening and why. For those of us who ushered in the Marvel Age, we took decades of experience and made it work for a new generation of readers. In turn, that generation took the lessons and applied them when they wound up in the business. Two artists tell of the emphasis placed on storytelling clarity when reader-turned-writer-turned-editor-in-chief Jim Shooter was in charge.

Bryan Hitch told interviewer Mark Salisbury, "The Marvel storytelling approach, which I think you can largely attribute to [former editor-in-chief] Jim Shooter, is an excellent starting point. Because it is restrictive, it teaches you some simple basics about how people read a comic and the importance of establishing who is doing what and where they're doing it. That's important in any visual medium; you need to get all that general information across as easily and straightforwardly as possible."

John Romita Jr., who grew up watching his dad draw *Spider-Man* and ably followed in his footsteps, added, "Jim Shooter's main thrust as editor-in-chief was to make sure that, first and foremost, readers had a great story in front of them at all times. He felt that Marvel's strength was in the storytelling, and he wanted writers and artists to get as much story into any given issue as possible. He

figured that nine or ten panels on a page should be the norm, as opposed to five or six, and he always stressed that the essence of good storytelling was in the establishing. He had it almost down to a formula; every two or three pages he wanted to see a wide shot of where you were, so that the reader never has to stop and wonder. That's the strength of the company, that's what people will enjoy reading, and it still holds. Along the way, some people have come in and bastardized that basic work ethic, but eventually it all comes back to story and storytelling. People aren't necessarily just looking at the pictures—which are, when it comes right down to it, just an addendum to the story—they want to be able to get to grips with the story itself. A lot of this came from Stan Lee, Jack Kirby, John Buscema, and my father, but Jim was even more committed. He was, 'Be specific, be strict,' and at the time he was almost standing over me and telling me this. I guess it was a little bit 'Big Brother,' but it certainly made a lasting impression on me."

Artist Dan Jurgens began his work at DC Comics in the 1980s and has since become a writer/artist with credits at DC and Marvel. Like Jerry Ordway, he's written for himself and for others and, given his artistic origins, has a good point of view on the current state and continuing importance of storytelling.

"The thing I harp on about more than anything else is my assertion that eighty percent of writers in the business don't understand comic book storytelling," he told Mark Salisbury. "They think they're writing movies or television. This applies especially to the full-script guys. I find very few of them really have the ability to address the needs of the medium, especially in terms of structuring proper pages, creating impact through the visuals, and building up tension and action in a story. It's very rare. I have drawn a couple of Archie Goodwin scripts, and Archie was the master, because although it was just the written word on the page, they were tremendously powerful in terms of pacing and structure. He understood the medium; he knew we were doing comic books. He didn't think we're doing a film, on paper, and there's a big difference.

"It comes down to recognizing the differences in storytelling between comics and, say, movies, and identifying the different ways in which you build tension. Consider the car chase, one of the hallmarks of the action movie, and try translating that to the comic page. It's very difficult to do a visually interesting car chase on paper. There are exceptions, some talented artists could pull it off, but it fails ninety-nine times out of a hundred. Why? Because a car chase drawn out on paper is almost always incredibly boring. Cars are just cars;

Robert Kanigher, in his *How to Make Money Writing for Comics Magazines*, written in 1943, outlined the formula in use at the time and that remained pretty much the same right into the early 1960s. For a nostalgic but somewhat useful look, check out the formula, the Comics Formula, that we all used back then:

1. The hero
2. With a female companion drawn along pretty lines
3. Frequently aided by a juvenile assistant
4. In a desperate struggle
5. In which life and the heroine's honor
6. And a national or global prize is at stake
7. Against the diabolical plotting of a master villain
8. And his gang
9. Against whom the hero has to employ all his super-talents of tossing mountains around, juggling battleships, defying gravity and common sense
10. In a script employing, in the order of their importance:
 a. Visualization (pictures)
 b. Dialogue
 c. Caption

there's no way to show emotion, and there's little change from panel to panel. That's something comic book writers often fail to grasp."

Let me interrupt Dan for a moment to concur with his point. Shortly after the film *Bullit* came out, Gene Colan drew *Captain America* #116 and tried to include a dramatic, thrilling car chase. At the time, I thought it wasted lots of pages without getting the point across, much as Dan mentioned above. I berated Gene for taking such a liberty, but in looking back, I can see he was trying something, and while it didn't work, I have to credit him for at least experimenting with the form.

And now, back to Dan.

TIMING AND TENSION

"Very few writers play with the concept of time on the page, which can be used to build dramatic tension. If you're reading a twenty-two-page comic and you've got an average of five panels on a page, you have a very steady pacing. The trick is to be able to speed up time or slow time down, something Frank Miller did so well in *Batman: The Dark Knight Returns*. If you break the action down into numerous small panels you get the effect of slow motion on the page. We see the gun, we see the necklace coming off Bruce Wayne's mother's neck, we see the pearls from the necklace dropping on to the ground, rolling away. Time slows down and almost stops, building tension. I don't see that technique used very often, and when I do it's very rarely structured by the writer. In movies, when they want to build tension the music gets louder, the action gets bigger, the shots come faster, and everything moves more quickly, and many writers try and duplicate that. But on a comic book page, the opposite needs to happen.

"Another way to build tension is to structure a page so you have twelve panels on it: three tiers of four. You start out with the character's face very small in panel one, and you zoom in slowly until in the last panel you just have a tightly cropped close-up. This slow zoom effect can often be more dramatic than one full-page splash. Another thing that bothers me is where I see writers trying to cram too much into a panel. They'll say, 'Page one, panel one: Superman swings his fist and punches Brainiac on the jaw, knocking him out through the window and he falls to the ground and hits the street.' That's eight panels. Or at least four. Not one."

Each character can be performing only one action in a panel. Your hero can be changing into his costume, or answering the phone, or taking a shower, but you can't have the artist try and do all three actions in a single panel.

Choreographing your scenes means never forgetting where your characters are so as you cut back and forth; you know where they were, where they are now, and where you need them to be next.

Let me wrap this chapter up by talking about flashbacks. It used to be, we used flashbacks to explain things that happened in the past, often merely to explain how our hero or (more often) our villain got out of the last predicament we left them in. Today, flashbacks are a marvelous dramatic device to enhance what we know about our characters. Television series, such as *Lost*, have elevated flashbacks into a new art form and have inspired many imitators.

Being a visual medium, if you intend on using a flashback, you need to work with your artist to key your reader in to the fact that you're flashing back to something in the past. *Lost* did transitions with an audio cue, so here, you need a visual cue. This can be achieved with page design, panel borders (scalloped or perhaps none), and color.

There has to be a compelling reason to use a flashback since it interrupts the narrative flow. Don't just use it for what's become known as the "info dump," with a lengthy explanation. That will stop your momentum dead in its tracks and possibly put your reader to sleep.

Everything on the page has to be there for a reason, and you, the writer, have to justify the choices you make in composing your tale.

Naturally, there are any number of working methods that fall between the two options referred to above— some writers do a rough page breakdown and figure out the panel structure as they write, for instance. It's the same old question of outlining vs. not outlining, with the one added element that you have an exact page length you have to meet, not a rough word count.

In 1988, Kurt Busiek offered the following advice to incoming writers, and he is letting me share it with you here:

Asking how much story goes into one single comics page is a lot like asking how long a chapter should be. The correct answer is "However much works," and that's no help at all.

There are two major factors determining what you can fit into a page. The first is that there's only so much room on the page. No matter how much story information you cram into each panel, there are physical limits to how much you can get on a single page. The second is the more aesthetically determined matter of how to pace the story.

As a general rule of thumb, you can figure that the average comic book page has five or six panels on it. Naturally, you can fit more panels on a page if they can be smaller than average and fewer if they have to be larger than average.

Some examples:

- A tight shot of something simple can usually be smaller than normal: a shot of someone's head with no important background, a hand opening a door, etc.
- A complicated panel or a panel that needs to carry a lot of information usually has to be larger than normal: an establishing shot of a location, a panel with three or more characters that have to be shown clearly, a shot of two armies engaged in combat, etc.

Those are the purely physical factors. What you can fit on a page is also affected by questions of pacing and what kind of effect you want to have on the reader. For example, the bigger a panel is, the more important it seems. If the "hand opening the door" panel mentioned above, for example, is a dramatic and important moment in the story, making the panel bigger will increase its emotional effect on the audience. Similarly, a simple headshot of a character talking doesn't need to be all that big, but if the character in question is shouting out some vital and telling piece of information that shifts the plot movement of the story in an entirely different direction, well, maybe it should be bigger. A full-page panel carries about as much impact as is possible, but even a one-third- to one-half-page panel will have a lot more impact than other, smaller panels on the page.

Along those lines, the size of the panel indicates to the reader how much time is passing in the story. Generally speaking, the smaller a panel is, the "faster" it happens, much the way a short, blunt paragraph "moves" faster than a long paragraph full of description and detail.

Some writers like to construct each page so that it works as a unit, so that the structure of the individual page is as important as that page's contribution to the structure of the story as a whole. This isn't necessary, but it does carry some benefits—most notably that it gives the artist, who of necessity has to construct each page as a separate structure, some organizational hook to build the page around visually. It also allows the writer to concentrate on smaller pieces of structure at any one time, just as structuring a novel a chapter at a time allows a writer to keep from being overwhelmed by the major structure of the novel as a whole while he's working on line-by-line details. However, there's no need to feel that you have to think about the structure of each individual page if that's going to make writing the script more difficult.

All the above said, there are two basic ways to break a plot down into pages and panels so it can be scripted:

- You can break down the story so that you have a full page-by-page, panel-by-panel outline before you start scripting. The advantage of this is that you know everything's going to fit from the moment you start the actual scripting. The disadvantage is that you get locked in, and if along the way you discover a way to handle a scene better that takes up more (or less) space, you're going to have to rework the balance of the script to fit it in.
- You can go ahead and start scripting without an outline, breaking down pages and panels as you go and keeping a general eye on how much space you're using (for instance, if you reach page 6 in a twelve-page script, you'd better be about halfway done; if not, you'll have to speed things up or slow them down to finish the story on page 12). The benefit of this is that you've got the looseness to take advantage of any structure ideas you have while writing. The disadvantage is that you may run out of space before you run out of story and have to go back and rewrite to fix it.

SPECIAL DOUBLE-SIZED ISSUE!

The mysterious identity of the Hobgoblin is one of Marvel's greatest subplots.

THE IMPORTANCE OF SUBPLOT

When comics evolved beyond short stories to full-length extravaganzas, it first meant more room for the fighting. But once comics began to become serialized, it meant we borrowed the subplot from fiction and radio (and later television) soap operas. The subplot allowed us to introduce secondary and tertiary stories that would percolate in the background and serve as ticking bombs; readers would wait breathlessly to see what would happen next.

Subplots allow a writer to enrich his character's world and show how his actions or inaction might affect those around him. This in turn allows us to deepen the characterization of our supporting cast and even our foes as they scheme before launching their latest attack against the hero.

Honestly, it really wasn't until the 1960s that companies used subplots in a significant way. We did it, DC did it, and in time most everyone was doing it with their recurring features.

Marv Wolfman said to me, "Comics is generally a continuing medium; the characters will appear month in and month out, so you want to intrigue readers with fleshed-out characters who seem to live and breathe. You do it through subplots. Where a character might be concerned with the main problem, they may also have a second problem, or a third or fourth one that is taking them away from their primary concern. Other characters have subplots as well; smaller stories that weigh on their mind as they do in real life. Subplots can take a two-dimensional character and make them three-dimensional. They can also add further intrigue to a story."

His longtime partner in crime, Len Wein, often tells of when he was writing *Luke Cage*. In one story, he cut away to a mysterious package being delivered. For several issues, the package sat there as people noticed it but everyone was too busy to actually open it.

Now, Len admits, he added the package since he wanted a new

subplot, but he actually was going on instinct. He had no idea who sent it or what was in it until he felt the teasing was done and it was time to bring the package to the forefront.

There are other writers these days who carefully plot out their series for months on end, figuring out where their characters are and which subplot will be used and when it moves from being the C story to the B story until finally it becomes the A story. It's all a matter of rhythm and timing.

Paul Levitz is famous for his carefully structured approach to plotting out the *Legion of Super-Heroes*, one of DC's first series to use subplots shortly after it was introduced in 1958. Paul has charts worked out for about a year out that show the plots, subplots, and key turning points in the lives of the futuristic teen heroes. Similarly, Mike Carlin devised his own charting system when the four Superman titles essentially carried the same story week to week in what he dubbed "megafiction."

Now both DC and Marvel bring their writers together with regularity to chart out the future of the characters and their shared universe. Such planning and careful seeding of clues and subplots allows projects such as *Secret Invasion* or *Blackest Night* to have the dramatic impact they do. It also provides a template for all the other writers and editors to follow when tying in with such major events.

Makes my head hurt to think about such meticulous planning. I've always been more of an instinctive writer.

Elsewhere . . .

I've never talked or theorized much relating to subplots. Roy Thomas reminded me, "Often, in fact, you'd start a thread and forget about it completely . . . like the Behemoth. I had to remind you about him in a Sub-Mariner story, or that single thought balloon wherein he had Professor X thinking about his love for Jean Grey, which was never again mentioned." Yeah, I am chastened at the memory of ending *Tales to Astonish* #80 with a promise to resolve the Behemoth's threat but totally forgetting to do so when I plotted the next issue, and my artist didn't remind me. When Roy brought it up, I hastily returned to the dangling thread afterward.

But hey, we were all feeling our way through this newfangled concept of subplots back then, so you'll have to forgive me.

As my artists began contributing more and more to the plotting, they picked up on things we did and carried them through to their logical conclusions. When Steve Ditko and I saved Aunt May's life with a blood transfusion from Peter Parker in *Amazing Spider-Man* #10, I never stopped to think what it meant for May to suddenly receive Peter's radioactive blood. Steve, though, did think about it and two years later had a storyline going where it made her deathly ill. That in turn led to the classic three-parter that included that terrific splash page of Spidey lifting the heavy machinery rather than give in to the aches and pains. That was the climax, the transitional moment from

DEMOGORGON. PURSAN. ZABULON. ASMODEUS. MOLOCH. VALEFAR. NUBERUS. SEVEN NAMES FOR SEVEN DEMONS. KNOWN TO VAMPIRELLA FROM THE STRANGE BOOK SHE WAS READING BEFORE DRIFTING INTO SLEEP, THEY NOW ECHO IN HER MIND IN ACCOMPANIMENT WITH THE MENACING, HALF-SEEN SHAPES MOVING THROUGH HER DREAMS...

AND GRIPPED BY NIGHTMARE MENACE, THE GIRL FROM THE DISTANT, DOOMED PLANET OF DRAKULON IS LULLED TO DANGER MORE IMMEDIATE, AND, FOR NOW, MORE REAL...

THE SUN FEELS WARM AND BRIGHT ON MY FACE, ADAM. IT'S LATE. BY NOW SHE MUST BE DEEPLY ASLEEP...

...WE CAN'T WAIT ANY LONGER!

I-I KNOW, DAD, BUT... IN THE PAST I'VE NEVER DOUBTED THAT WE, LIKE VAN HELSINGS BEFORE US, WERE *RIGHT* IN WHAT WE'RE DOING. YET SINCE WE'VE BEEN TRACKING THIS GIRL...

CALL IT A *FEELING*, MAYBE I'VE INHERITED A LITTLE OF YOUR *PSYCHIC POWER*, BUT SHE DOESN'T SEEM LIKE THE *OTHERS!* FOR THE FIRST TIME, I FEEL LIKE A...A *MURDERER!*

EVEN THOUGH WE *KNOW* SHE PREYED ON YOUR OWN UNCLE, MY *BROTHER*, ADAM? FED ON HIS LIFEBLOOD LIKE EVERY OTHER CREATURE OF THE NIGHT WE'VE HUNTED?

I KNOW THE DEMANDS I MAKE ON YOU AREN'T EASY, SON. BUT HAVE YOU FORGOTTEN THE *OATH* WE SWORE, THE PROMISE WE MADE AFTER WHAT HAPPENED TO YOUR *MOTHER...?*

WHATEVER HER DIFFERENCES, THIS GIRL BELONGS TO THE SAME BROOD OF EVIL WE'VE VOWED TO DESTROY. IT *MUST* BE DONE, ADAM... *NOW!*

Left and following pages: Adam Van Helsing lusts after Vampirella, while his father wants to hunt her, carrying forward character arcs as well as setting up subplot complications for later exploration.

our second act to the third act (just seeing if you're still paying attention to the lessons).

"You were capable of thinking relatively long term, of course, when you wanted to," Roy continued. "I still recall the day, not many months after Ditko left, when I was in on a plot conference with you and John Romita, and you two began to discuss where the storyline—or, more precisely, the relationships of the characters, I believe—were going some months down the line. This was the first time I had seen this kind of advance thinking, and the expression on my face must've betrayed me, because you stopped and asked me why I had the funny look on my face. I remarked that this talk about the future issues of *Spider-Man* sure wasn't the way I thought of comic books as usually being handled. I was aware that this was quite a bit different from the way Julie Schwartz, say, handled his books at DC, the other main comics in my life at that point.

"For the most part, I think you just winged it, but in some cases you seemed to have had a direction in mind. You always thought of Peter as winding up with Gwen, for instance, and never with MJ, which is why you always had trouble coming to terms with the fact that you ever approved the idea of killing Gwen. I'm sure you and Jack discussed at least some aspects of Sue Storm's pregnancy and the birth of their child . . . and, although nothing much was decided, whether the kid would have any superpowers or not. Jack was left to handle a lot of the sub-plotting in *FF* and *Thor*, but you were there for the broad strokes, including, I'm fairly sure, the introduction of Sif right after the departure of Jane Foster. The problem was, I don't think you—or, for that matter, Jack—had much of an idea of

where to take the Thor-Sif thing once it was established."

He's probably right, because as I said, there were so many stories to write, and my instincts said we needed a romance as powerful as Thor but didn't envision where that would go. Still, her introduction in *Thor* #136 came at a good time, as it propelled the stories in new directions.

A good subplot will allow you to set up the introduction of new characters or complications. It can break up the main action of the issue and build tension, so as the hero and villain are battling and the fate of the cosmos is at stake, we cut away and check out a plane landing at JFK Airport and a new figure enters the terminal. She gets her luggage and hails a cab, giving the hero's home address as her destination. And just as you begin wondering who she is, we cut back to planets blowing up. Now you have a new mystery to ponder until the following issue, presuming the universe survives the battle.

Subplots can rise to become the main plot, but they can also be a parallel story to the main plot. But just as the larger story comes to a conclusion, so, too, must your subplot. You should never start something without determining at the outset if it will rise to the main plot or launch a secondary subplot or just resolve itself. The example with Len above came from instinct based on years of writing. Those just beginning their careers should make certain they have every resolution in mind before writing word one.

Sub-plotting had its heyday in the 1960s and 1970s and is used a little less often these days, much to the detriment of the comics, I think.

The mystery of the Hobgoblin's identity was a running theme in the Spider-Man family of titles for quite some time, complicated when writers and editors came and left, each with their own belief as to who wore the mask. Another Spider-Man subplot happened after Norman Osborn's demise, the original Green Goblin. Harry Osborn seeks revenge on Spider-Man, never suspecting that his best friend is his father's killer.

Miniseries, one-shots, and graphic novels are just a few examples of the various comic book formats.

WHERE TO TELL THE STORY

We've created a story, populated it with characters, and figured out the story structure, but now we need to determine where best this story fits. And the best way to learn about comics is by reading them. That leads me to talk a bit about comic book formats. After all, each format has page count restrictions, which in turn affects the kind of story you can tell.

Way back in the first chapter, I noted how comics were originally anthologies filled with a hodge-podge of features from one to ten pages in length, more or less. In time, as page counts dropped, so did the number of features. As heroes became popular, they earned their own titles, so you had several stories featuring a singular character.

These were all monthly or maybe quarterly titles. Starting in the late 1950s and increasing like kudzu, comic book stories began to be continued from issue to issue. First there were two-parters then three-parters and finally serials. Still, they all were found in regularly published comics. These ongoing series remain the bread and butter of the comics field.

Today, most companies have a standard twenty-two pages for the story. The norm today is to serialize the story so the "done in one" story is the rarity, which is different from my experience, which had the stories largely done in a few pages or a single issue. Regardless, as the writer, you need to determine if there is enough story for the page count you have to work with. That requires you to rough out in your mind or on paper how you envision the story flowing and seeing where things need tightening or expanding. Sometimes, you discover you need more pages—then you have to see if there's enough story to continue it to the next issue. Oftentimes today, that's fine, but every now and then you have the finite page count, and if the story doesn't fit, it's back to the drawing board.

One-shots allow creative teams a chance to play with a character or tell a significant story apart from the character's ongoing series, such as Red Sonja: Monster Isle.

ONE-SHOTS

Starting around 1960, comics began releasing one-shots—extra-sized annuals, or giants that reprinted older stories. Marvel changed that with *Fantastic Four Annual #1*, which consisted of new material. Annuals had the extra pages, which allowed us to tell bigger stories, such as Reed and Sue's wedding and the birth of Franklin three years later. We tried to find epic ideas that required the pages, from the drama behind Peter Parker's parents' final fate to the all-out-action fist-fest as Thor and Hercules rumbled for the first time.

We started doing all-original material with our very first annual, featuring—who else—the Fantastic Four.

MINISERIES

By the late 1970s, the comic shops had arrived and publishers began experimenting with what could be released to the reader. DC Comics released the first miniseries, a three-issue self-contained story titled *World of Krypton*. Since then, miniseries have been a vital component in a publishing plan. They can tell a story to try out a new character (something that used to occur in DC's *Showcase* or Marvel's *Marvel Premiere/Spotlight*) or take an exceedingly popular character and extend his brand by telling a separate story. Done right, with the right creators, you can create tremendous excitement.

After Wolverine achieved immense popularity after joining the Uncanny X-Men, one of Marvel's first miniseries took him out of the team and gave him his first solo tale. It didn't hurt that Chris Claremont followed as writer and was paired with hot artist Frank Miller. That story has endured, spawning countless revisits, and I hear it helped inform the story of the second Wolverine feature film. Not bad, eh?

Spinning off from the main series, Project Superpowers, Masquerade *gave a popular character her own spotlight.*

World of Krypton *(DC Comics, 1979) took a story intended for* Showcase *and gave it a separate title, introducing an entirely new format for comics.*

MAXISERIES AND BEYOND

I'll let you in on a secret: Miniseries started off as three-issue affairs because of some arcane Canadian postal regulation. When that became a moot point, they lengthened for a time to either four or six issues in length. Then the maxiseries idea came about, a twelve-issue affair kicked off by DC's *Camelot 3000*. So anything longer than six issues tends to be considered a maxi, got it?

The annual continued to be a good idea, so the notion that you could tell a single story in one book, perhaps with extra pages, seemed good. So, now we had one-shots that, again, tended to be one creative team producing a story. If a standard comic had a twenty-two-page story, the one-shot tended to be at least thirty-eight pages in length—plenty of room for an engaging story, perhaps something too big for a standard comic. One-shots allowed top talents to come and play with a character when their schedules prevented them from coming for a run of the monthly title.

These one-shots, miniseries, and maxiseries grew more sophisticated as publishers played with the paper stock and the cover stock so they got slicker and thicker and more expensive. It also raised the stakes for what went between the covers since the stories still had to deliver an entertaining reading experience—otherwise the reader may not come back the next time.

Project Superpowers *was a year-long event, a sprawling story that had a specific beginning, middle, and ending.*

Black Terror #1 is an example of a character gaining enough popularity from one series to sustain a title of his own.

THE COLLECTED EDITION AS GRAPHIC NOVEL

What happened next was a transformative step for the field. DC took the four-issue miniseries and not only added pages but came up with a sophisticated package that said this was something far different than the monthly comic. Frank Miller's *The Dark Knight Returns* introduced what became known as the Prestige Format and presented a far more complex story in terms of structure and tone. In four forty-eight-page installments, he created a grim and gritty possible future that explored a terrific *What if . . . ?* concept. It set sales records and demanded reprints.

DC then collected the four issues in both hardcover and trade paperback, taking the collection of reprints in a brand new direction. The single story became the first major commercial graphic novel featuring a superhero.

Now, the term *graphic novel* has been evolving since it was first coined in 1964. These days, about any comic found on the shelves of a bookstore is considered a graphic novel, but there really are two versions.

Sherlock Holmes *Vol. 1* took the miniseries and put the entire story in one place, making for a better reading experience.

When DC first collected The Dark Knight Returns in 1986, they released it first as a softcover and then two weeks later as a hardcover—giving collectors a choice.

THE GRAPHIC NOVEL

There's the long-form story told in one presentation, such as Will Eisner's classic *A Contract with God,* which many consider the first American graphic novel (Europeans call their version albums; go figure). At much the same time, Jack Kirby and I produced our Silver Surfer masterpiece for Simon & Schuster. Knowing it was going out to a potentially wider audience, I distinctly took the Surfer and Galactus out of the familiar Marvel Universe and told a science fiction epic that could stand on its own. We thought at the time it was the right decision, and it probably was. Obviously, if we were producing that story today, we would prepare it for a mass audience far more familiar with the Fantastic Four. When producing lengthier works like this, you have to take your audience into consideration.

These graphic novels are indeed novella-length in their presentation, usually going from one-shot to graphic novel when the page count exceeds sixty-four pages. Some may make the distinction less by the page count and more by the physical package.

The other version is the collected edition, which is taking a single storyline or single character and collecting the issues for the bookstore reader. *The Dark Knight Returns* was actually a collected edition, but these days, bookstores go by the format of a book and consider them all graphic novels.

As a writer, it's important to make the distinction, since this affects how you structure and write your story. Let's say you want to tell the Battle of the Bulge. Do you do it in one long form and figure out the necessary page count to get your story across? Or do you structure it by week, and therefore each part is a week of the battle told over the course of six installments? That affects how you

Will Eisner's A Contract With God **is considered the first American graphic novel.**

tell the story, since you'll need five climaxes or cliffhangers to keep the reader interested enough in coming back.

ADAPTATIONS

Another format to touch on is the adaptation. Comics have adapted movies, television series, and books going back to the halcyon days of *Classics Illustrated*. The adaptation process can be difficult as you adjust the needs of one medium for another, and invariably you never have enough pages to do the job to your satisfaction. I've never adapted another work outright, but from what I gather, it can be quite the challenge.

Often you take the source material, the prose or the script, and try to figure out how many comic book pages it would take if you had an unlimited page count. Then you see how many pages you actually have and determine how to trim elements here and there. Sometimes, as Roy Thomas did with the Conan stories of Robert E. Howard, he would annotate the particular story and let the artist figure out how best to adapt the work. In most cases, though, you write a complete script since the licensing agent usually has the right of approval.

Adapting stories isn't really what we're here for, though. We're here to create and tell original stories featuring exciting characters.

Alice In Wonderland #1 *cover (above) and interior pages (following page) show how Lewis Carroll's imaginative prose inspired artists to depict the characters and settings.*

Alice was beginning to get very tired of sitting by her sister.

WILLIAM THE CONQUEROR, WHOSE CAUSE WAS FAVOURED BY THE POPE...

And of listening, as she read aloud from her book.

She was considering whether the pleasure of making a daisy chain would be worth the trouble of getting up and picking them...

...when a white rabbit with pink eyes ran close by her.

There was nothing so very remarkable about that, and the hot day was making her feel rather sleepy and stupid...

...but when she saw the rabbit take a watch out of its waistcoat pocket, and she heard it say to itself...

OH DEAR! OH DEAR! I SHALL BE TOO LATE!

Alice started to her feet, and, burning with curiosity, she ran across the field after it.

AND ANOTHER THING . . .

One more thought. Comics have been used as marketing, sales, and educational tools. Comic books can be terrific teaching tools. We all learned that during World War II, when we were drafted away from our typewriters and drawing tables to go help Uncle Sam. Will Eisner managed to turn his wartime experiences to inform *P*S Magazine*, teaching soldiers how to perform preventative maintenance. He started it, and the dang thing lasted for decades, going from Will to Wally Wood to Murphy Anderson to Joe Kubert, resulting in some of the finest comic artwork you've never seen.

Some, like Jack Kirby, saw serious action overseas; I managed to avoid such dangerous duty. I did, though, make my own humble contribution by writing a manual, as I told the readers of *Foom* magazine: "I had just written a training manual on finance for a colonel. They were having trouble training finance officers quickly enough, so comes payday and the men in the foxholes wouldn't get paid. There weren't enough payroll officers around to pay them. It was wreaking hell with the morale in the army. So I took the manual that told them how to fill out the forms, and I rewrote it in comic book style: We were able to cut the training time in half, because they could learn quicker from this comic book."

I'd watch training films and write instructional manuals in comics form, an entirely different kind of adaptation. I created Fiscal Freddy to teach people how to fill out those tedious forms. I kept everything very light, and sure enough, it got the lessons across and kept me from KP duty!

*Amazing layout sketch from the wonderful Wally Wood for the P*S Magazine!*

The ways in which comic book writers write are as varied as the stories they tell.

PHYSICAL PREPARATION

Now, actually writing the script or plot/dialogue requires mental and physical preparation. As the years passed at Timely, I was never fully comfortable writing in the office, so I arranged it so I could write at home at least one day a week. I was and still am a creature of habit, preferring to do my creative work in a space that makes me feel comfortable, where I can access my reference books. Here's a trick: I tended to write my scripts standing up, so as not to get too sore sitting in one position. I used to stack tables on the patio in the backyard and stand there, pounding out my peerless prose.

"One thing I've always been lucky about," I also wrote in *Excelsior!*, "I never seemed to develop that old bugaboo called 'writer's block.' Whenever I have to write something, the words always seem to come to me. They may not be the right words, they may not even be good words—hell, they might even be the wrong words—but I can't remember ever sitting and staring off into space trying in vain to think of something to write. There are so many words and thoughts available to us, it's never seemed all that difficult to grab some of them and put them to work."

I guess you could say I was a professional writer without describing myself as an artist who tortured myself over every plot point and every utterance from my characters. I got a kick out of writing comics for all those years, don't get me wrong, but it was also a job. Often, I felt like I was the last man standing, unable to abandon the other artists and staffers, so I doggedly stayed through the ups and downs of comics in the decade after World War II ended. As I wrote in my autobiography (still on sale in finer establishments), "Being the ultimate hack, I would start doing my thinking when I sat down in front of the typewriter, and not a minute before. Because, when I wasn't actually writing, my thoughts were centered on far more important things, like movies, sports, and girls. So, since I didn't consider comics the be-all and end-all of my existence, I was able to live with the fact that the outside world would never be impressed by the work I was doing."

Of course, that changed pretty quickly in the 1960s, and I've proudly proclaimed my profession ever since. Times have certainly changed for people working in the field, and it's all been for the better.

The words kept on coming when I wrote comic books. Writer's block was never a problem!

WRITERS WRITE

If I didn't write, I didn't earn money. It was usually that simple. As a result, I would write one story for whichever title needed one, then roll a fresh sheet of paper in the typewriter and begin the next story, most often for another genre. During the Marvel Age, I don't think I ever did two stories for a single title back-to-back. You have to keep the books filled and the artists busy.

One story is like another in that they have a structure of a beginning, middle, and ending. As a result, I could go from *Millie the Model* to *Ziggy Seal* to the *Two-Gun Kid* without batting an eye.

About the only time I had to slow down my furious pace was in the 1960s when I was dialoguing stories with Thor, Doctor Strange, or the Silver Surfer, because none of them spoke in modern idiom. Each had a distinct way of talking, and I had to concentrate a little differently.

And were I interested in resuming that workload today, it still wouldn't bother me. I'm a writer, and writers write, especially if they want to pay their bills.

As I was shifting from editor to publisher, I was welcoming aboard a new generation of writers, and many of them were comics fans who proved talented enough to be hired. But they still needed some training, and while there was no one with the experience to do that for me back in the day, I felt it important to impart

whatever wisdom I'd accumulated. One of those first lessons was that every comic book will be somebody's first. The writer needs to keep this in mind when writing the final dialogue so it's clear what's happening, who these people are, and why we care. In writing a comic book, have your characters speak like real people, not like inhabitants of a strange and baffling new world!

Millie the Model #1 was Marvel Comics' longest running humor title, first published by the company's predecessor, Timely Comics.

BEFORE YOU WRITE

In talking shop with other writers, it became clear that everyone has a different approach to actually writing their stories. Traditionally, before anyone starts a story, the assignment is discussed with the editor. Depending on the relationship between the writer and the editor, this could occur every month or just once every few months, as a batch of stories, complete with subplots, get discussed.

Matt Fraction said in *The Comics Journal* that his discussion with the editor goes something like this: "Uhh, I kind of know the beginning, maybe a middle beat, and an ending. I sort of know who he's gonna fight, what we're gonna get, and what the hook is. Starting very broad and then narrowing in, moment to moment. These index cards are really helping. [Laughs] I have a three-by-five-foot corkboard and a lot of index cards. That's gonna really make a difference. I'm gonna really turn the corner this year, I can feel it."

His co-interview partner, Denny O'Neil, observed, "The thing I miss most is editors who want to do that. That's pretty much the way I most successfully worked: exactly what you described. I know where it's going, I know one or two of the set pieces, and I either know, or will pay attention to when the time comes, what pulls them into the story. I'm not going to open on five pages of talking heads if it's an action story.

"But one of the great things for me about writing *Iron Man* was for about three hours a month, just sitting in a Chinese restaurant on Second Avenue with Mark Gruenwald and working the story out. People don't seem too much to want to do that any more. For a lot of years, my wife, Mary Fran, has been my de facto editor, in that I can walk around town with her and talk out story problems. She's not a writer; she has a stepson and a husband who are—she's been around this for twenty years. And sometimes just talking it out, you'll solve your own problem, explaining it to someone else."

Iron Man #158 by Denny O'Neil.

THE WRITING PROCESS

What about the actual process of sitting and writing? Well, look at how Garth Ennis described the process in an interview:

"I don't see a script in terms of pictures and word balloons, I see it in terms of people and, ridiculous and mad though it sounds, I hear them saying things. It's like I hear Jesse [Custer] drawling away in that Texas accent and hear Cassidy's kind of lilt, and I see them moving about. They're not like frozen pictures to me. That's not to say I regard them as real people or anything like that, but it's like I'm seeing the scene unfold and it's up to me to try and capture it. When it comes to actually writing a particular panel, I'll do my best to freeze the action in my head and describe what they're doing for [*Preacher* artist] Steve Dillon. That's the point at which I have to try and write down the dialogue, describe where the emphasis goes and how the punctuation works.

"So you end up with the script written out in longhand, and then I'll take a lazy afternoon to type it up. It comes in at something like a script a week, which includes maybe a day and a half off. Sometimes, it's a lot quicker. I've written whole episodes in two days because I've been enjoying them so much I haven't wanted to get away from the pen and paper. It's also taken two weeks, just because it's a real drag. At the moment, it's an average of five days per script.

"My main inspiration when I'm sitting down to write is the story itself. Let's see where it goes, let's move the characters on, put them through their paces, let's see what happens when so and so runs into so and so. Let's see what happens when that idea you've had for the strip for so long actually goes into the mix. It's curiosity, about what's going to happen next. I just love stories."

Garth Ennis's Preacher #1.

OTHER APPROACHES

Other writers do what they call "pre-fighting" the manuscript. They create a file on their computer for everything related to the story and then begin placing documents there. It could be correspondence with the editor or research you've collected or just story notes. Then you open a blank document, and rather than face a blank page at the beginning, you being with the nuts and bolts. Add a header or footer to the page so you and your editor know what it is you're writing and what page you're on. You format the page (unless you're working from a template) so the fonts you want are set up and maybe even go through the manuscript and add in "page 1" through "page 22" so you don't lose track.

Some writers actually produce a short plot in a few paragraphs or number a sheet of paper with the number of pages allotted and start roughing in where they see the action, subplots, transitions, and climax. Only then does the actually scripting begin.

On the other hand, the prolific Chuck Dixon is my kind of guy, a speed demon. "Well, I always thought you wrote comic books fast. When I was a kid, it seemed like Stan Lee wrote half the books out there, so I thought this was a medium where you just had to get it done in a hurry. I've always kind of looked up to screen-writers from the thirties and forties, who could crank out a movie script in just a few weeks. So I just thought writing was something that was done quickly, and I carried that childhood impression into adulthood.

"I don't actually spend much time at the keyboard. Most of the time is just spent walking around, thinking about the stories. Some stories get thought about for months before I actually write them. I'll keep adding scenes and figuring out connections. Then, when I sit down at the keyboard, it's pretty much all in my head. It may take one or two days, with only a few hours work each day, to get the script done. There's times when I've got to get a script done; a fill-in issue, or a penciler needs something and another writer has fallen down on the job, so they need something in a hurry. It's not unusual for me to write an entire script, starting cold with no idea, and have it done by the end of the day.

"Generally, I don't sit down to write until I have the opening. To me, the opening is the most important part of a comic book story because that's what's going to drag the reader through the next twenty-two pages. With the opening, I sit down cold. There's no notes, no sketches. The only thing I'll do if I'm nearing the end of the story and I'm, on, say, page 14, I'll take a piece of paper and make little squares from 14 to 22, so I can see how many pages I've got left. That's it. And then rewrites after that if they're called for. I only do one draft."

WHEN ARTISTS WRITE

Now, artists or those writers with some art training probably approach their scripts a bit differently. After all, they can "see" the story more clearly than we mere writers can.

In an interview with Mark Salisbury, Dan Jurgens noted, "Strangely enough, I don't do thumbnails or sketch out a book first. I just write it. When I'm writing for myself, I write what I call a truncated plot, in that it's shorter, briefer. What I'm basically doing at that point is describing the main story and character elements for the editor, so he knows what's going to happen. When I write for another artist I do a more detailed plot, and by the time I type it up I know what it would look like if I were going to draw it. I write it for myself in terms of what I think it will look like visually, which is kind of unfair on the artist, but it's the only way I can work. But then I say to my artists, 'Make it your own and take it from there.' I type out a plot so it lists panel-by-panel what will happen on all twenty-two pages. As I type it, I'll say, maybe, 'Down shot: ticker-tape parade New York City,' or 'Wide shot,' or 'Extreme close-up, crop the face like this.' I'm writing it for myself, what I can draw, and I know what it'll look like. But the artist is still free to take it and move it around, and they always surprise me. But then, that's what the collaborative process is all about.

"Part of it was a reaction on my part to having once worked with [writer/artist] Keith Giffen, who, rather than write out a plot, would just send in his sketches of the pages. Keith's plot amounted to a twenty-two-page book that was already drawn out. And Keith's storytelling approach is so incredibly personal, with nine panel grids and the way he would characterize the action, it almost overwhelms another artist. And I also worked with

Dan Jurgens's Superman #61, *page 15 pencils.*

another writer who did that same thing, but in his case couldn't draw and did not have the storytelling sensibilities that Keith had. I found it tremendously frustrating to work from [drawn plots], because what you don't get is any of the flavor. If the story or scene is set in an exotic locale, you don't have anyone typing out something like, 'We're in a rundown slum area of Mexico City. Garbage lines the streets. There are rats everywhere. There's even a dead wino laying in the corner.' The atmospherics aren't there. So, as an artist, I reacted very strongly against that process, and it's why I would never do that to someone else."

Frank Miller revealed to Salisbury, who seemed to talk with *everyone* at some point, that the lesson he learned early and carries with him to this day is to know your ending. Without it, he notes, you're lost and pretty much flailing about. Now, while I agree with Frank, I have to admit that, often, as we were pounding out the monthly issues, I didn't always know how these continued stories were going to resolve themselves. But that came after decades of experience and trusting my artists to help me figure out how to bring each escapade to a satisfying conclusion.

Frank's approach has been to start with an idea for a character, such as "Conan in a trench coat," which evolved into the grizzled Marv in his dark *Sin City* series. Interestingly, once he has a character, he comes up with the ending. To reach the ending, he figures out certain milestones to achieve while he's also sketching out the look to his characters. Along the way, Frank takes notes, does sketches, and lets everything percolate in his brain. Finally, he scribbles his notes and posts them to his wall and then sits down to draw.

Sin City: The Big Fat Kill #2
(Dark Horse, 1994).

When writing for others, though, Frank Miller says, "I tend to put things together longhand, because I physically enjoy that process more. Then I shut down at the computer and, depending on who I'm working with, I'll either type up a whole script, complete with panel descriptions, or I'll simply write up a scenario. With Bill Sienkiewicz or Geoff Darrow, I'll write a scenario. They prefer to work that way, and they're such mavericks that every time I've written full scripts I've had to rewrite them anyway. On *Elektra: Assassin* I had written a full script, and when I saw the artwork I realized it was a completely different comic than what I had envisioned. It's the end product that has to work, and ultimately *Elektra: Assassin* was much better for Bill doing what he did. With *Hard Boiled*, when the pages came in I simply threw the script away and spent three or four horrible days looking over this magnificent artwork with no idea what to do with it, until I realized the book had become a comedy.

"Dave Gibbons and I work very formally, in that I send him stuff with brief panel descriptions—I'm not trying to compose the drawings for him, because he does that so well himself—with all the captions, word balloons, and sound effects in place. But I don't make them do what's in my head; I want to see what's in their heads. Since I don't collaborate with other artists that often, I get to work with the best and I wouldn't want to handcuff them."

Elektra: Assassin cover by Bill Sienkiewicz. By 1986, experimentation with art styles and storytelling had been accepted by readers. Frank Miller and Bill took the popular character and showed readers something new and fresh and quite daring.

DOING THE WORK

I could talk to a dozen more writers and get many more points of view and tips on how they work. Clearly, the key is to find something that works for you. Many lock themselves away, some play music, something without words, some select soundtracks to get them in the mood for whatever they're writing. Others go to a coffee shop or library to get away from distractions.

In all cases, there's a story in mind. There are notes in a journal, or on index cards, or scribbled longhand on a yellow notepad. Whatever works for you is fine, but then you need to begin the actual writing.

If you're calling for specific images, you need to direct your artist to the reference. Embed a link to something you saw on the Internet, or cut and paste an image into the manuscript itself.

Notice the dialogue, title, and captions are placed carefully on this Vampirella *splash page so nothing obscures the main image.*

DIALOGUE AND CAPTIONS

When writing a full script, you need to make certain you separate out art descriptions from dialogue and from sound effects. In many cases, your script will look much like a screenplay or theatrical script. You identify the speaker and use a colon, no quotation marks are required unless you want them in the finished comic book.

Now, how many words do you use? As many as you need. I ran toward the verbose and Roy ran to the more verbose. These days, Brian Bendis seems to be the dialogue-heavy king of comics. Others are sparer, such as Frank Miller with *Sin City*. It comes down to the needs of the story.

Word balloons take up space, after all. You want people to see the gorgeous art that tells the story. The old rule of thumb used to be no more than thirty-five words per balloon, no more than two hundred or so words per page. That includes captions, too.

These days people tell stories using a character's point of view as narration in the captions. This technique has replaced the more traditional thought balloon. Either way, it gives the reader a glimpse inside the character's mind and can help convey a mood or help add shading and depth to a character, while keeping the other characters being spoken to clueless as to what's really on his mind.

Comics have used bold words for emphasis since the very early years of the field. These days, fewer and fewer writers feel the need to select words to be lettered in bold. You can decide for yourself if you want to use them. One rule for bold words: only "bolden" a word that a person speaking would naturally emphasize in his or her speech. One exception: sometimes it might be helpful to make a name bold.

The Death-Defying Devil #2 shows the bold word, which gives the dialogue some needed emphasis to convey emotion.

SOUND EFFECTS

While writing the script or dialogue, you need to determine your sound effects. How does a fist meeting a jawbone sound compared with a laser blast hitting an indestructible shield? Obviously, onomatopoeia comes into play, and most writers today eschew the more traditional sounds, such as *POW!*, *WHAP!*, and *BAM!*

Comics do have distinctive sounds that will alert the reader to specific characters. A *THWIP* will tell you that Spidey is spinning his webs, while a *SNIKT* indicates Wolverine has popped his claws. Most gunfire is rendered as *BUDDA-BUDDA-BUDDA*, one of the lasting elements from the war genre.

Some writers eschew sound effects, but effects do add a layer to the overall reading experience, and frankly, I can't imagine writing a comic without them. Making them can actually be fun as you make the sound and then try to find the letters to immortalize the noise.

Athena #4 shows how effective a well-placed sound effect can be to add a dimension to the art and color.

THE SOUND OF SILENCE

Silence, as they say, is golden, and silent panels used judiciously work as effectively as the most poignant speech. The absence of caption, word balloon, and sound effect can heighten tension and let the art tell the story. Your script or dialogue has to call attention to the silence, telling your editor and letterer NO COPY, so they don't think you left something out.

The impact of seeing a single tear roll down a cheek or the Bat-Signal flashing in the night sky tells you what you need to know. Additionally, silent panels also are frozen moments in time, which can be effective when used as part of the overall pacing in a story. Go back and look at the silent panels in your favorite comics and you'll see what I mean.

Look at a silent sequence and you'll see it conveys a certain passage of time, usually slower. Now, add your own dialogue and reread the panels and you will feel the time pass more quickly. Entire comics can be done silently if planned out properly, although this technique should be used only when it seems appropriate to your story and the characters.

Even I, king of wordy panels, have been known to use the occasional silent panel.

This page and following page: These pages are from New X-Men #121 *and illustrate the power of a page free of balloons and captions.*

Comic strips and comic books are pretty similar, but there are some vast differences, including just how much story you can tell in a given day. I riffed at length on this in the introduction to a 1986 collection of the *Spider-Man* comic strip, from Ballantine Books. I had stopped writing monthly comic books for a few years and thought it would be like riding a bicycle, but it was nothing like that at all. First of all, comic strips have no tires.

I excerpt myself for your edification:

"Obviously, before the artist can draw the story there must be a story to draw, so let's discuss the story first. How does a comic strip writer dream up an idea for a story? I wish I knew.

"Sometimes a storyline will come to me in a flash. I'll be taking a shower, or walking the dog, or eating a pizza. Then zingo! Inspiration strikes! Just like that, out of the blue. At that moment, if you were near, you'd hear me talking to myself. 'Hey, why don't I do a story about Spidey taking a shower? Or walking the dog? Or eating a pizza?'

"See how easy it is? Still, it doesn't always work that way. You can have only so many pizza stories.

"Perhaps the most grueling part of the process is eliminating an idea because, in some way or other, it has already been done. Coming up with something resembling a fresh plot is about as easy as finding a kid who loves to do homework.

"But, sooner or later, the idea takes shape.

"I work a little differently from other adventure story writers. Instead of first deciding who the villain will be, or what the crime will be, or what sort of deadly danger our hero will face, I go another route:

"I first try to come up with a unique human interest angle, or a compelling subplot, some problem for Peter that seems virtually unsolvable. And one of the best ways to do that is to say 'What if?'

"For instance: What if Peter Parker had an accident, or became ill and needed a blood transfusion? If a doctor ever tested his strange, radioactive blood, our hero's secret would be revealed! Therefore, Peter can't allow anyone to give him a transfusion. But, without one, he might die!

"With that as a start, we're off and running. Once I get a little germ of an idea like that, the rest becomes comparatively easy.

"That's the kinda jazz that turns me on. The more complicated the plots gets, the better I like it. The more obstacles I can throw in Spidey's way, the better I like it. The best thing about it is, once I dream up the first gimmick, the others seem to spring to life of their own volition. All it takes is a start and then it's like a snowball rolling downhill.

"I feel that it's as difficult for a writer to keep their own personal convictions out of what they write as it is for people in general to keep their personal thoughts and convictions out of what they say in conversation.

"The *Amazing Spider-Man* comic strip has one quality about it that is shared by no other similar strip. Spidey is virtually the only newspaper strip character who spends most of his time soliloquizing. Think about it. In virtually every other story strip, the hero's (or heroine's) word balloons represent what the character is saying. Period.

"But in our wondrous web-swinger's strip, you're just as likely to be reading thought balloons which clue you in to what he's thinking."

ANATOMY OF A COMIC BOOK STORY

In 1999, prolific writer Chuck Dixon prepared the following guide for would-be writers. It first saw print in Mark Salisbury's must-read *Writers on Comics Scriptwriting* and is reprinted here with Chuck's kind permission.

THE OPENING ACTION

This can be the inciting incident of the story, or it can just be a sequence that shows how good our hero (or villain) is at what he does. I can't tell you how many faceless thugs have been shot, beaten, or humiliated in the openings of my stories just to give the readers a recap of how bad my title character is. It's a challenge to come up with new ways to accomplish this. This scene can also be used for exposition, recap, characterization or humor. Sort of like the pre-credits sequence in a James Bond movie. You can also use it as a springboard to flashbacks. I once opened a story cold with the Punisher leaping from a plane at 35,000 feet without a parachute. The next eighteen pages told, in flashback, how he got to be there.

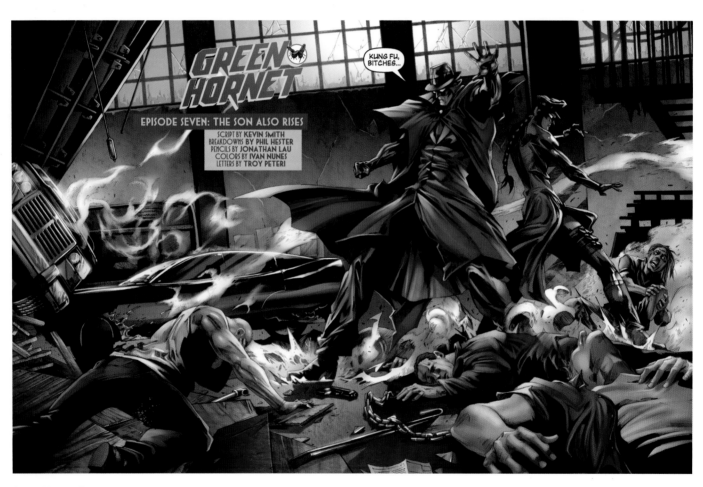

Green Hornet #7 opens with an action sequence, as the Hornet and Kato appear triumphant over the criminals.

THE MINOR ACTION

This can be supporting characters in some kind of action that parallels the main story. It can be the villain beating up one of his own henchmen (my personal favorite), or the hero encountering conflict as he moves through the story. Any excuse for this scene's appearance is a good one. So long as someone's being thrown through a plate glass window on page nine, you're on the right track.

CLOSING ACTION

If it's a cliffhanger it can be a short action piece that leaves our hero in a dilemma, making your next issue opener real easy to write.

If it's not a cliffhanger, then it should be your main action set piece and take up the most pages. Don't rush the ending. The readers are looking for a payoff and will be disappointed if the final conflict isn't a zinger.

None of this is meant to denigrate the plot aspects of your story, but plot must be hammocked between action. If you're reading this, there's nothing you need to be told about plot.

There are other formulas:

THE ALL-ACTION ISSUE

This one is a killer to write. The action set piece starts on page one and roars through to the conclusion. You have to carry the plot through dialogue between the combatants or witnesses, or the internal dialogue of the hero. But if you can write a good one of these, you've got my respect. One act.

TWO-BEAT ACTION

A brief inciting incident and a little exposition that just sets up an extended action sequence that takes us to the last page of the book.

Black Terror #1 keeps things moving panel to panel, and note the change in angles as we move around the skull in the background.

Even though Captain America was first created in 1941, his early adventures are still acknowledged through continuity.

BIRTH OF A UNIVERSE

When I created the Fantastic Four, it wasn't planned as the beginning of what we now lovingly call the Marvel Universe. Honestly, that didn't really come about by design, although since we were borrowing the Human Torch's name from the Golden Age it seemed natural to revive Sub-Mariner from the past as an antagonist, which took me all of four issues to figure out. When the Human Torch and the Sub-Mariner first fought, it was an earth-shattering event. Not only did their epic battle fill an entire issue of a title, but it also told the reader that they lived in the same world.

Since then, the notion of a shared universe has become commonplace and expected whenever a new line of titles arrives.

It used to be that the characters crossed paths, fought one another, or paired up to fight the bad guy, but rarely, if ever, were previous encounters mentioned. Yes, they lived in the same world but in the most casual of ways.

But really, the idea that my New York–based heroes would interact with any regularity happened because it just "felt" right. After all, they were all flying around the same city, so no doubt they would cross paths. It all grew very organically and has now become a major element in many mythos, not just in comics. Look at the complex continuity linking five *Star Trek* franchises or the years of history informing the *Star Wars* universe.

In time, though, it became logical to link in the past exploits of our heroes and villains, especially once Captain America was thawed out and was a living link to the past. But that also meant we were now accepting their older adventures as part of the fabric of the still-evolving universe. By ignoring his 1950s exploits, it opened the door for a later writer, Steve Englehart, to write an extraordinary tale that showed it was actually someone else masquerading as Cap during the period, using the continuity flaw for a dramatic saga.

When villains showed up, we first had to stop and explain how they survived the last encounter when the heroes, and the readers, thought the villain had met his grisly end.

The continuity we built for the Marvel Universe was one of the many reasons we stood apart from the competition. Sure enough, they followed, as did others, and now we live and die by continuity.

The issue of whether slavish devotion to the details over the last seventy years of the Marvel Universe or seventy-five years for DC Comics is a good thing has been endlessly debated.

Now, when I was writing the stories, there was a lot less to recall, and we weren't looking through older comics for unexplained story points or contradictions to smooth over. That, fortunately, became a trend after I stopped writing regularly, which is just as well, since I like to keep things moving forward, rarely looking backward.

Fantastic Four #1 was ordered up by publisher Martin Goodman, but it never occurred to any of us that it would create one of the first cohesive shared universes in popular culture.

Captain America Comics #78 (Atlas, 1954) featured Cap as a school teacher taking on Communist agents, later inspiring Steve Englehart to enhance the star-spangled avenger's mythos.

The Human Torch's epic battles with the Sub-Mariner were among the earliest crossovers in comic book history.

CONTINUITY AND CONSISTENCY

Still, when you create a series with recurring characters and situations, you need to maintain internal consistency. If your hero is a five-foot four-inch, 120-pound blonde with blue eyes and a dragon tattoo on her right bicep, then that has to be consistent throughout. If her parents are named Jim and Jennifer, then that remains the same. But if ten years ago you determined she hated spaghetti and then write a story today showing her ordering it at a restaurant, don't sweat it. Continuity, to me, is a guide, and you should adhere to it at all times, but don't let it become your straightjacket.

Of course, that's speaking about you and your own creation.

If you're playing in the Marvel or DC sandboxes, and they insist on a devotion to what has come before, then those are the rules you play by.

One of the chief proponents of continuity is Roy Thomas, who has mined the past better than most. When I asked him about continuity and if it helped or hindered, he replied, "Either one. It depends on the company and the policy. Continuity (as well as the kind of continuity, of course) is a major reason that Marvel was able to pass DC in terms of popularity by the early 1970s. Readers felt they were immersing themselves in a real world, wherein Spider-Man, say, would be the same character in his own magazine or as a guest in someone else's, and events that had happened to him wouldn't simply be ignored. Of course, continuity can get to be a problem after a certain amount of time, only in part because it can tie a character to certain dates. Sub-Mariner, Captain America, and the original Human Torch had no problems because they were birthed during the WWII years, but eventually that became a problem for DC, which decided retroactively that Superman and Batman didn't exist during World War II. For my part (and there are lots of readers like me), I can't take a comic book universe that lacks continuity seriously. Batman now seems to be almost a different character in his many series, a Rorschach blot for whatever the writer

Above and next spread: This sequence from Project Super Powers *Chapter 2 integrates the disparate backgrounds and histories of the characters into one universe, clarifying things for the reader.*

has on his mind, and I wouldn't be surprised if that principle has extended to many other characters, now that continuity has come to be seen as 'baggage' rather than as a colorful and useful history."

CONTINUITY VS. RETCON

I gotta be truthful with you and admit that I never thought about continuity and retcons (retroactive continuity; you did read the glossary, right?) when I did my writing.

Since the 1970s, the continuity of the Marvel and DC universes has been a work in progress, constantly being modified to suit the needs of the moment. I'm reminded a bit of Eldon the handyman from *Murphy Brown,* never quite done renovating her home.

A retcon can be explaining away a minor flaw or inconsistency or placing disparate elements into a single framework. I guess you can say I first did that when we brought back the Golden Age Human Torch in *Fantastic Four Annual* #4 and explained how he and the modern-day Torch could be in the same world.

Larger retcons are also known as reboots. John Byrne's *Superman* has already been mentioned as an example. Older characters are dusted off, brought back from the grave, whatever, to be reinserted in the modern continuity, now in a fresh context.

Some retcons get retconned by subsequent creative teams—such as John Byrne revealing that Queen Hippolyta traveled back in time to adventure as Wonder Woman, explaining why the Justice Society of America roster included the Amazon Princess only to have *Infinite Crisis* undo that revelation—which can only make your head hurt. If you're going to play with the status quo, make certain it makes sense for the characters and that your editor and his boss agree with the change, since everyone else will have to live with it.

Some writers can't seem to help themselves, but no doubt there are also commercial considerations at play, since familiar characters sell well, while many comic book fans are risk-adverse and won't sample your latest hero.

Amazing Spider-Man #544 shows Peter Parker and his wife, Mary Jane, dealing with the final hours of Aunt May's life, bringing to a conclusion a relationship that began in Amazing Fantasy *#15 those many years ago.*

The Man of Steel #3, on the other hand, reestablishes the relationship between Superman and Batman in the wake of both characters having been revamped in 1986.

CONTINUITY AS ALBATROSS

On the other hand, there are those from the latest generation of writers who feel differently. Look at what Matt Fraction said of the topic in *The Comics Journal*: "Continuity: I think that continuity's the devil. I'm a fan of consistency—I think consistency is the watchword.

Continuity? I mean, I've been reading comics for thirty years now, my parents have been reading comics as long as I've been writing them professionally, and anytime I'm in sticky territory where I'm not sure my folks are going to be able to follow what's going on, it's like a little red flag goes up. So, I try to make things as accessible as humanly possible and as consistent with the history and the continuity. But continuity-heavy stuff—and I write *Uncanny X-Men*—I am in a continuity minefield many days of the week and I try to avoid that exclusionary approach. Even when you're wrapped up in these big crossover events or when the currents of the macro-narrative are flowing in a certain direction, I still think there are ways that you can write and be as accessible as possible to somebody. I was told that Stan Lee always used to say that every comic is somebody's first comic. While I'm not a fan of characters speaking in logos, spelling out for everyone what their powers are and what they do every third panel, I think there's a way that you can write these stories to make them accessible to newcomers and make them satisfying to people who have been reading."

You should never lose sight of making your books as accessible as possible. Some companies use recap pages, and others have a caption box on the first page, but you should also be able to get people pretty caught up through dialogue and storytelling. But that comes with its own pitfalls as well.

Marv Wolfman, known for his terrific work on the continuity-altering *Crisis on Infinite Earths*, admitted

Secret Wars #1 took a toy tie-in project that was canceled and turned it into a smashing sales success, introducing elements that have remained a part of the Marvel Universe.

to me, "I'm not a fan of continuity. I believe continuity holds the best writer hostage of the worst. I believe your characters should be consistent, but you don't need to be slavish about everything that ever happened in the past or you get bogged down in the

small details that make it harder to tell a good story. Be consistent—to make a character feel real—but not to the point of ruining your story."

Which is pretty much what I said earlier, but it's nice to see someone agree with me.

Secret Wars #8 shows off Spidey's new black costume, which was later revealed to be a sentient alien symbiote named Venom.

WHEN CONTINUITY IS VITAL

The big event stories all tend to be based on some element of the continuity, such as the *Secret Invasion*, which was all built on the shape-changing Skrulls in *Fantastic Four* #2, never knowing the seeds we sowed. To make these cross-company series work, the continuity between the titles and the source material to create the inciting incident needed to be properly drawn from the company's continuity. The master architect for some of these events, Brian Bendis, does his homework.

"This is the thing I get the most crap for online," he told me. "Continuity is incredibly important; it means everything in the world. I used the Molecule Man in *The Avengers* recently and people wondered if I knew his history. Of course I know who he is. Why would I waste a second on him if I didn't know and love Owen Reese? But, there was no need to bog down the forward momentum with the character stopping to recite his *Marvel Handbook* entry. That's not how people lead their lives. I don't see a reason to see this story buckle. That's why there's the *Handbook* and *Who's Who*. I read research every day and make sure I have my facts right.

"I know we were raised on comics that do that a lot, the info dump. We've seen Wolverine with a giant thought balloon covering events leading up to that moment. It creates a very flabby narrative full of exposition that can derail the dramatic elements, which are much more important. I spend a lot of time wading through a lot of research.

"[Former Marvel president] Bill Jemas introduced the streamlined recap page that started in the *Ultimate* books. It's a great idea, and everyone could benefit from doing this. It gets across a lot of simple ideas. The worst recap pages are the ones with seven paragraphs. In *Secret Invasion* we did it in a few paragraphs, unencumbered with clunky exposition.

"The best at it was Frank Miller during *Daredevil*. He found ways to tell how Matt Murdock was hit by a truck within his noirish narrative. That was a perfect example, which does help the story—it gets the information across and sets the tone.

"The writer has to remember that today, at least half or more of your audience will be reading the story as a collected trade. When you read Frank's *Daredevil* in a trade, you get stuck with Matt Murdock's origin every twenty pages, and it does jar you. You would be remiss if you don't consider the trade readers versus your single-issue readers. You need a fluid story with tension building in your trade paperback. You're serving both masters exceptionally well."

But what about the argument that writers should not be hamstrung today from telling a dramatic story because of some element from twenty-five years ago?—you hear me asking.

"Characters can grow and learn from their mistakes. I can demolish someone's storyline but show that the character has learned and grown. In shared universe, I'm working on characters shared by as many as ten to fifteen other writers every month. We have to deal with each other's nonsense and do so in the name of creativity.

"Ridley Scott once said the best movie he ever made was *Blade Runner*. Its tight budget made him create solutions to his problems that were tight and slick. On movies with no budget, problems led him to make some bloated decisions that ruined the story.

"Continuity doesn't pose obstacles unless you choose to see them that way. What they really are are excuses for creativity, solutions to your problem—very exciting. Some of our best storylines came out of that, including old continuity. You're writing about a character—not the minutiae, but the feeling from the old material."

To which I say, 'Nuff said!

Recap page from
Ultimate Avengers 3 #2.

THE AVENGERS IS A BLACK OPS INITIATIVE THAT FIGHTS THE THREATS TOO DIRTY FOR THE ULTIMATES. WITH NICK FURY IN CHARGE AND GREGORY STARK, TONY STARK'S BROTHER, PROVIDING TECH, THE FIELD TEAM IS:

HAWKEYE	BLACK WIDOW	RED WASP	WAR MACHINE	NERD HULK
CLINT BARTON	MONICA CHANG	PETRA LASKOV	JIM RHODES	BRUCE BANNER'S CLONE

PREVIOUSLY:

Blade is back and that can only mean one thing: vampires are afoot!

And Blade's not the only one thirsting for vampire blood. Daredevil's former trainer, Stick, has recruited the very young Ray Conner to take on the Daredevil mantle and kick some bloodsucker butt. Too bad even super heroes are susceptible to bite marks as Stick and Daredevil get taken down by—surprise—a vampire Nerd Hulk. Looks like the Avengers need to start watching their backs *and* their necks.

But what is the reason behind the recent vampire attacks?

BLADE VERSUS THE AVENGERS
PART TWO OF SIX

WRITER	PENCILER	INKER	COLORIST
MARK MILLAR	STEVE DILLON	ANDY LANNING	MATT HOLLINGSWORTH

LETTERER	COVER	ASSISTANT EDITOR
VC'S CORY PETIT	ED MCGUINNESS & MORRY HOLLOWELL	SANA AMANAT

SENIOR EDITOR	EDITOR IN CHIEF	PUBLISHER	EXEC. PRODUCER
MARK PANICCIA	JOE QUESADA	DAN BUCKLEY	ALAN FINE

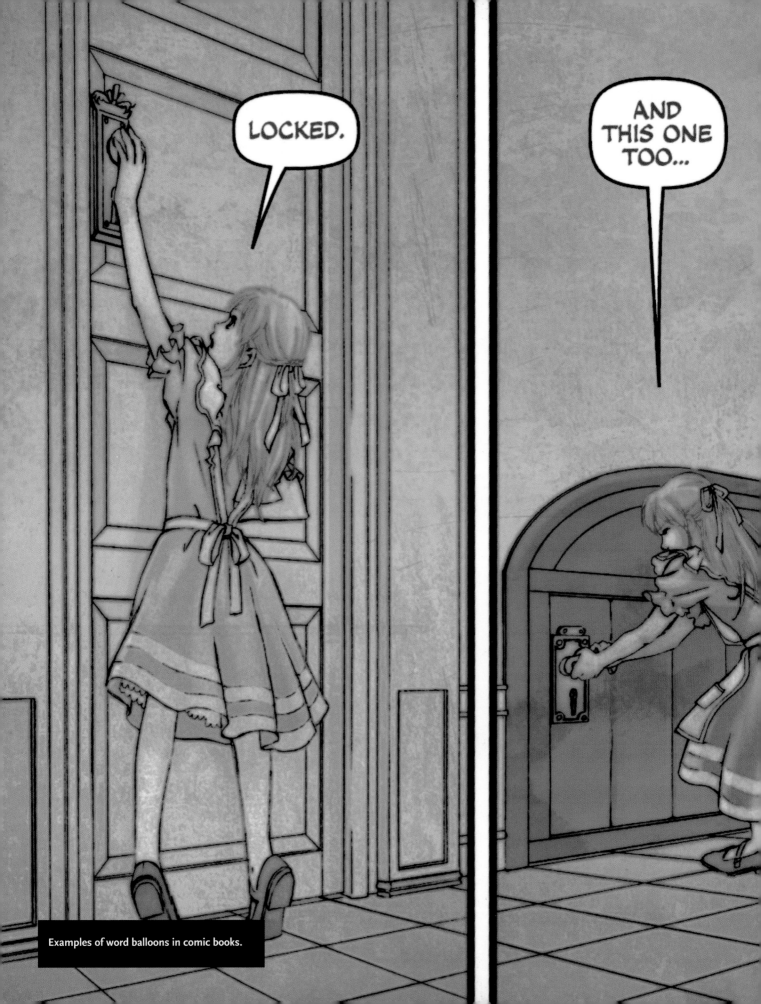

Examples of word balloons in comic books.

SCRIPT FORMAT

The finished script should be clean and polished, words spell-checked, and each page properly numbered. On more than one occasion did I discover one of the writers mis-numbered a script and we ran a page short or long. The manuscript is not a work of art to be admired but a professional working document that any editor or artist can read and understand.

The format varies, as you've seen from the illustrations sprinkled throughout, but it has to be neat, legible, and preferably in an electronic form for ease of editing and passing around to others.

The above applies to a full script or just the plot or just the dialogue.

When preparing the plot, you need to make certain you spell out what's expected, and if you're being detailed, how many pages you anticipate each sequence will take.

Dialogue usually accompanies photocopies of the penciled pages with numbered captions and balloons marked by you.

One of the things that helps explain why Marvel Comics took off in the 1960s is that the dialogue rang true. Don't write down to your readers! I said that earlier and I repeat it now because it's one of the most important lessons you should take away from this book.

After years of working on countless short stories with Jack, Steve, Don Heck, Dick Ayers, and others, I could tell a fine story in six to ten pages and have a beginning, a middle, and an ending that would satisfy the reader.

But, as we switched from monsters and aliens to superheroes, and I lengthened the tales to twenty pages, we all had room to breath. Because my artists were fleshing out the plots and adding their own twists and details, once the pages hit my desk, I could see the story with fresh eyes and this time just concentrate on the dialogue.

By now, you know I was feeling-pretty good about writing to please myself and figuring the readers would come along for the ride. After years of working in the office and commuting to and from Manhattan, I heard lots of different voices, dozens of dialects, and certainly different educational backgrounds. It allowed me to infuse my characters with that same range of sound.

Alice in Wonderland #1

Page Two

This is a three panel page with one wide letterbox type panel across the top of the page and then two tall panels under it. We have tried to open the layouts up as much as we can where we have the room, just so the backgrounds become a real feature of the story. We love how you handled the interior of the house on the tryout pages so we want to give you plenty of room to show off!

Panel One.

This is a wide panel with Alice crawling along the rabbit hole towards us. We can see the round bright shape of the rabbit hole entrance in the left background, and the rabbits backside going out of shot to the right in the right foreground. Between the rabbit hole entrance and the rabbit, the centre midground we have Alice crawling along on her hands and knees as she follows the rabbit. Roots hang down and brush against her face, and little bugs and beetles hurry out of her way as she passes by. She doesn't lo keen remotely scared. One caption from the narrator.

Cap: The rabbit hole went along like a tunnel, and then dipped suddenly down, so Alice had not a moment to think about stopping herself.

Panel Two.

This is a tall shot with Alice falling into shot at the top of the panel. She keeps falling for the next four panels, and we imagine that instead of her skirt inflating like the Disney film, that she should slowly tumble head over heels over the course of the four panels. We thought this would look like she was actually falling rather than floating, and it would enable her to reach out for objects at different angles making the panels more interesting to draw and read. In this shot she is just falling into shot, so maybe we can only se two thirds of her, with her feet still being up out of sight off panel top. She is reaching out to take a jar labelled "Marmalade" off a shelf she is falling past. The rest of the panel is a dark vertical tunnel, which has items of furniture randomly placed here and there on the walls. We had the idea that the items on these panels could prefigure the rest of the story, and kind of resemble things Alice might have herself at home (I think we stole this from the David Bowie film Labyrinth by the way). The walls are dotted with roll top desks, and little glass fronted cupboards and bookcases, it has tall grandfather clocks and rocking chairs. The shelves and cupboards have all kinds of things on them (apart from the marmalade Alice grabs) including a Teapot, a cup and saucer, a top hat, a little toy rabbit with buttons for eyes, some playing cards, chess pieces, a nursery rhyme book, open at Humpty Dumpty, to name just a few. You don't have to fit them all in, but it would be cool if there were things to spot in each panel, and if those items were ones that cropped up again in the rest of the book. Some (like humpty dumpty) don't happen until issue 3 or 4 but that will be a nice thing to realise when you re-read it for the second time.

One little thing we also thought of was that in each of the four falling panels there should be a framed picture somewhere of the Cheshire cat. They don't have to be the in the same frame, or in the same place in the panel even. In the picture in Page Two Panel Two, it's the whole cat, in Page Two Panel Three, it is vanishing away, so we can see through part of it, in Page Three Panel One it's just the head that's left,

Alice in Wonderland
page 2 script.

1

WORD BALLOONS

Which brings me to discussing word balloons. I developed a reputation through the years as being very particular about how word balloons work and how they are to be placed on a page. Trust me, I didn't arrive at Timely knowing this arcane science. No, it came through trial and error and developing a good eye for these things.

I've always felt balloon placement is very important. It's actually part of the artwork. Putting a word balloon in the wrong place on a panel can spoil the dramatic effect of the artist's drawing. In fact, whenever I wrote the copy for any stories that had been illustrated in the so-called Marvel Manner, I always indicated where the balloons—and sound effects—should be placed in each panel. And I roughly lettered the sound effects myself to give the letterer an idea of how I wanted them done.

Much as the artist visually constructs the story to most clearly convey the events to the reader, the word balloons, captions, and sound effects work as part of the page's overall design. A "dead" space in a panel could be enlivened with a well-placed balloon or sound.

First of all, we read comics from left to right, top left and across, then down. So, when you have a caption or word balloon, you need to anchor it to the top left corner of the panel.

Knowing your reader will move to the right of that, you need to position your balloons so one leads naturally to the next.

You can have an exchange between people by having the first speaker's dialogue broken into two connected balloons, placing the second speaker's dialogue in between so you go from one to the next with ease.

If my character has a lot to say, and they usually do, I break the speech into several balloons and place them around the panel so you get a sense of pacing even within that one image.

The captions and dialogue frame the artwork, letting the reader see the people involved. A cardinal rule, broken all too often today, is when people are speaking to each other, their eyes have to meet. Placing balloons between them creates a barrier that dilutes the scene's impact.

Sound effects should be placed near the source of the sound, and their size will help determine the kind of

impact being felt by the characters in the panel. We'll get to the letterer's role in all this on page 200.

Your title and credits should be clearly placed in and around the action, but like the balloons, they should not interfere with the main figures. A good title display will go a long way toward setting the mood of the story.

Today, many people choose to float their captions and word balloons as opposed to my anchoring them along the borders. I probably developed the technique, given my verbosity, and the modern method may work just as well. The bottom line is clarity to the reader so there's no confusion where to start, where to go next, and where to end.

As the dialogue writer, if you see a confusing page design from your artist, it is vital you place the balloons as the road map, simplifying the cluttered arrangement of panels. It can be awkward and confusing, but your job is to make certain the story is read the way you envisioned it.

THE ARTISTS

You've written your script or plot and have handed it to the editor. He or she praises your brilliance and your on-time performance, promises the check is in the mail, and sends the story off to the artist.

You move on to your next assignment and wonder what is happening to your story. And the answer, my friends, is that each artist works with a script differently. Some read it a few times, some get started right away. Some call the editor and complain, while others dutifully gather up the required references and brew a fresh pot of coffee.

The relationship between the writer and the artist is an alchemical one, and not every combination works, even when the two have worked together in the past. Sometimes it is because the character is different or the artist handles a script differently than he does the plot.

Alice in Wonderland #1 page 2 pencils.

WHEN THE ARTIST RECEIVES THE SCRIPT

Jerry Ordway is a rock-solid professional and has been in the field long enough to have developed a good approach to his job. He told me, "When an artist is working from a full script, the story is already paced out panel by panel, and the artist has a very different job than on a plot-style job. For me, a full script has to be about *staging*, to make sure that there is sufficient room for dialogue (which is already there, waiting to be shoe-horned in) as well as making certain the characters are drawn in a way that facilitates the order of the speakers. Many writers use a casual 'back and forth' conversation style in a single shot, and with two speakers the staging is tricky, but oftentimes you can have more than two speakers. I would first thumbnail a page in a rough layout form to 'service' the dialogue, not worrying about anything but the flow of the action and the balloons. If an artist is like me, he or she will assign space to dialogue first, to make sure there is room for the lettering, and then try to carve out a bigger panel, so that it all fits. A pet peeve of my own happens to be when I have a script that has the characters talking against the same backdrop over four pages, such as people sitting in a diner. Many young writers focus on characterization over action, and it makes for a boring visual. A movie or TV show can spend ten minutes in the same location and do so because they have a budget for sets or location scenes. Comics don't have those restrictions, so let loose, and give the artist some fun stuff to draw, while you pontificate. This point should never be lost on a writer: Comics are a visual medium.

"One of the best complete script writers I've worked with is Alan Moore. He has an amazing visual sense, as well as the ability to communicate in words what he wants the artist to draw. That sounds like it would be simple, but it's not. The writer has to be as careful in wording the panel descriptions as they would the dialogue. Clarity is key. Remember, the artist is reading it, not hearing you speak it. Alan is careful to give stage direction in the correct order as well. If, on page 3, a specific person, place, or thing is highlighted, you need to let the artist know before then. If the hero reaches into his backpack on page 3 to grab his grappling hook, you sure better mention the backpack in the earlier pages. There's nothing worse than getting to page 4 and realizing you have to go back to the earlier pages and add accessories. I read through the script once or twice all the way through, but when I start the drawing, I draw a page or so per day, so I may not remember descriptions on later pages at the time I'm absorbed in page 1. I have had a few mishaps on jobs, where I had to go back and add things, and it's especially hard if you already sent the earlier pages in to an inker. I have also run into problems on occasion where a script page continues to another sheet of paper, with no "continued on next page" at the bottom, and have drawn a whole page only to discover additional panels on the next sheet of paper. Not a fun thing."

THE ARTIST AS COLLABORATOR

Legendary artist Neal Adams explained to the equally legendary Will Eisner in his book *Shop Talk*, "I assume [the writer's] my counterpart: he is the writer side and I'm the artist side. I try to tell the story he's written as well as I can. I try to tell his story, because I know in the back of my mind that if I have a story, I'll be able to tell it some other time. I don't like to be in the position where I don't like what he's done, because what happens is, you get pulled in two different directions. First, you want to do a good story. Second, you don't agree that a specific story is good. In order to make it good in your eyes, you have to ignore a certain part of the story. That dilutes the story. I'd rather go to him and say, 'Look, I have a problem. Can you help me? I'd like to do this instead of that.' If I can't, I'll do the story the way it's written. I'll do it, because, it seems to me, by mucking with his story, I am diluting my own work. For that period of time, I say, 'This is a good story.' If I don't like it, I don't work with him again. The strength of a story can get lost trying to fix something you don't think is right."

The great Gil Kane, who I didn't work with nearly enough, once explained, "I obviously think in terms of the total story . . . I approach the material on a page-by-page basis, trying to determine whether I'm going to be very expressionistic, theatrical in presentation, or very schematic like, say, Hal Foster, who has a very schematic approach—a way of dramatizing a story that proceeds almost like a blueprint—or, Eisnerish: very dynamic, dramatic, understated, subordinating everything to the characters and story itself. I'm influenced to the extent that I think I can go either way."

Alice in Wonderland #1
page 2 inks.

KNOW THY ARTIST

Writers sometimes prefer knowing or insisting these days on knowing who the artist will be and tailor the story to his or her strengths. That makes a lot of sense, and there's certainly a larger pool of talent to pick from than there was when we were inventing the Marvel Universe.

Meantime, when Steve had long before left *Doctor Strange*, the series was written to ape his style for a time until we assigned the strip to Gene Colan, a far different, more photo-realistic artist with a vastly different storytelling sensibility. As Roy, the writer at the time, recounted in *Alter Ego*, "Gene was the artist who really turned [*Doctor Strange*] on its head from what it had been before. [Bill] Everett, Marie [Severin], [Dan] Adkins, and Sam Kweskin had all been doing their own riff on Ditko, which was probably what Stan wanted at the time. After all, Ditko had a unique way of doing worlds and dimensions. When Gene came in, he had no feel for that approach. I doubt he ever considered drawing stairways to nowhere, and other things Ditko had done. Gene's idea of another dimension was

mostly a lot of smoke and mirrors with a whole different look . . . but it was great in its own, different way.

"As a writer, I had to adjust, because now there were things you couldn't do in *Doctor Strange* that you could've done with a Ditko-influenced artist. At the same time, Gene's work opened up possibilities for the characters to become more human, because he made everybody—Doc, Clear, Wong, even the mansion—look so real. As an 'accommodating' writer, I started plotting the stories differently, finding ways to bring in more human elements. I think that's why those issues are remembered fondly today: Gene and I established a little different grammar for *Doctor Strange* than before. Others have built on that since, but we started it, and it was mainly because Gene wasn't capable of or interested in thinking the way Ditko did. That isn't a criticism of Gene. If you're going to have Gene Colan draw something, don't ask him to imitate anybody else. So we didn't."

Neil Gaiman was among the first writers to insist on knowing about the artist, and as he told Mark Salisbury, "I trust my scripting and writing skills

enough. I know my storytelling skills are not the greatest in the world. On the other hand, I also know that what I suggest will work, so what I always say at the beginning of any script when working with a new artist is, 'Look, I'm the writer here, you are the artist, if you can see a better way of doing it that way—not a different way, but if you can see a better way, then do it that way.'

"It depends on the artist and what I'm doing. On *Sandman*, with a very few exceptions, I didn't want to give people leeway. I wanted to make sure they got it right. I feel when you're telling an artist, 'Do this' or 'This will work', what you want is for them to do that and for that to work. And mostly it does. When you give an artist leeway, unless you trust them implicitly and know what you're going to get, you can very often wind up with something that bears no relation to what you did. I've heard too many horror stories from too many friends of mine who write comics, where what actually came out bore no resemblance to anything that was in the script and then they had to desperately try and cover it over by rewriting."

Astonishing X-Men #25, written by the wondrous Warren Ellis!

ARTISTIC FREEDOM

"It really depends on the artist and what they're looking for," Joe Kelly said in an interview with Salisbury. "Do they understand the script? Are they the type that wants to contribute? I always indicate in the beginning that although I put in a lot of detail it's open to their interpretation. If they think they can story-tell something better, as long as they don't lose any important elements, I don't care if they do that. Sometimes they take me up on that and sometimes they don't. Sometimes the artist won't necessarily know what's an important story point if I don't tell them. I worked with one artist who didn't always get the jokes, so he just didn't draw them. It was like, 'Okay, that was a good joke, and now it's not going to be in there.'

Some writers will add or subtract detail from their scripts based on their knowledge of the artist. Warren Ellis, the British writer of such works as *Transmetropolitan* and *Astonishing X-Men*, once said, "It all depends on who I'm working with. If I'm working with someone for the first time, I will envision the book very clearly and in some detail so they can understand how I see things, what my visual sense is like. Once I've been working with them for a while, the scripts become more pared down. With Darick [Robertson], who I've been working with for two years now on *Transmetropolitan*, I write fairly lean scripts—unless I'm after a specific effect or I'm describing something that must be imagined in absolute detail—because I know how he thinks and he knows how I think. We understand each other's eyes, and so I can write a scene knowing how he'll stage it. To be honest, I find it more interesting at the start. It's almost like the first few weeks of a love affair, where your new girlfriend is just so new and you're still exploring and learning and are fascinated by anything that they do."

HORROR STORIES

The writing veteran Denny O'Neil observed, "Back when I started, we mostly didn't know the artists. You may have had an idea. But like, *Green Lantern/Green Arrow:* I didn't know that Neal [Adams] was gonna do that first issue. So I came up pretty early on with the concept of an artist-proof script, and then I abandoned it later. But I remember one western I did for Charlton: 'A man called Lobo is leaping over the boulder, a gun in both hands, shooting the weapons from his blah-blah!' And what I got was a medium close-up of a guy sort of holding a six-gun next to his ear. And I later found out, this particular artist—if it didn't exist in his swipe file, it didn't exist in his world.

"One of my ex-freelancers has a horror story of working Marvel-style with a given publisher, and he gets the artwork back and one of the three main characters is nowhere present in the story. So he asks about this and is told, 'Well, the artist doesn't like that character.'"

Those were some terrifying tales, and they certainly match some of the boneheaded excuses I heard through the years. Fixing it in the lettering is one of the last steps to be taken, when you're absolutely out of time. If any editor is worth a damn, he'll have the page fixed by the culprit. Yet, editors today—much like we used to be in the 1960s—sometimes are so behind on their deadlines that redrawing is impractical. Then there are editors who wouldn't think of offending an artist's talent by asking for changes.

THE ARTIST SPEAKS

Joe Kubert, who is not only a marvelous artist but a gifted educator, running his Joe Kubert School of Cartoon and Graphic Art for over thirty years, also valued having story input. "If you had some input into the story, you felt that you could benefit the final results. That is what we were striving for. We wanted to be able to participate in the portrayal of a story by more than just drawing pictures to words. Many of us were working on scripts that we thought were terrible, absolutely awful. But that was the last thing we would tell an editor. That was like yelling sour grapes. The situation today is completely different. Suggestions are invited from one and all so that the results will reflect the best creative efforts available. This team effort results in the most successful publications."

Sgt. Rock by Joe Kubert.

PUTTING PENCIL TO PAPER

But what happens when the artist receives the script?

Jim Lee, who has risen to fame and fortune as both a titanic artist and a business mogul, outlined his evolving methods this way: "I've done it a number of different ways, and the method has clearly evolved from early on to the way I work now. You develop a system and adapt that as you progress. It becomes easier, more streamlined, mainly because you've done it a lot of times. Originally, I'd go through the script—and I actually still do this—and put asterisks next to the key scenes, or things I want to highlight, question marks next to things that don't make sense, or might be difficult to draw panel-to-panel. After that I'd go through and put brackets next to various sentences or paragraphs, all the time figuring out what I think would fit onto each page. Then I'd get typewriter paper and break the bracketed sections down on that, as thumbnails. I'd do that for the whole book and then start drawing. The nice thing about doing it that way was that you could theoretically pick up page

22 of a story, draw that first, and then work backwards. It helps to work out of sequence sometimes, because you know where each page leads you and how the next page starts off. Sometimes it seems you're actually going faster that way, because hey, you're on page 18 in no time! Nowadays, I read the script and while I still sort of highlight and bracket it off, I then just go straight to the art board."

I was fascinated to hear how John Romita Jr. developed his working habits, which are very different from what his dad used to do with my plots. He told Mark Salisbury, "Originally, the way it would work is this: Once I'd read the lot through, I'd take a magic marker and identify between five and ten key sequences, and then grade those according to their dramatic weight. If it was a battle, I'd put it in a broader category, with an allowance for big panels, whereas a conversation piece would be grouped allowing for maybe six or seven panels a page. Then I'd take one segment of the typed plot at a time, pull out about six or seven specific storytelling points, and draw a line underneath to indicate

that's one page of the finished comic. I'd then do the same for the rest of the plot, all twenty-two pages' worth.

"Nowadays, because I'm a little more confident in my storytelling, I just make brief numbered notes on the plot, identifying the main action and character stuff. I'll end with maybe two hundred of these notes, which I'll then break down into the twenty-two pages. As I go, I'll rearrange an action sequence here, maybe pushing some panels onto one page, allowing for a double-page spread there. It takes one full day of what I call thumbnailing, even though it isn't really. I don't do any little sketches; it's all textual notes and mental pacing. Once I have my twenty-two pages visualized, allowing for maybe 125 or 130 panels in total, I'll start thinking about the actual pages and getting the action where it should be. I like to have definite breaks between the pages, with a clear segue from one to the next, so there's maybe a dramatic turn of a head at the foot of one page and on the next is a wide shot of somebody jumping on someone else."

THE COLORIST

Truth to tell, while I loved working with the artists and considered myself a fairly good art director, I never paid that much attention to the color. When I started, and until I was kicked upstairs to being publisher, comics were colored in a traditional manner that allowed a mere sixty-four color choices.

This didn't really allow for a lot of creativity, so I pretty much left the colorists alone. Stan Goldberg, who wrote and drew countless *Millie the Model* stories for me, was also our top colorist when the Marvel Age began. He helped design the memorable color schemes for our new heroes. He recalled to Jim Amash in *Alter Ego*, "Stan wanted bright colors; he didn't want anything subtle. He said, 'We do comic books. We want the characters to stand out.' He told me to color them with bright reds and blues and on and on and on.

"I always used red, yellow, and blue for the superheroes. Green, browns, shades of red, and purples were the colors I saved for the villains. It was a formula, and it worked. The colors I picked for the villains made for a better contrast with the heroes. I certainly didn't want to use the same colors for the villains that I used for the heroes, because when they came into contact with each other, it'd have been harder to visually separate them. Green was a neutral color to use, and I could use different shades of it for the villains."

Today, it's a whole other story, one that I recognize adds a layer of story-telling. But, the basics of a good color-ist remain, and Goldberg summarized them nicely when he said, "Someone who wants to learn and has art abil-ity—you have to have color sense and understand how a page should be color balanced. Design is important. I used to read the story before I colored it in order to get a sense of what would work best to set the proper mood.

"Covers have to attract the reader.

Alice in Wonderland #1 page 2 colors.

We had a little more leeway with covers, because the printing was better on them than on interior pages. We could do more with gray and brown on covers. That's why I used them more on covers rather than the interiors, because gray was more unpredictable on that inside paper."

There are several books on color—how to do it and how color helps the story. While overall they help the fin-ished product and therefore help tell your story, their scope is really beyond what I need to cover in this book.

LETTERING

I was blessed to work with some of the finest men and women to hold a pen in all of comics. Before we began crediting them, they were the real unsung heroes of comics—the letterers. They made our words fit and look good and sound more important than we ever imagined. I got to work with the best: the brothers Sam and Joe Rosen and then Artie Simek, whose daughter Jean followed in his colossal footsteps.

Today, with very few exceptions, all comic book lettering occurs on computers, and you have to be a bit of a technical whiz to make the words, sound effects, and titles sing. I'm amazed to learn that with sound effects, the letterer tends to add the color, guessing that it will work in a complementary way with the colorist's efforts.

Lettering first was done on the original penciled art using rulers, French curves, and pens employing indelible India ink. Now the finished, inked artwork is scanned into a computer and sent to the letterer and colorist, usually simultaneously. The letterer, using Adobe Illustrator, does his thing while the colorist works in Photoshop, each delivering files to the Bullpen. Only then are the files magically merged and proofs generated to check spelling, balloon placement, and color before final corrections are made.

The rabbit hole went along like a tunnel, and then dipped suddenly down, so Alice had not a moment to think about stopping herself.

She found herself falling down what seemed to be a deep well.

Either the well was very deep or she fell very slowly, for she had plenty of time as she went down to look about her.

WELL! AFTER SUCH A FALL AS THIS I SHALL THINK NOTHING OF TUMBLING DOWNSTAIRS! HOW BRAVE THEY'LL ALL THINK ME AT HOME!

WHY, I SHOULDN'T SAY ANYTHING ABOUT IT, EVEN IF I FELL OFF THE TOP OF THE HOUSE!

Alice in Wonderland #1
page 2 colors with letters.

TOM ORZECHOWSKI

The letterer's job is easily defined but, in practice, involves managing a lot of wiggle room. The ideal is to flatter the script as well as the flow of the art, to integrate new elements—balloons, captions, and sound effects—appropriately and nondisruptively within the existing artwork. There should be a feeling of rhythm, of a logical flow from one panel to the next.

The majority of mainstream comic book lettering today is done digitally. Font choices are left to the letterer, in most cases. There are some conspicuous holdouts, such as *Archie Comics*, for which lettering is done in the traditional manner, by hand, using Speedball nibs and India ink.

Most of today's letterers use text fonts purchased from designers such as Blambot, although a few, including yours truly, have designed several styles of their own. The requirement of attractive title work leads some to acquire fonts from such non-comics-oriented sources as Font Diner, Veer, and My Fonts, which carry fonts from a variety of designers.

The most remarkable aspect of digital lettering is that it remains deeply rooted in the hand-drawn work of previous decades. The best dialogue fonts have a bounce to match the liveliness of the art; the best sound-effect fonts have some quirks. Today's best letterers have a solid familiarity with the work of those who came before!

British-born Richard Starkings has an award-winning career and was one of the pioneers of digital lettering. He also used his success with computer lettering to form Comicraft, the first real studio to produce lettering for companies in bulk. He wrote, with John J. G. Roshell, Comic Book Lettering the Comicraft Way. *He tells me his favorite sound effect is* FOOM!, *which makes me laugh.*

RICHARD STARKINGS

It looks like there's nothing to it, but comic book lettering is a sublime and invisible art. Years ago, writer Jeph Loeb told me that he regarded the relationship between the letterer and the writer as being akin to an inker's relationship to a penciler. After all, once the writer has turned in his script, it is the responsibility of the letterer to marry the words to the art, thereby interpreting and strengthening the writer's lines just as the inker interprets and strengthens the penciler's lines.

Sometimes, the letterer's performance is a matter of pacing—the placement of one balloon at the top left of a panel and another balloon at the bottom right so that the reader's eye is allowed to read the artwork in between the balloons and then gasp at the delivery of the lower placed line of dialogue. Sometimes the performance is more like the work of a Foley artist in the movies—adding gentle footfalls to a sequence set in an alley, or placing the *THWIPP* of Spidey's web shooters within his latest tangle with Doc Ock. At other times, the letterer has to ham it up for dramatic pronouncements such as "FLAME ON!" or "IT'S CLOBBERING TIME!," and at others he acts more like a sound editor, to ensure that whispered dialogue is placed close enough to the characters to make their utterances seem hushed but far enough away from the characters who aren't supposed to hear their words so that we believe the illusion.

Beyond such spoken elements, the lettering artist must also perform the roles of graphic designer, when presented with a title page or character logo; a typesetter, when presented with a newspaper headline or magazine cover; and a sign painter, when the story requires an inn sign, hotel logo, or storefront. The best comic book letterers switch seemingly effortlessly from one role to the other, creating letters that seem to belong to the art, rather than the script provided by the writer.

As the pioneer of digital comic book lettering, I am well aware that computers, and the availability of quality comic book fonts like those made available by my Comicraft studio, have made the task of lettering seem comparatively easy. However, when I'm asked by young hopefuls how to go about lettering comics, I always point them to the professionalism and artistry of the masters, all those letterers working with pens in the '60s, '70s, and '80s. The Rosens, Simek, Ben Oda, Gaspar Saladino, Todd Klein, Bill Oakley, Ken Bruzenak, and Tom Orzechowski and British masters Tom Frame, Johnny Aldrich, Annie Halfacree, Steve Craddock, and Bill Nuttall.

And you just thought these guys merely copied your dialogue and captions without careful consideration. We know better and are made to look better thanks to their efforts, always done without sufficient time and all too rarely thanked.

'Nuff Said!

WHAT IS AN EDITOR, ANYWAY?

Matt Fraction said in his *Comics Journal* interview, "I've been very lucky, I have very good editors. I feel like I have guys who I workshop ideas with and who will make them sound better and make me look like a much better writer than I am.

I've had a very easy time of it, really. My editorial relationships have been really conducive and really terrific, and I feel that they've made me a better writer just through working with a good editor. I have no problems being edited, I have trouble with the stupid stuff, but the meat of it has been great and I've worked with some really great guys who have a terrific instinct for story. As I've come from an indy-art-school world where it's very loosey-goosey and make-it-up-as-you-go, I've been lucky to work with guys who have helped me focus and narrow it in a way and I think the writing is better for it. People have horror stories, but I think I've been really lucky.

"The role of the editor has changed and evolved, much like the comic books themselves. In the old days, the editor was akin to God: He giveth work, and he taketh it away. He controlled who wrote and drew which character or feature, handed out the checks, and was master of every facet of the comic, from plot to sending it to production. The editor checks to make sure the script is funny, interesting, easy to understand, enjoyable, and well-written."

Today's editors still work with the talent, but there's a lot more infrastructure built into most comics publishers, so they are aided and abetted by assistant editors, proofreaders, marketing and sales staff, pre-press people, and manufacturing people. Workloads have always been heavy and pay has always been questionable, but we edit because we love being involved in the art form.

Editors are also the gatekeepers. They determine who gets in and who does not, evaluating new talent and raiding other companies for stars—and with that comes the requisite risks and rewards. As Roy Thomas put it to me, "Of course, the first trick is to get in, and that will often be a combination of hard work and more than a little bit of luck. After that, well, I don't think you can do much better than quote what guys like Julie Schwartz and Otto Binder (a couple of true pros) always said: You need to be good and reliable and likable. They maintained that if you had two of those three qualities, you'd be employed for a very long time."

In our conversation, Marv Wolfman added, "Look at what books the editors edit. See what their interest is. If you're trying to get work with an editor who primarily does science fiction, sending them a superhero love story might not be the best way to go. Often books are simply assigned to editors, but you can over time get an idea what they want. If you want to sell, you have to know the market."

As for how people get in, I frankly am a little out of practice with how it works today. But never fear, reader. I asked a number of veteran editors from several of today's top companies for their advice. See what they have to say on the following pages.

Me at my trusty typewriter (1950s).

CHRIS RYALL: EDITOR IN CHIEF, IDW COMICS

I look for the same things that editors have looked for since the days of chiseling words onto stone tablets: a captivating idea dressed up as a professional submission. Although possibly even more important than the idea and the presentation thereof is the more general idea of making an editor's life easier.

Seriously, that simple idea can result in so much more work, once a modicum of talent has been established. It boils down to the fact that pretty much every editor is too busy to find proper time to read submissions and is likely looking for reasons not to hire you—don't give them that. Be professional, courteous, and patient, and when you get work, deliver on time. That can go a long way no matter who you're dealing with or what specific requirements they might have. It sounds basic, but there's an alarming number of people who don't operate this way, so if you make less work for an editor even while meeting deadlines and being competent at your craft, you might be able to make a real go of things for a long time.

As for how you break into comics, that's the real quandary, isn't it? Writers definitely have to try harder than an artist, whose work can be evaluated in seconds. New writers can't be looked over as quickly, and likely won't be looked over at all without some sort of track record. It's that old saw: You need to be a published writer, but how can you be when no one will take a chance on publishing you? And unfortunately, there's no easy answer. The fact is, there are limited numbers of writing gigs even at the best of times, so the thing to do is to not depend on those openings. Chances are, most editors have

a general pool of people they like to work with already, and you add to that the dearth of time to evaluate writing samples, and, well, new writers are bound to face either rejection or, worse, lack of any response. My solution to this, even as an editor and a publisher, is cut them out of the equation. Sure, everyone eventually would like to take a crack at the big, popular characters at the major publishers, but before you'll ever get handed a chance to do that, you need to get some work published. These are good ways to go about that:

Aim low, and start small. That means forget pitching Marvel or DC right out of the gate. Hit the smaller publishers who might look to hire you for little or no upfront money. Self-publish, an option that gets easier every year now. Getting published in comics can get you into the hands of editors at bigger publishers, and then look to work your way up. Comics, while not offering the many financial or other perks of, say, movies or video games, are nevertheless an important part of the entertainment industry, and to really break in, it requires hard work and patience. There are no corners to be cut, and indeed, if you look at most of the top writers in the field now, they all worked their way up from obscurity over a number of years.

ANDY SCHMIDT: FORMER MARVEL EDITOR, CURRENT IDW EDITOR, FOUNDER OF COMICS EXPERIENCE

I expect a new writer to have command of the language. Spelling mistakes and grammatical errors are a real turn-off. Right off the bat, I know I'm going to have a more work-intensive edit if I have to catch a lot of things like that. So that's a big strike against someone pitching. That said, one error isn't going to kill you. It happens to everyone, but you hit two, three, four, and I know I'm in trouble.

I expect writers to want to work with me. That means I want them to cooperate and help me run a line of comics rather than fight me at every turn. Healthy discussion and even arguments are fine as long as we get to what makes the story stronger in the end. I don't need a pushover either. But I don't need a fight over every little thing.

I need a new writer to be patient. I'm not always going to be able to look at his or her pitches (though I try). It takes time. So be patient. Build a more personal relationship if you can over e-mail or the phone or, even better, in person at a convention. I'm looking for someone to be a part of a team and for someone who's going to elevate the material.

When evaluating someone's pitches, I'm really looking for three things:

1. A good hook or premise that's engaging on its own.
2. A complete story with a beginning, middle, and end. This would include the obstacle or obstacles that the hero must overcome and rising action and, of course, the inevitable conclusion.
3. And this is the most important: a story about a character that only works for that character. That means that if say Wolverine is in use elsewhere at the time that you can't just stick Spider-Man in the story and have it work out the same way. If

Current Marvel Executive Editor Tom Brevoort.

you can do that, then you don't have a character-driven story, and that's a real problem. All stories come from character, so start with the character and build backwards to the situation that's going to engage this character in a way no other character would react to it. That should lead you to your adversary and your premise or hook.

CHRIS WARNER: ARTIST AND EDITOR, DARK HORSE COMICS

Aside from making deadlines, which almost goes without saying, I expect a writer to know what the story is about. And by story I don't mean plot; I mean the heart of the narrative, the reason I should care about why these characters are doing what they're doing. There should always be a fundamental thematic operating principle at the center of any story.

I don't think you need to beat the audience over the head with a didactic moral; in fact, the audience may not even need to know explicitly what the heart of the story is, but the writer should know. And of course, for that to happen, the story has to be about something, and you'd be surprised how often writers don't take this into account. Sure, we want rousing action and genre fun, but if the story isn't really about anything, it will have no real resonance with readers and will just be a video game. And video games do video games better than comics do video games. Also, cultivate the ability to think outside your own experiences and biases. Stretch your perceptions by crafting protagonists who think and believe differently than you do, even perhaps who think and believe in ways you abhor. Don't make your characters one-dimensional caricatures. Your characters will only become interesting when they challenge your own positions, beliefs,

Current Marvel Chief Creative Officer Joe Quesada.

morals. Ultimately, writing is about exploring conflict, and what better way is there to serve that function than by challenging your own personal operating system?

As for breaking in as a writer, I have three suggestions: write, write, write. Get published anywhere you can, any way you can. Find up-and-coming artists and work on online projects together. Find small-press publishers and try to get freelance work, even for little or no money. Keep active, stay positive, and if you really have what it takes, eventually you'll crack the code. Breaking into comics as a writer at the major publishers is very difficult, so you have to stay at it. It's all about playing the long game.

SHANNON ERIC DENTON: EDITOR, WRITER, PUBLISHER, ACTIONOPOLIS

If someone is sending me a pitch, I like it to be a concise pitch. I want a logline and a short sum up. Editors have lots to do, and if a monstrous pitch comes across their desk, chances are it'll get pushed aside in favor of something that doesn't get in the way of getting their day's work done. And keep in mind we all have bosses. So if we're not the final say-so (and assume we're not), then this same pitch has to get read by several very busy people who are all also trying to find time in their schedule to read it.

And keeping that in mind, please include your bio. The editor isn't

always going to be in the room with all these folks when they finally have the time to read it. Knowing that you have done other published work is a huge leg up. It shows you aren't asking them to be the first to take a chance on you as well as shows that you've actually completed something.

If you are new, then try to find a good artist to team up with to get something made/published. In the era of web publishing, it no longer means you have to have deep pockets or take a financial risk to get your work seen. Now the only risk is the same one every creator faces—that of investing the time. It's not easy and there isn't any one way of doing it, but getting it done speaks volumes to your dedication as a writer and your willingness to work.

Last, I'd recommend being social and likable. It seems like an obvious statement, but unfortunately there are those who don't understand the team aspect of this medium. It becomes very clear to the team when one person is ruining the endeavor for everyone else. In a business where every little advantage is a blessing, it is simply bad business and unprofessional to handle yourself in a manner that isn't gracious or respectful to the other members of the team.

MARK WAID: WRITER, EDITOR-IN-CHIEF, BOOM! STUDIOS

Writer Devin Grayson has a terrific quote: "Breaking into comics is like breaking into a high-tech military compound, because the first thing publishers do once they realize you're in is they go back and seal your entrance so no one can get in the same way." In other words, it's tough to make your break in traditional ways, particularly for writers. Fewer and fewer editors or publishers have

the time needed to go through blind submissions, and the majors like DC or Marvel won't even look at over-the-transom plots or scripts.

The good news, however, is that not since the dawn of the medium has it been easier to break into comics as a writer, and that's because of the power of the Internet. Every editor I know and most of the creators I listen to follow webcomics, and many editors are drawing new talent off of the web based on what they read there. It's the ultimate democratization of the process; even if you self-publish a black-and-white comics sample to hand out at conventions, it's still going to cost you money. Doing comics for the web is essentially free (provided that, as a writer, you can hook up with a reliable artist). That means there's a lot of them out there competing for attention, but the cream rises (and gets attention from publishers), trust me.

Marvel Comics' talent coordinator, C. B. Cebulski, writes a great blog (http://chesterfest.blogspot.com) wherein he periodically lists sites that pair up young writers looking for young artists and vice-versa. If you're a new writer looking to make this a career, start networking on the web and see if you can find an artist with whom to collaborate for online comics, then hit every message board in the comics community to publicize it once you've got a body of work up and ready to view. If you're good, we'll find you.

Stan here. If you have something to say, and can say it creatively, you can work in the field. Women are emerging as an increasingly visible part of the creative community, and I am agog at C. B.'s report that in 2009, he helped eighteen women (out of 144 people) get work at Marvel.

SHAWNA GORE: EDITOR, DARK HORSE COMICS

The basics to start with here are simple respect, courtesy, and not wasting someone's time. Since so many of these interactions happen at conventions, everyone who is looking for help or advice or a foot in the door needs to be ready for that conversation when it happens. I've had people wait in a line for an hour to talk to me only to find that they have no work at all to discuss, but they are "thinking about getting into comics" and would like my advice on how they might start the process. As an editor, it's par for the course that you'll be dealing with writers and artists of various levels, but writing seems to be the component that lots of people think "anyone" can do. So I think it's a bad call to go to a working professional in a specific industry just to run your career brainstorming ideas past her.

Assuming our writer is past that level, it's important to view any opportunity you get with a publishing professional as a potential job interview. I've seen an amazing spectrum of behavior from writers and artists over the years—everything from a guy at WonderCon staring at me in amazement while saying, "I didn't know girls edited comics!" when I introduced myself during his portfolio review, to one of my favorite new discoveries, who just wowed me with a really nicely arranged portfolio and a remarkably positive and dedicated attitude.

For the most part, editors who are working one-on-one, either at a convention or over the phone, want to know that the time they're spending with you is not wasted. Even if, as a writer, you feel like the editor you're talking to might not be the best candidate for understanding your work, that editor's perspective should still

be considered and valued. To make sure that happens, it's a good idea for the writer to come prepared not only to hear criticism about their work but also to ask for more! And to ask for more detailed examples of what is or isn't working.

It's also very helpful when people who claim to be creators, either writers or artists, simply create. If you're a writer, then write. Write stories, write scripts, write in your diary, write a blog. If you're really a writer, you will write because you know you need to in order to hone your skills. If you're a "wannabe" writer, you'll wait for someone to hire you first, then you'll start writing.

Some of you may actually prefer to produce your comics on your own. After all, that's been an element in the comics field since the mid-1970s. Many make a mediocre living at it, while a handful hit homeruns and sustain entire careers with their own projects. Among those early successful pioneers are Wendy and Richard Pini, who launched *ElfQuest* in 1978 and haven't looked back.

RICHARD PINI: CO-OWNER, WARP GRAPHICS

I'm going to recall my own experiences from the heyday of Warp Graphics—and perhaps get myself pumped up for what may lie ahead for *ElfQuest* as well. (Let's be optimistic. If the *ElfQuest* movie does well, there are possibly new comics and new young adult novels to be created.)

It always surprised me, when aspiring writers or artists would approach Warp looking for work, that so many of them had little or no idea what *ElfQuest* was. I never knew for sure if this was due to the applicant's self-confidence ("I'm so good I can work with any character or story idea you can throw at me") or naïveté about

our fantasy world ("It's elves, right? I can do elves; I play D&D."). *ElfQuest*, as we (mostly Wendy) created it, was and is a detailed, fleshed-out world, and at the very least I wanted aspiring artists and writers to know who the major characters were and the adventures they'd had.

We are probably more persnickety about character revamping than longer-established publishers such as Marvel or DC Comics. Superman, Batman, Captain America—these characters had been around so long that it became impossible to write stories for them using the tropes that had served decades previously. *ElfQuest* was (and still is) a young and sprawling, brawling saga whose characters and situations are still gelling.

We have definite ideas about the direction we want the stories to go, and so we have always looked for that most rare talent who is capable of "getting it" (the underlying gestalt of the entire mythos), being faithful to said gestalt, as well as bringing fresh style and insight to the telling and illustrating.

Oh, and editors also want it on time.

I recently received an e-mail from a young person who asked, more concisely than I've ever seen before, about self-publishing: "Is it true that *ElfQuest* made you rich when it first came out?" After I stopped laughing I replied that the elves had been good to us over the past thirty-plus years and that we hoped they would continue to be. I never know what to say to the young hopefuls who look at *ElfQuest*'s admittedly uncommon path seeking to emulate its success, particularly in print. In the late 1970s the Internet did not exist as the information-channeling entity it now is. Direct-sales comics shops were burgeoning all over the country as outlets

for independent publications. Alternative comics were few, and the field was wide open. Comics distributors were springing up. Even the "big two" companies, Marvel and DC, were releasing only a few dozen titles per month between them. There was plenty of room for an upstart like *ElfQuest* not only to get shelf space but also to enjoy significant word-of-mouth publicity—since there weren't thousands of "channels" (blogs, review sites, etc.) clamoring for attention.

The flip side of that coin, of course, is that today with the web anyone can launch a webcomic for almost no cost. And seemingly almost everyone has done so.

But when I say this to the young hopefuls, that's when their eyes glaze over, because while I'm telling them how they can "break in" to the comics, I'm not telling them how to get rich at it, or simply make a living. No one's figured that economic model out yet. So I tell them as gently as possible to do what they want because they love it, but keep the day job.

Don't forget, the elves have been around for over three decades. We got lucky, and the elves managed to entrench themselves early on, when the playing field was a lot emptier and there was much more room for growth. Can we even still call ourselves self-publishers after several years of licensing DC Comics (and now Warner Bros.) to handle all aspects (save the actual creation) of getting the material out there? We're still making a living, but these days it's from royalties and option fees.

WRITING AS A BUSINESS

You have talent and manage to interest editors in your work. Congratulations. Now comes the hard part: turning that into a career. When page rates were laughably low, writers would write by the pound, working quickly and in whatever genre the editor wanted. They could make a low-paying but acceptable living in the field, but it was tough, especially as companies came and went.

Some editors would only give work to married freelancers, figuring that they had at least one other mouth to feed and therefore would have added incentive to actually deliver the assignment on time.

The point is you need to recognize that this is a business. Not just the publishing business but the You the Writer business. Even if you have a day job and write comics at night and on weekends, this aspect of your life is a career and needs to be treated like one.

As Shannon Denton told me, "There is the job aspect of this career that is often overlooked: If your boss tells you to write a twenty-two-page story, you write a twenty-two-page story, or the gig goes to someone who can."

Writers and artists hate deadlines. The joke used to be the talent would ask the editor, "Do you want it good, or do you want it Tuesday?" The editor would invariably reply, "I want it good and on Tuesday."

"I love it," Matt Fraction said about deadlines. "It keeps me honest, you know? I would nitpick endlessly if I didn't have deadlines. I thrive with that little bit of pressure. It helps me not be precious; I could noodle around forever, would I not have people calling and asking, 'Where's the script?'"

Honesty with your editor is important. If you receive an assignment with a deadline, make certain it's a date you can meet. If you can't, see if there's any accommodation that can be made. Sometimes it's better to walk away from an assignment you know

you cannot handle rather than accept it, be late, and anger your editor. It may be the last time you hear from him or her.

You need to know how long it takes you to write a script or a plot. This is vital if you have other commitments, such as a day job, school, or childcare. Don't accept more work than you can comfortably handle. One example is given by Kurt Busiek from when he was quite in demand as a writer. "If I'm doing four regular books, then theoretically that's one a week in any given month," he told Mark Salisbury. "I have two offices: one in my home and one outside. The outside one is for solitude. When I'm dialoguing an issue of *The Avengers* I'll take the pages and go to the outside office. There's nothing else to do there—I don't even have a solitaire game on the computer—so I'll just script pages until I'm done. But when I'm plotting a story I'll be in my office at home, where I've got an entire wall of bookshelves full of old copies of *The Avengers*, *Iron Man*, *Captain America*, and *Thor* to look stuff up in. Those are the times I'll be on the phone with my editor talking about ideas and puttering around until I have a structure for the story."

My old pal Dick Giordano always taught that if an artist drew four pages in a single day even once, he talked himself into thinking it could be achieved again and again and accepted work based on that once-in-a-lifetime four pages a day. That's how people find themselves getting into trouble.

TAXES, DEDUCTIONS, RECORD KEEPING

But remember, this is still a business.

When you get paid for a script, you are being paid as a freelancer without any deductions from your fee. As a result, you need to make certain you set money aside for taxes. There are no benefits for freelancers, so you need to plan money for retirement, savings, investments, and what have you. This is slowly changing as various organizations such as the Freelancers Union and the Science Fiction Writers of America fill the gap, but you need to do your homework.

A good rule of thumb these days is to budget fifty percent to live on and fifty percent for taxes, savings, and investment. Find yourself a good accountant familiar with freelancers who can help you determine if incorporating makes sense or if setting up an LLC (limited liability corporation) works in your favor.

You will likely be asked to file quarterly estimated taxes, and you need to make sure there's money set aside for this.

Since we're talking about taxes, the good news is that you can also take deductions related to your work, and that's a pretty broad category. Again, talk to your accountant, but just about any expense related to your writing career can be used as deductions—phones, postage, computer equipment and supplies, research books, and so on. It's trickier, but if you have a dedicated home office, a percentage of your home expenses can

also be applied to your earnings. Of course, you have to be able to prove it to the IRS, so get smart early. Save and categorize your receipts (either paper or electronic). Set up systems to keep tabs of your work delivered and when payments have been received to make certain your clients are paying you. Everyone has a different routine, so pick whatever makes you happy, but pick something and stick with it.

Tony Stark, the pinnacle of professionalism.

The Avengers #184.

Batman #300 cover
by Dick Giordano.

PERSONAL PRESENTATION

How you communicate and present yourself to your employer is important. Be polite and clear in your phone calls or e-mails. Be presentable when coming to their office. These are pretty basic ideas but worth restating.

Be prepared to be told no or have work not be deemed acceptable. Rejection is a part of life, and you have to handle it with grace and dignity. Sure, you can ask for clarification on why the work has not been accepted, but don't get into an argument. Don't lose your cool and say things that may cost you future work. If you write an angry e-mail, don't hit the send button until the next day and you've had a chance to sleep on it and reread your missive.

Especially at the beginning of your career, you'll still be learning, and rather than be defensive, be open-minded and see what they have to say. If you pitch to five editors and one says you need work on structure, then maybe he has a point, but if you pitch to five editors and all five say you need to work on structure, then they're probably right. Take the sum total of the feedback you receive from friends, family, other writers, artists, and editors and see what the common themes are and work on them.

"I've done a couple of writing seminars and what have you, and if I could go back in time and tell myself anything about it, it would be 'Give yourself the gift of sucking,'" Fraction said. "You kind of have to let yourself be lousy and just do better next time and believe that there will be a next time and get it done and move on to the next thing. Otherwise, I'd have paralysis by analysis."

See how Black Terror can't keep his composure? Do the opposite.

TAKE IT LIKE A PRO

What comes with not being good enough is the possibility of losing an assignment. You need to take the good with the bad and handle the situation well. Denny O'Neil recalled in *The Comics Journal*, "I once took someone off a book and pointed out that this person had missed a dozen deadlines in a row, and the writer didn't understand why I was upset about that, why that was a reason to switch writers.

"It's something about the people who come up primarily through fan culture—it's their hobby. The other thing is, Dick Giordano used to say, 'We have to remember we're not curing cancer.' We had to remember that what we do—storytelling—is very deep in the human psyche and very important to us and may have something to do with our survival. But any individual story—whether it's written by Shakespeare or by the guy who does the funnies for the bubble-gum—is not, at the end of the day, that important. It's an interesting job, it's a fascinating job, I can't imagine anything that would have given me more satisfaction, and not everything I did was awful, but it was just writing another story in a world that's full of stories."

Trying to be a writer can be lonely work. But it's work, and you need to be as good as the competition, if not better, and it's okay to reach out to others for advice. Writers' groups and workshops are great ways to help hone your craft.

Ultimate Spider-Man #151.

Ultimate Spider-Man #153.

YOU, THE BRAND

Speaking of routines, I asked Brian Bendis what the structure of his day is like. He's a stay-at-home writer with a prolific output, and here's what he told me: "I'm a very blessed man in my family life. A normal day: I get up around eleven or noon while the kids are at school. So I do business and maybe get a little bit of writing done. I then pick up my children from school. Now, on Mondays and Wednesdays I teach class, then pick them up. I get my family together, we hang out, eat dinner, do homework, play, etc. Then it's shower time and bedtime for the kids, then I sit down at my desk and work into the wee hours of the morning.

"It's hard to turn off the writing, and I'm very fortunate to have a glorious, understanding wife."

He also stressed that when you create something and want to sell it to a publisher, you need to remember that while you may be on good terms with the editor, editor-in-chief, and even the janitor, the company is not your friend. You need to protect your intellectual property, and when entering into any contract with a publisher you are best off having a lawyer protecting your interests.

It used to be companies owned everything you did for them, but these days if you create a hero or villain for a shared universe such as DC or Marvel, you can have a piece of the action on up to fully owning the creation for other companies and imprints. Heck, some writers are doing very nicely, living off royalties from some of these characters.

Then there's getting attention for yourself, building up name recognition for *Your Name*. Your name is your brand, and you have to make certain people know who you are. Many look to me as one of the first to make a name for myself as a comics creator, and I did that to build up the Marvel line, making a lot of noise to differentiate Marvel from the Distinguished Competition (as I used to call them).

Today, the tools available to writers are vast. You can, of course, create a blog and post information about your upcoming assignments or other details in your life. You can set up pages on Facebook and LinkedIn. Twitter is a great short-burst tool to remind your followers when you have new material coming out. Many post on the day of a book's release and engage with fans as initial feedback comes in. I may be eighty-seven, but I have been tweeting for a while, and the responses have been incredibly gratifying.

If you can afford it, attending conventions around the country is another way to get out there and interact—not only with your readers, but also with your publisher, prospective publishers, and your peers. Conventions are the ultimate networking opportunity and a chance to talk shop, give tips, get tips, and hopefully find a willing editor to pay the bar tab.

But a word to the wise: Everything you post in cyberspace lives on forever. If you get into a message board battle with someone, regardless of the subject, it may stain your reputation. Think twice before hitting the Send or Enter key. The same goes for when you sit at a convention booth or on a panel.

Everyone's entitled to an opinion, and not everyone is going to love your work. Even you truest fans may not love every story you write. They paid to read your work and are entitled to their opinions. Be gracious and thick-skinned so you will survive to write again tomorrow.

This is a business, and as businesses go, it's one of the greatest careers anyone could ask for. Little did I know when I started at Timely in 1940 that I would still be at it, an idol of dozens (okay, thousands) decades later. All those years of pounding out stories as fast as I knew how created the opportunity for bursts of inventiveness and creativity that have endured for decades. I never lose the thrill of seeing characters I've written cavort across the television screen in wonderful animation or, better yet, stand dozens of feet tall on movie screens, seeing actors impersonate the heroes and villains I helped create. It all starts with an idea and then committing it to paper. Hopefully, this book has put you on the right path and you follow it to making your own dreams become reality.

Excelsior!

ABOUT THE AUTHOR

Born Stanley Martin Leiber on December 28, 1922, the man who would become one of the greatest comic book writers grew up in New York City. He graduated from DeWitt Clinton High School in 1939 and went to work for the WPA Federal Theatre Project. Stan got his start in comics when he got a job at Martin Goodman's pulp magazine company, Timely Comics, in 1940, working as a gofer for editor Joe Simon.

In 1941, Stan's "Captain America Fouls the Traitor's Revenge," a text story in *Captain America Comics* #3, became his first comic book credit. He signed it "Stan Lee," preserving his birth name for loftier works. He graduated to his first comic book series, "Headline Hunter, Foreign Correspondent," a backup in *Captain America Comics* #5. His first superhero story, an episode of the Destroyer, appeared in *Mystic Comics* #5. The same month, August 1941, his first creations, Jack Frost (*USA Comics* #1) and Father Time (*Captain America Comics* #6) appeared.

After Simon defected to DC Comics with Jack Kirby, Martin Goodman named Stan editor of Timely Comics, a temporary assignment that never ended. He worked at Marvel, with a brief foray in the military. He enlisted on November 9, 1942, joining the U.S. Army's Signal Corps. In 1945, Stan returned to the private sector, resuming his role as editor.

In 1947, Stan wrote *Secrets Behind the Comics*, his first attempt to share information with would-be comics creators. That same year, he married Joan Clayton on December 5. They have been happily married ever since and welcomed their daughter, Joan Celia "JC" Lee, in April 1950.

In 1961, Stan conceived the story and characters to comprise the *Fantastic Four*, kicking off the Marvel Age. The *Fantastic Four*'s success led to the addition of *The Incredible Hulk* and *Thor*, taking the lead spot in *Journey into Mystery*. The same month *Thor* debuted, *Amazing Fantasy* #15 introduced Spider-Man.

Now an entertainment industry icon, Stan was inducted into the Jack Kirby Hall of Fame in 1995. In 2008, Stan received a star on the Hollywood Walk of Fame. His bestselling book *Stan Lee's How to Draw Comics* was published in 2010.

RESOURCES

RECOMMENDED READING

Hey, True Believer, we're not done with you yet. Throughout this book, we've referenced numerous books, and it's only fair to provide you with a list of recommended reading. Most of these are enduring works and should still be in print. If not, try your local library and used book sellers.

WRITING

You may have other books for inspiration, but it never hurts to have a good reading list at your fingertips.

Adventures in the Screen Trade: A Personal View of Hollywood and Screenwriting, William Goldman
Alan Moore's Writing for Comics, Volume 1
Comics and Sequential Art, Will Eisner
The DC Comics Guide to Writing Comics, Dennis O'Neil
Graphic Storytelling and Visual Narrative, Will Eisner
The Insider's Guide to Creating Comics and Graphic Novels, Panel One: Comic Book Scripts by Top Writers, Andy Schmidt
On Writing, Stephen King
Panel One: Comic Book Scripts by Top Writers, Nat Gertler
Shot by Shot: A Practical Guide to Filmmaking (3rd ed.), John Cantine, Susan Howard, and Brady Lewis
Story: Substance, Structure, Style and the Principles of Screenwriting, Robert McKee
Understanding Comics, Scott McCloud
Understanding Media, Marshall McLuhan
Writing for Comics with Peter David, Peter David
Writer's Guide to the Business of Comics: Everything a Comic Book Writer Needs to Make It in the Business, Lurene Haines
Writers on Comics Scriptwriting, Mark Salisbury
Writers on Comics Scriptwriting, Vol. 2, Andrew Kardon

ON COMICS

It also pays to know something about the history of the comics field, so here are a few overviews that will help you:

Comic Books 101: The History, Methods and Madness, Chris Ryall and Scott Tipton
Comic Book Nation: The Transformation of Youth Culture in America, Bradford W. Wright
Comic Wars: How Two Tycoons Battled Over the Marvel Comics Empire—And Both Lost, Dan Raviv
DC Comics: A Celebration of the World's Greatest Comic Book Heroes, Les Daniel
From Girls to Grrrlz: A History of Women's Comics from Teens to Zines, Trina Robbins
Marvel: Five Fabulous Decades of the World's Greatest Comics, Les Daniels
Men of Tomorrow: Geeks, Gangsters, and the Birth of the Comic Book, Gerard Jones
Seal of Approval: The History of the Comics Code, Amy Kiste Nyberg
Stan Lee's How to Draw Comics
Ten-Cent Plague: The Great Comic-Book Scare and How It Changed America, David Hajdu

BIBLIOGRAPHY

BOOKS

Goulart, Ron. *Over 50 Years of American Comic Books*. Mallard Press. Lincolnwood, IL. 1991.
Groth, Gary, and Fiore, Robert, editors. *The New Comics*. Berkeley Books. New York. 1988.
Kaplan, Arie. *Masters of the Comic Book Universe Revealed!* Chicago Review Press. Chicago, 2006.
Lee, Stan. *The Best of Spider-Man*. Ballantine Books. New York. 1986.
Lee, Stan. *Bring on the Bad Guys*. Fireside Press. New York. 1976.
Lee, Stan. *Origins of Marvel Comics*. Fireside Press. New York. 1974.
Lee, Stan. *Son of Origins of Marvel Comics*. Fireside Press. New York. 1975.
Lee, Stan. *Stan's Soapbox: The Collection*. The Hero Initiative/Marvel. New York. 2008.
Lee, Stan, and Mair, George. *Excelsior!* Fireside Press. New York. 2002.
McLaughlin, Jeff, editor. *Stan Lee Conversations*. University of Mississippi Press. Jackson. 2007.
Raphael, Jordan, and Spurgeon, Tom. *Stan Lee and the Rise and Fall of the American Comic Book*. Chicago Review Press. Chicago. 2003.
Ro, Ronin. *Tales to Astonish*. Bloomsbury. New York. 2004.
Salisbury, Mark. *Artists on Comics Art*. Titan Books. London. 2000.
Salisbury, Mark. *Writers on Comics Scriptwriting*. Titan Books. London. 1999.
Schumer, Arlen. *The Silver Age of Comic Book Art*. Portland, Collectors Press. OR, 2003.
Schutz, Diana, editor. *Will Eisner's Shop Talk*. Dark Horse. Portland, OR. 2001.
Thomas, Roy, and Sanderson, Peter. *The Marvel Vault*. Running Press. Philadelphia. 2007.
Wiater, Stanley, and Bissette, Stephen, editors. *Comic Book Rebels*. Donald I Fine. New York. 1993.

PERIODICALS

Alter Ego, assorted issues, Roy Thomas, editor.
Back Issue, assorted issues, Michael Eury, editor.
Comic Book Artist, assorted issues, Jon B. Cooke, editor.
Write Now! issues #1–20, Danny Fingeroth, editor.

INDEX

K

Kane, Gil, 76, 192
Kanigher, Robert, 67, 102, 127
Kato, 78–79, 81–82
Kelly, Joe, 195
Kirby, Jack, 10, 20, 51, 52, 81–83, 125, 151
Klein, Todd, 201
Krazy Kat, 13, 14, 108
Kubert, Joe, 196, 197
Kung fu comics, 58–59
Kurtzman, Harvey, 30, 112

L

Lee, Jim, 198
Legion of Super-Heroes, 132
Letterers, 39, 200–201
Levitz, Paul, 132
Logos, 40
Lone Ranger, 63, 68. See also Westerns

M

Mad magazine, 62, 76
Mangas, Japanese, 23, 40
Marvel Comics
 Fantastic Four in, 10–11, 84
 Goodman and, 17
 style of, 80–85, 91, 93, 126
 subplots in, 132
Marvel Universe, 10–11, 21, 43, 112, 148, 174, 182, 194
Mary Jane novels, 56
Masquerade, 98, 142
Maxiseries, 144–145
McCloud, Scott, 50
McKee, Robert, 114
Metal Men, 102
Mickey Mouse, 38, 72
Miller, Frank, 142, 146, 162–163, 184
Millie the Model, 20, 62, 69, 72, 100, 156, 157
Miniseries, 40, 142–143, 144
Mister Miracle, 53
MLJ Publishing, 21, 69, 80
Moench, Doug, 93
Molecule Man, 184
Mole Man, 70
Moore, Alan, 51, 192
Motivation, 101
Mr. Face, 106

N

New Comics, 16
New X-Men, 167–168
Not Brand Echh, 76
Nuttall, Bill, 201

O

Oakley, Bill, 201
Occult, 65, 66
Oda, Ben, 201

O'Neil, Denny, 158, 196, 216
One-shots, 40, 140, 144
Ongoing series, 41
Ordway, Jerry, 86, 192
Origin, 41
Orzechowski, Tom, 201
Outcault, Richard, 13
Owl, the, 98

P

Panels, 42, 46, 93
Parks, Ande, 81–82
Patsy & Hedy, 69
Pekar, Harvey, 96
Penciler, 42
Pérez, George, 90
Phantom, the, 43
Pictures/artwork.
 for *Alice in Wonderland*, 149, 191, 193, 199, 200
 close, medium and long shots in, 124–125, 128
 evolution of, 50
 freedom for, 86, 87, 90, 91, 93, 195
 with full scripts, 86–87
 in Marvel style, 80–81, 196
 methods for, 198
 page spread of, 123
 problems with, 196
 prose and, 51–57
 from scripts, 192
 staging, 192
 thumbnail, 112, 161, 192, 198
 writers collaborating on, 192, 194, 196
Pini, Richard, 209
Platinum age of comics, 42
Plots, 42, 80–85, 86, 132–137, 188
Popeye, 43
Popular Comics, 16
Preacher, 159
Professionalism, 212–215
Project Superpowers, 94–95, 98, 124, 125, 142, 144, 177–179
Prose, 49, 51, 149
*P*S Magazine*, 151
Publishers, 42

Q

Quarterly publications, 42
Quesada, Joe, 207

R

Reboots, 43, 180
Recap pages, 184, 185
Red Sonja, 33, 38, 66, 74, 75, 140
Retcon (retroactive continuity), 43, 180–181
Revivals, 43
Robertson, Darick, 195
Romance comics, 20, 62, 70
Romita, John, 80–81, 83
Romita, John, Jr., 126, 198

Rosen, Sam and Joe, 200
Ross, Alex, 94–95, 97, 98, 105
Roth, Werner, 86
Ryall, Chris, 28–29, 205

S

Saladino, Gaspar, 201
Salazar, Edgar, 42
Samson, 99
Sandman, 90, 194
Schmidt, Andy, 29, 31, 206–207
Schwartz, Julie, 100, 204
Science fiction, 61, 62, 64
Scripts
 of *Alice in Wonderland*, 189
 definition of, 43
 formats of, 188–189
 full, 86–90, 91, 125, 126
 plot-first, 80–85
Secret Invasion, 184
Secret Wars, 182, 183
Seduction of the Innocent (Wertham), 43
Semimonthly publications, 43
Sequential art, 43
Sgt. Fury and His Howling Commandos, 67, 72
Sgt. Rock, 67, 197
Shakespeare, William, 14, 49, 108, 214
Shared universe, 43
Sherlock Holmes, 118, 120, 146
Shooter, Jim, 126–127
Shorten, Harry, 80
Shot by Shot, 30
Shuster, Joe, 18
Siegel, Jerry, 18
Sienkiewicz, Bill, 163
Silence, 167–168
Silver Age of comics, 43, 100
Silver Surfer, 23, 25, 102–103, 108, 109, 148
Simek, Artie, 200
Simon, Joe, 80
Sin City, 162
Software, 28–29
Sound effects, 166, 190, 200
Splash pages, 43, 123
Splash panels, 43
"Stan's Soapbox" columns, 46, 112
Starkings, Richard, 201
Stark, Tony, 210–211, 213
Steranko, Jim, 123
Stories. See also Writing
 action in, 170–171
 arc of, 32
 Busiek on, 129
 characters in, 112, 115
 confrontation in, 116
 flashbacks in, 128
 formula for, 127
 ideas for, 112–113, 169
 inciting incidents in, 113, 114, 115, 118, 170

pictures/artwork in, 112, 123–125
 resolution in, 118
 setting in, 120–121
 setup in, 114, 116, 123
 tension in, 128
 theme of, 112
 three-act structure in, 114–119
 timing in, 128
 transitions in, 112, 118, 122
 weather in, 120
Sub-Mariner, 20, 38, 174, 177
Subplots, 132–137
Superheroes. *See also Amazing Spider-Man*; Fantastic Four; Superman
 colors for, 199
 in comic books, 62
 creation of, 96
 definition of, 43
 motivation of, 101
 problems for, 71
Superman, 43. *See also* Superheroes
 Batman and, 181
 consistency and, 177
 creation of, 18, 19
 Jurgens writing, 161
 reboot of, 180
Supporting characters, 107, 132, 171
Sword-and sorcery genre, 66, 74

T

Teen humor, 20, 21, 62, 69
Terror, 65
Terry and the Pirates, 47
Thomas, Roy, 31, 80, 86, 177, 204
Thor, 87, 96, 108
TPB (trade paperback), 43
Transmetropolitan, 195
Trautmann, Eric, 83
Two-Gun Kid, 96, 156

U

Ultimate Avengers, 184, 185
Ultimate Spider-Man, 91, 92, 216, 217. *See also Amazing Spider-Man* Ultimates, the, 87
Ultra-Humanite, 43
Understanding Comics (McCloud), 50

V

Vampirella
 cover art for, 41, 60, 72
 dialogue and, 164
 Dracula and, 104
 full scripts and art for, 83, 88–89
 inkers creating, 39
 motivation and, 101
 story of, 110–111
 subplots in, 133, 134, 135